Waterfalls
of Pennsylvania

A Guide to More Than 180 Falls in the Keystone State

Jim Cheney

Adventure Publications
Cambridge, Minnesota

Dedication

To Julie, Jude, and Eleanor—never stop exploring.

DISCLAIMER This book is meant as an introduction to the waterfalls of Pennsylvania. It does not guarantee your safety in any way—when visiting waterfalls, you do so at your own risk. Neither Adventure Publications nor Jim Cheney is liable for property loss or damage or personal injury that may result from visiting waterfalls. Before you visit a waterfall, be sure you have permission to visit the location, and always avoid potentially dangerous situations or areas, such as cliffs or areas with moving/deep water or areas where wildlife (such as snakes or insects) may be a concern. In particular, beware of slippery rocks, drop-offs, fast-moving or high water, and wilderness conditions. Your safety is your personal responsibility.

Editors: Brett Ortler and Ritchey Halphen
Cover and book design: Lora Westberg
Proofreader: Dan Downing
Cover photo: Miners Run Falls (see page 121) by Jim Cheney
Interior photos: Jim Cheney except as noted

10 9 8 7 6 5 4

Waterfalls of Pennsylvania: A Guide to More Than 180 Falls in the Keystone State
Copyright © 2020 by Jim Cheney
Published by Adventure Publications
An imprint of AdventureKEEN
310 Garfield Street South
Cambridge, Minnesota 55008
(800) 678-7006
www.adventurepublications.net
All rights reserved
Printed in the U.S.A.
ISBN 978-1-59193-911-5 (pbk.); ISBN 978-1-59193-912-2 (ebook)

Acknowledgments

When I started traveling Pennsylvania in 2013, I had no idea how many waterfalls there were in the state. Without the millions of people who have read my website, **UncoveringPA.com,** over the years and the many who have provided suggestions of little-known spots to visit, I never would have been able to complete this book.

I also wouldn't have been able to complete this book without the support of my wife, Julie. Thank you for staying home with the kids while I trekked miles into the woods in search of hidden waterfalls, and for your patience when you went with me and I needed to get just one more shot (which almost always turned into 10 more).

And thanks to you, the reader of this book. I hope the waterfalls listed here provide you with as much joy and as many adventurous days as they have provided me.

—Jim Cheney

Table of Contents

Central Pennsylvania

Pennsylvania Wilds

Laurel Highlands

Western Pennsylvania

18 More Waterfalls to Explore . . . 208

Introduction

Waterfalls have fascinated me for as long as I can remember. As an adult, whenever I'd take a trip, whether it be to New Hampshire or Mongolia, I'd always search out a few waterfalls to visit.

In the summer of 2013, shortly after moving to Pennsylvania, I visited my first waterfall in the state: Dingmans Falls. At the time, I was preparing to launch a website about Pennsylvania travel and had recently quit my job to go all-in on this new endeavor.

I launched **UncoveringPA.com** in August 2013. Since then, I've visited every corner of the state on multiple occasions and have visited more than 1,000 different tourist attractions in Pennsylvania. While I love museums, historical sites, and great breweries, my favorite spots to visit are waterfalls. Since the summer of 2013, I've visited more than 200 of them.

For several years, I had been contemplating putting together a book of Pennsylvania waterfalls to showcase my favorites throughout the state. So when Adventure Publications came calling, I quickly discovered the perfect opportunity to branch beyond my website and share the beauty of Pennsylvania waterfalls in a different format.

Of course, this isn't a complete list of waterfalls around the state—I'm continuing to explore and find even more great waterfalls to visit. But if you're looking for the best Pennsylvania waterfalls, this guide is a great way to get started on your journey.

–J. C.

Pennsylvania Waterfalls

Most people are surprised to learn that Pennsylvania is home to hundreds of beautiful waterfalls. While many of our waterfalls lack the grandeur of those of other destinations, the Keystone State has more than enough great waterfalls to keep you busy for a long time.

What I love most about Pennsylvania's waterfalls is how varied the experience of visiting them is. Many of these waterfalls are located along a roadway or an easy trail, but just as many are hidden deep within the state's public lands. There are even waterfalls in this book that aren't located along any trail and require you to walk directly up the streambed to see them.

The greatest concentration of waterfalls in Pennsylvania is in the northeastern and southwestern corners of the state, though you'll find waterfalls in nearly every part of Pennsylvania listed in this guide.

The northeastern part of Pennsylvania is broken into two subregions in this book. The **Poconos** are home to the largest waterfalls in the state, while **Northeastern Pennsylvania** (which, somewhat confusingly, is located west of the Poconos) is home to even more great waterfalls.

In the southwestern part of the state, the **Laurel Highlands** are home to many more fantastic waterfalls. While they may lack the towering height of those in the state's northeastern corner, they are just as beautiful.

Seasonal Variations

Of all the natural sites you can visit throughout Pennsylvania, none change more than the state's waterfalls. Not only do they change based on the season, but they can also look different from day to day depending on the flow of water. This means that no two visits are the same, and I've enjoyed visiting many of the waterfalls in this book several times.

Typically, the best time to visit waterfalls is in the spring, when melting snow and increased rain ensure that the waterfalls are flowing at full capacity. In fact, a few waterfalls in this book rarely flow well outside of this time of year, and that's been noted where this is the case.

In the summer, rain is usually less frequent; this means that there is less water to flow over the face of the falls. While some waterfalls look great during the summer months, many are mostly or completely dry. If possible, try to visit after a day or two of rain.

In the fall, water levels tend to rise, and the beautiful fall foliage of Pennsylvania can lead to some amazing shots. While the flow isn't as consistent as it is in the spring, fall is my favorite season for photographing Pennsylvania's waterfalls.

In the winter, it's often cold enough to mostly or even completely freeze Pennsylvania's waterfalls. Use caution if you opt to visit waterfalls during the winter, as many of the ones in this book sit down unmaintained dirt roads, and getting stuck could be dangerous or even deadly.

I also recommend packing a pair of crampons or microspikes, as the land around the waterfalls can often be icy. A few waterfalls are completely or mostly closed in winter; I've noted that where applicable.

Trespassing/Private-Land Info

With one exception, all of the waterfalls listed here are on public land. The exception is **Bushkill Falls,** located in the private recreational facility of the same name (see page 26 for more information).

Occasionally, however, even public lands may be unexpectedly closed to the public. Should this happen with any of the waterfalls listed in this book, please respect any posted closures and *do not trespass.*

Note that several waterfalls I originally planned to include in this book are now closed to the public because of improper behavior by visitors. When visiting the waterfalls in this guide, please do your best to leave no trace of your visit so the people after you can continue to enjoy the falls.

Safety Around Waterfalls

While any outdoor activity comes with some risk, visiting waterfalls carries a bit more. The areas around waterfalls can often be slippery, with steep drop-offs and uneven terrain. People have been seriously injured or even

killed at some of these waterfalls when they didn't exercise proper caution, so please be extremely careful, especially when water levels are high.

At some waterfalls, you may find signage or fences that encourage you to stay back from the edge or from venturing to certain places. Respecting these is not only a way to keep yourself safe, but it also ensures that the waterfalls will remain open to visitors for many years to come.

Note: A number of waterfalls in this guide require off-trail hiking. Where this is necessary, I've noted it within the text. Hiking off-trail is recommended only for those experienced with this type of hiking; at a minimum, you should hike off-trail only if you have (1) a partner and (2) a GPS unit and/or a compass and paper map in case you get lost. If you must hike alone, always tell someone where you're going and when you expect to be back, and bring enough gear with you in case you would have to spend the night alone in the woods.

Hunting is a popular pastime in Pennsylvania, and many of the waterfalls listed in this guide are on land where it is allowed. When hiking in these areas, particularly on state game lands, wearing a blaze-orange vest and hat is recommended to ensure that you are seen. When hiking on state game lands from November 15 through December 15, you must wear at least 250 square inches of blaze orange.

Animals and Plants to Watch Out For

Pennsylvania is home to more than 20 kinds of **snakes,** most of them benign. **Copperheads** and two types of rattlesnakes, the **timber rattler** and the

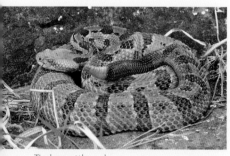

Timber rattlesnake
Photo: James DeBoer/Shutterstock

eastern massasauga, are the exceptions. The copperhead is the most widely distributed of the three, occurring in most habitats across the state, with the exception of the most northern reaches. The timber rattler (*left*) is found primarily in the mountainous regions of Central and Northeastern Pennsylvania, while the massasauga primarily inhabits

a small area in the western part of the state as well as a few areas in Eastern and Central Pennsylvania. Hibernation season is generally November–April.

To avoid encounters with venomous snakes while hiking, stick to well-used trails, and wear over-the-ankle boots and loose-fitting long pants. (Rattlesnakes like to bask in the sun and won't bite unless threatened, but give them a wide berth.) Don't put your feet or hands where you can't see them; step on logs and rocks, never *over* them; be especially careful when climbing rocks; and avoid walking through dense brush whenever possible.

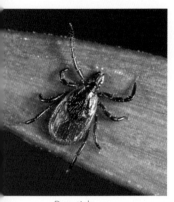

Deer tick
Photo: Jim Gathany/Centers for
Disease Control and Prevention

Ticks are often found on brush and tall grass and are most active in Pennsylvania between April and October, but they can bite you at any time of year. The tiny deer tick (*left*) is the primary carrier of Lyme disease.

Wearing light-colored clothing helps you spot ticks before they bite; coating the tops of your socks with insect repellent is an effective deterrent, as is tucking your pants into your socks. Most importantly, visually check your hair, the back of your neck, armpits, and socks after a hike. During your posthike shower, take a few moments to do a more complete body check.

Use tweezers to remove ticks that are already embedded: grasp the tick as close to your skin as possible, and pull it gently rather than twisting it out. Thoroughly clean the bite and your hands with rubbing alcohol or soap and water. If you develop a rash, fever, or flulike symptoms within several weeks of getting bitten by a tick, see your doctor.

Poison ivy (*right*) grows abundantly throughout Pennsylvania, especially near streams and ponds. It occurs as a vine or ground cover, three leaflets to a leaf, hence the old rhyme "leaves of three, let it be." If you've come into contact with poison ivy, wash the rash thoroughly with soap and cold water; then apply calamine lotion and/or an anti-itch cream. If itching or blistering is severe, see a doctor.

Poison ivy Photo: Tom Watson

Likewise, wash clothes, pets, or hiking gear that may have touched the plant—it's not unheard of to experience a second outbreak of poison ivy a year after the first due to picking up a pair of boots that weren't properly cleaned.

When it comes to wildlife, **black bears** are generally the only mammals that pose a potential threat. (**Coyotes** can pose a threat to small pets.) If you encounter a bear in the woods, it will likely run away, but if it doesn't, back away slowly while making noise and trying to look large—don't run or climb a tree.

What to Bring

While it can be tempting to pack little more than your camera when visiting Pennsylvania's waterfalls, there are a few more items you should throw in your bag before leaving your car.

At a minimum, I suggest packing water, a few snacks, a compass or GPS unit, a flashlight, extra batteries for the devices listed here (plus your phone if it has a removable battery), and a first aid kit. If the evenings are cool, pack an extra pair of socks, a jacket, and a flint. While most hikes are uneventful, you never know when an accident may happen or when you might get lost, and it's always best to be prepared with more than you think you'll need.

If possible, also pack a paper map and/or a road atlas of the area you're visiting. Even if the waterfalls aren't shown on the map, it can still help you find a route out should you need to evacuate as quickly as possible.

Photographing Waterfalls

There is nothing that I enjoy photographing more than waterfalls, and I also enjoy helping other people learn to photograph them. I run several on-site workshops in Pennsylvania each year (see uncoveringpa .com/photography-workshops for details), but here's a quick rundown.

You can get great shots of waterfalls with any camera, including the one that comes with your smartphone, but you'll need a few pieces of more-specialized gear if you want to shoot photos of waterfalls like the ones in this book. My recommended gear list is as follows:

- DSLR camera with manual settings
- Tripod
- Polarizing filter
- Neutral-density filter

There are three primary ways to photograph waterfalls:

1. You can use a multisecond shot to completely blur the water.

2. You can use a shutter speed of around one-tenth of a second to blur the water but still provide detail in the water.

3. You can take a shot with a shutter speed faster than one-hundredth of a second to freeze the water.

The photos in this book were shot with one of the first two methods. You can set the shutter speed on your camera using either manual mode (labeled M on your camera) or shutter priority mode (labeled S or TV). Shutter priority mode is my preferred setting in most situations.

If you want to blur the water, you'll need to set your camera up on a sturdy tripod, turn off any image stabilization on your camera, and use either a remote cable release or your camera's internal timer. This will ensure that you have a steady camera when you shoot a photo with a long shutter speed.

I never shoot photos of waterfalls without a polarizing filter, which helps cut through glare on the water and rocks surrounding the waterfall and helps to give your images a more professional look. I will also often use a neutral-density filter. These filters are simply dark pieces of glass that allow you to shoot at slower shutter speeds than your camera would normally be able to.

If possible, try to shoot waterfalls either (1) near dawn and dusk or (2) on a cloudy day. Shooting in bright sunlight can create harsh shadows and make it much harder to get a well-balanced photo. While the beautiful glow of early-morning or evening light is ideal, that's not always practical due to time constraints. Because of this, I find myself most often shooting waterfalls on cloudy days whenever possible. If you must shoot on a sunny day, as I sometimes have to, compose your shot and, if possible, wait for a cloud to block the sun briefly before shooting your image.

How to Use This Book

This book covers the entire state of Pennsylvania and is organized geographically. The state is divided into seven regions: **The Poconos,**

Northeastern Pennsylvania, Southeastern Pennsylvania, Central Pennsylvania, the **Pennsylvania Wilds**, the **Laurel Highlands**, and **Western Pennsylvania**. The overview map on page 16 shows the approximate location of each waterfall.

Within each region, the falls are ranked according to three general categories: **Top 16, Must-See,** and **Other Falls.** As you might expect, the Top 16 Falls are the best waterfalls the state has to offer. Most of these entries include four pages (a few include more); all include a large two-page photograph to show off these falls' beauty and power. Must-See Falls are wonderful in their own right, as are Other Falls, which get shorter shrift only to keep the book from expanding to five volumes. And if you just can't get enough, head to page 208 and you'll find a table with **18 More Waterfalls to Explore.**

In each section of the book, I include the following information for each waterfall:

Location: Where the waterfall is located; this is usually a park or other natural area. The approximate location is marked on the mini-map to the left of the hike name.

Address/GPS for the Falls: The vast majority of the waterfalls in this guide do not have formal street addresses; therefore, GPS coordinates are listed for nearly every waterfall. After you park, plug these coordinates into your favorite mapping software, and it will show you right where the waterfall is located.

Directions: Instructions for driving to the falls or trailhead.

Website: Where you can find more information. Where no official source exists, I've included a link to my website, **UncoveringPA.com,** which lists additional information and any trail updates.

Waterway: The river or stream that produces the falls; some falls are located along unnamed streams/rivers.

Nearest Town: The closest town/city.

Height: The approximate height of the falls, though this can be difficult to measure accurately in some situations.

Crest: The approximate width of the falls; this can vary quite a bit depending on the season and rainfall patterns.

Hike Difficulty: How difficult the hike is overall, described as *easy, moderate,* or *strenuous.* (NA, or "not applicable," is listed for trips where no hiking is involved—for example, where the waterfall can be viewed from the road.)

Trail Quality: How well marked and secure your footing is on the trail, as well as details about the trail surface, obstacles, and stairs.

Round-Trip Distance: How far you'll need to hike from your car to the waterfalls and back.

Trip Report & Tips: A step-by-step account of my visit to the falls, including detailed directions to reach the falls as well as suggestions for the best places to view the falls from. Trip reports also include interesting sights and attractions to look out for on the way, possible hazards, recommendations, and the best times to visit the falls.

Big Falls on Heberly Run (see page 60)

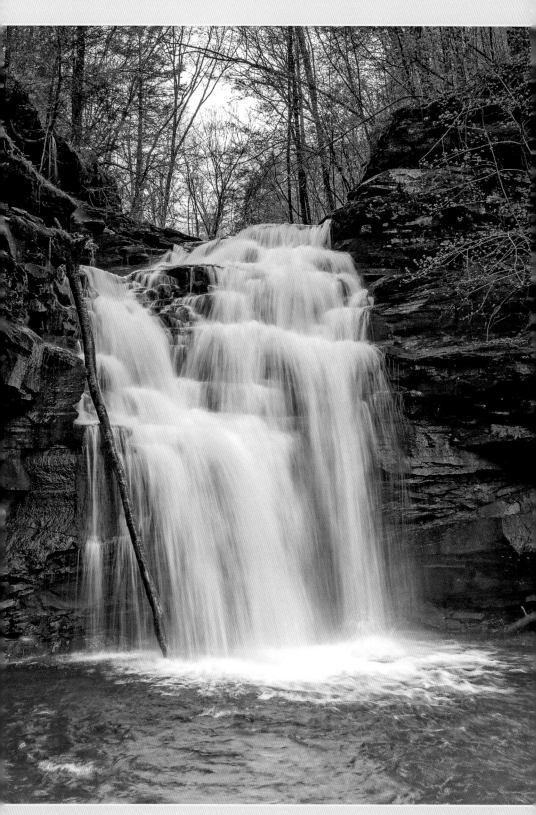

Map of Pennsylvania's Waterfalls

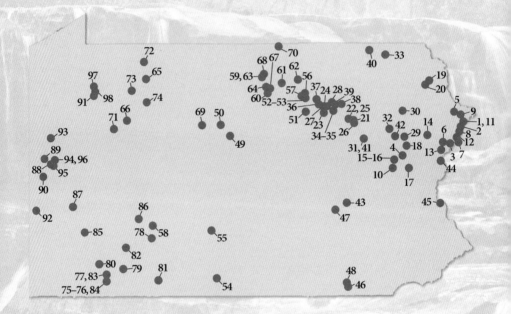

The Poconos

1 Raymondskill Falls (p. 18)

2 Dingmans Falls (p. 22)

3 Bushkill Falls (p. 26)

4 Hawk Falls (p. 33)

5 Shohola Falls (p. 35)

6 Resica Falls (p. 37)

7 Tumbling Waters (p. 39)

8 Hornbecks Falls (p. 41)

9 Savantine Falls and
Sawkill Falls (p. 43)

10 Cave Falls (p. 45)

11 Hackers Falls (p. 47)

12 Camp Hidden Falls (p. 47)

13 Marshalls Falls (p. 49)

14 Rattlesnake Falls (p. 49)

15 Buttermilk Falls (p. 51)

16 Luke's Falls (p. 51)

17 Wild Creek Falls (p. 53)

18 Tobyhanna Falls (p. 53)

19 Tanners Falls (p. 55)

20 Prompton Falls (p. 55)

Northeastern Pennsylvania

21 Falls Trail (p. 56)

22 Waterfalls of
Heberly Run (p. 60)

23 Angel Falls (p. 64)

24 Ketchum Run
Gorge (p. 68)

25 Sullivan Falls (p. 73)

26 Adams Falls (p. 75)

27 Dry Run Falls (p. 77)

28 Alpine Falls (p. 79)

● Top 16 ● Must-See ● Other

Raymondskill Falls

At 150 feet, Raymondskill Falls is the tallest publicly accessible waterfall in Pennsylvania.

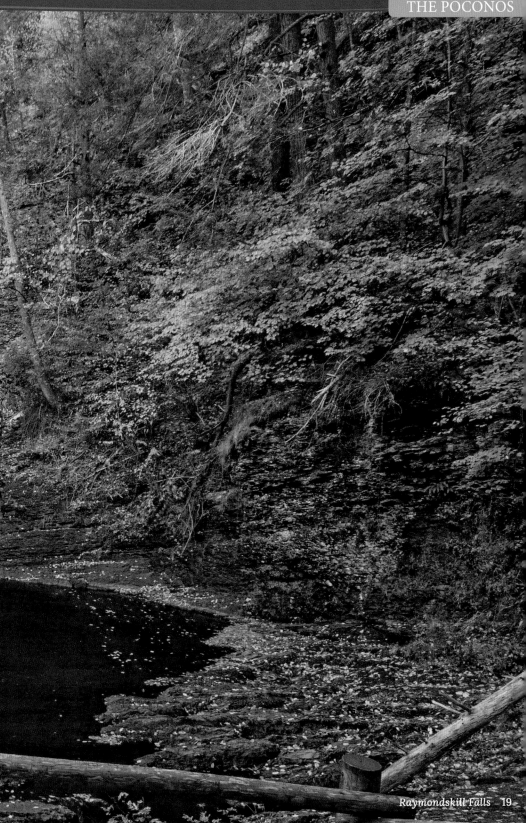

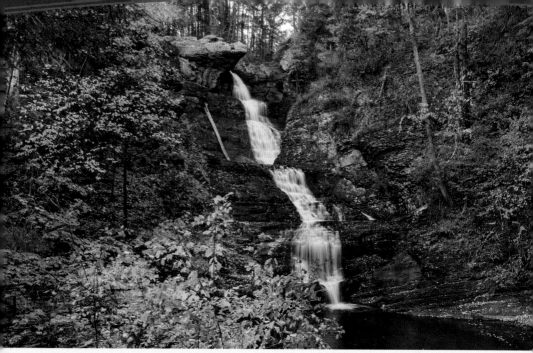

The upper two drops combine together for about half the total height of the waterfall.

Raymondskill Falls

Raymondskill Falls features three drops and two viewing platforms.

LOCATION: Delaware Water Gap National Recreation Area

ADDRESS/GPS FOR THE FALLS: 41.289556, -74.842667

DIRECTIONS: From Milford, take US 209 S. for 3.1 miles. Turn right onto Raymondskill Rd., and drive 0.5 mile until you reach the parking lot on your left.

WEBSITE: www.nps.gov/dewa/planyourvisit/raymondskill-creek-trail.htm

WATERWAY: Raymondskill Creek

HEIGHT: 150 feet **CREST:** 8–10 feet

NEAREST TOWN: Milford

HIKE DIFFICULTY: Moderate

TRAIL QUALITY: Short but steep in places

ROUND-TRIP DISTANCE: 0.5 mile

TRIP REPORT & TIPS:

Raymondskill Falls is the tallest publicly accessible waterfall in Pennsylvania. Its 150 feet is split among three drops, with the last being both the hardest to see and the tallest. When water levels are high, a side waterfall plunges adjacent to the lowest drop, creating a unique scene.

Facing the restrooms, take the trail to your right down to the first viewing platform at the top of the waterfall. From here, you can look down over the three tiers of Raymondskill Falls and really get a great appreciation for the height of this beautiful waterfall.

Once finished here, head back a few yards and take the trail that heads downhill. At another intersection, turn right to visit the second viewing area, located below the falls' top two tiers and just above the lowest tier. A large pool separates the top two tiers from the lowest tier.

Many visitors to Raymondskill Falls end their visit at the second viewing platform and return to their cars by heading straight up the trail from the second viewing area. However, those that do are missing four beautiful waterfalls farther upstream.

To see these falls, head back up to the top of the waterfall. Where the trail splits, with a left turn taking you to the top of the falls and a right turn taking you back to your car, go straight over the small hill. Once at the top, you'll see a path that follows along Raymondskill Creek.

While it can be challenging in places to find this unofficial trail, the underbrush is very sparse, which makes it easy enough to make your own path along the creek.

In the 0.5 mile between the top of Raymondskill Falls and Raymondskill Road, there are numerous cascades and small waterfalls, in addition to four larger falls. These range in height from roughly 10 feet to 25 feet tall; all are quite powerful when Raymondskill Falls is flowing well.

After walking roughly 0.5 mile, you'll come to Raymondskill Road. Turning right and walking down Raymondskill Road will bring you back to the Raymondskill Falls Parking Area in roughly 7–10 minutes. Make sure to use extreme caution, as the road is narrow, with no shoulders to speak of, and there is nowhere to walk but on/alongside the road itself.

Dingmans Falls

The second-tallest waterfall in Pennsylvania is located along a handicapped-accessible trail.

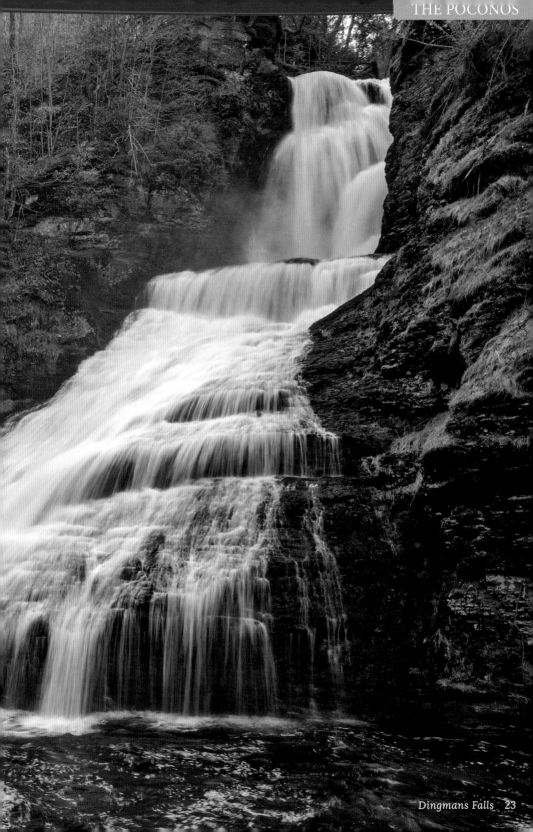

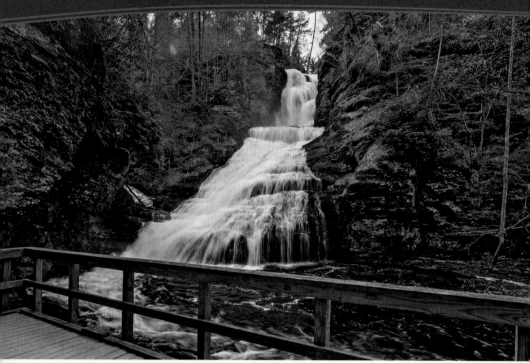

You'll find a great viewing area at the base of Dingmans Falls.

Dingmans Falls

Don't miss the impressive Silverthread Falls, which you pass along the way to Dingmans Falls.

LOCATION: Delaware Water Gap National Recreation Area

ADDRESS/GPS FOR THE FALLS: 41.230583, -74.892083

DIRECTIONS: Take US 209 S. out of Milford for 8.3 miles. Turn right onto Dingmans Falls Rd., and follow it for 1 mile until it dead-ends at a parking area.

WEBSITE: www.uncoveringpa.com/dingmans-falls

WATERWAY: Dingmans Creek

HEIGHT: 130 feet **CREST:** 5–7 feet

NEAREST TOWN: Milford

HIKE DIFFICULTY: Easy

TRAIL QUALITY: Handicapped-accessible boardwalk

ROUND-TRIP DISTANCE: 0.8 mile

TRIP REPORT & TIPS:

Dingmans Falls—the second-tallest waterfall in Pennsylvania—is also one of the few waterfalls in the state that is handicapped accessible.

From the parking area, take the boardwalk adjacent to the restrooms. After about 0.1 mile, you'll come to the 80-foot Silverthread Falls. This waterfall has carved an amazingly thin channel through the bedrock and is an impressive waterfall in its own right.

After enjoying Silverthread Falls, continue on the boardwalk. It passes through a beautiful forest for another 0.25 mile before turning into a crushed-gravel path for the last 0.1 mile to the base of Dingmans Falls.

A viewing platform gives you a great head-on look at this incredible waterfall.

If you have time, take the staircase next to the viewing platform, which takes you on a path leading to the top of Dingmans Falls for even more impressive views.

It's worth noting that while you can drive up to the parking area during the warmer months of the year, the last mile of roadway from US 209 isn't maintained in the winter. The waterfall area isn't closed, but you'll have to walk the road for 1.1 miles to access the falls after the first major snowstorm of the year through midspring.

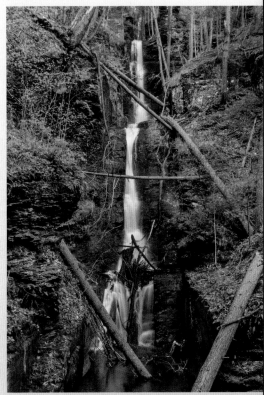

Silverthread Falls is located along the trail to Dingmans Falls.

Bushkill Falls

In addition to the namesake falls, there are seven other waterfalls to explore here.

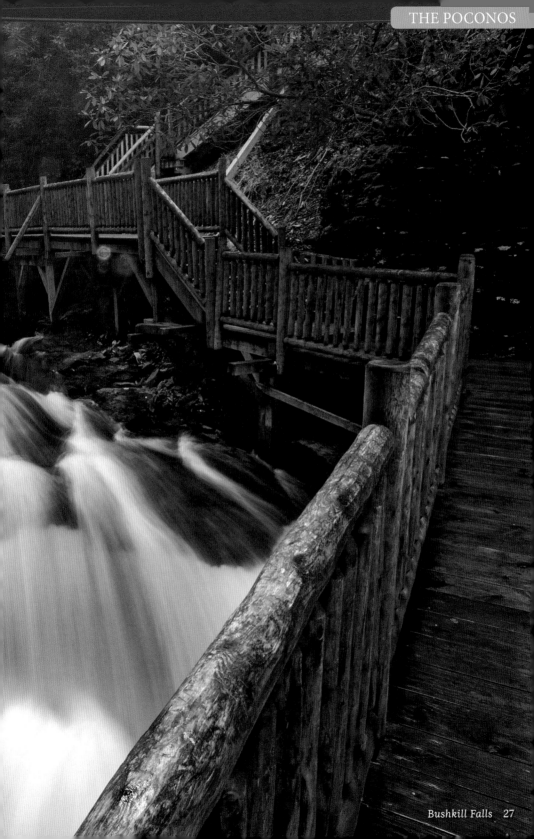

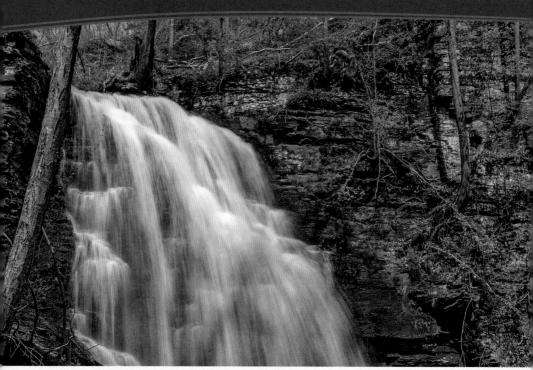

Bridal Veil Falls is one of eight waterfalls at Bushkill Falls.

Bushkill Falls

While this is the only Pennsyvania waterfall in this book that requires paying an admission charge, it's well worth the cost.

LOCATION: Bushkill Falls

ADDRESS/GPS FOR THE FALLS: 138 Bushkill Falls Trail, Bushkill, PA 18324

DIRECTIONS: From Stroudsburg, head north for 14 miles on US 209. Turn left onto Bushkill Falls Rd. In 2 miles, the entrance will be on the left.

WEBSITE: www.visitbushkillfalls.com

WATERWAY: Little Bushkill Creek and Pond Run Creek

HEIGHT: 100 feet **CREST:** 15–20 feet

NEAREST TOWN: Stroudsburg

HIKE DIFFICULTY: Easy–moderate

TRAIL QUALITY: Boardwalks and steps around the main falls, dirt trails elsewhere

ROUND-TRIP DISTANCE: 0.25 mile–2 miles

ADMISSION: $14.50 weekdays, $16.50 weekends and holidays; see website for additional information

TRIP REPORT & TIPS:

Bushkill Falls is one of the very few natural sites in Pennsylvania that charge an admission fee. Nevertheless, this land—open April–November and privately owned since 1904—is well worth visiting.

There are eight waterfalls here, ranging from about 10 feet in height all the way to the 100-foot Bushkill Falls.

Bushkill Falls, the closest waterfall to the entrance, can be observed easily from above with a round-trip hike of around 0.25 mile. There's a lot more to explore here, though, than just the top of the main falls.

The park's map offers a variety of routes that can be taken, but I'd recommend an approximately 2-mile hike that passes all of the waterfalls at the site.

After enjoying the top of Bushkill Falls, hike to its base. Seeing it from above is impressive, but the best viewpoint, in my opinion, is from the boardwalk near the base of the falls. Once you've had your fill of Bushkill Falls, start hiking down the steps along Little Bushkill Creek.

The trail soon passes along and then below Lower Gorge Falls as it cascades down the mountain. While this waterfall is quite large, it features several drops, which makes it not quite as impressive as others in the park.

The trail continues down the gorge toward the confluence of Little Bushkill Creek and Pond Run Creek.

The area along Pond Run Creek isn't nearly as highly trafficked as the main waterfall, but you'll find four beautiful waterfalls along this waterway, including three that are quite impressive.

The trail crosses Pond Run Creek and follows it upstream on the left bank. The first half of the hike up the stream is along a rocky but fairly easy dirt trail.

After about 10 minutes of hiking, the boardwalks return. Soon after that, 20-foot Bridesmaid Falls comes into view.

Just above Bridesmaid's Falls is Bridal Veil Falls. At approximately 30–35 feet tall, this is the tallest waterfall on Pond Run Creek. A boardwalk leading toward the base of the falls offers fantastic views.

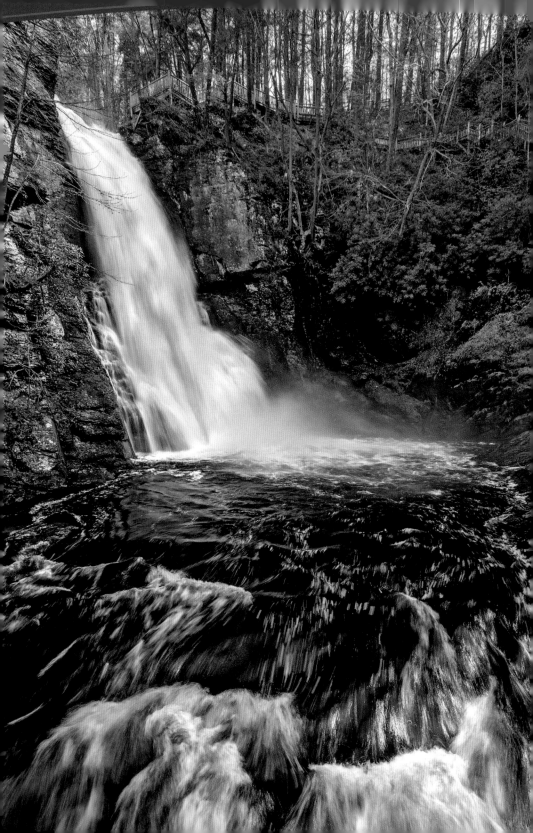

TRIP REPORT CONTINUED: Continuing upstream is another 15-foot waterfall, confusingly also called Bridesmaid's Falls. I'm not sure why there are two waterfalls of the same name in the park, but alas, there are.

The trail continues to follow Pond Run Creek to the top of the hill. A bridge crosses the creek above the fourth waterfall on this creek, which is not only hard to see but also apparently unnamed.

After climbing Pond Run Creek, the trail turns right and follows a wide, flat path over the plateau toward Little Bushkill Creek. Continue straight on this trail until you reach 10-foot Pennell Falls.

From Pennell Falls, the trail follows the creek downstream toward Bushkill Falls. After a few minutes of hiking, the trail splits, with the trail to the right being the more scenic.

Here, the boardwalk crisscrosses the creek and offers fantastic views and photo opportunities. It is also here where you'll find the eighth waterfall at Bushkill, Laurel Glen Falls. This 10-foot waterfall near the boardwalk is, in my opinion, one of the most beautiful sights in the entire park.

Just below this area, the trail returns to the top of Bushkill Falls. Take some time to once again enjoy the waterfall before returning to the park's entrance.

Bushkill Falls is one of the most majestic waterfalls in the Poconos.

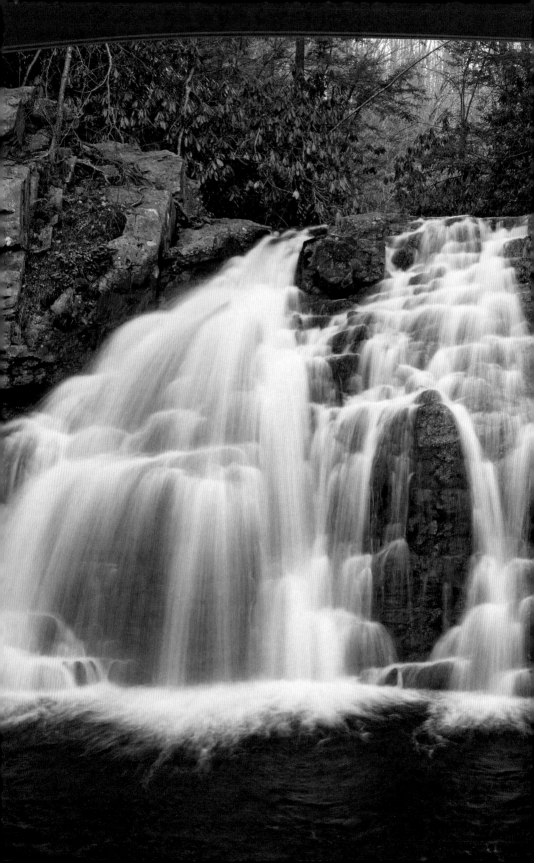

Hawk Falls

LOCATION: Hickory Run State Park

ADDRESS/GPS FOR THE FALLS: 41.006139, -75.633806

DIRECTIONS: From Exit 284 on I-80, follow PA 534 E. for 9.5 miles. The parking area for Hawk Falls will be on your right, just after you cross under I-476. If this lot is full, there's another one on the left side of the road.

WEBSITE: www.dcnr.pa.gov/stateparks/findapark/hickoryrunstatepark

WATERWAY: Hawk Run

HEIGHT: 20–25 feet **CREST:** 8–10 feet

NEAREST TOWN: Albrightsville

HIKE DIFFICULTY: Moderate

TRAIL QUALITY: Dirt trails; can be tricky to get to the bottom of the falls

ROUND-TRIP DISTANCE: 1.2 miles

TRIP REPORT & TIPS:

From the parking area, head along the road toward the highway overpass for about 100 feet to get to the Hawk Falls trailhead, which will be on your left. From here, the trail is an easy-to-follow 0.6-mile hike to Hawk Falls.

About two-thirds of the way through the hike, you'll cross a beautiful wooden bridge over Hawk Run. After crossing the stream, head downhill a bit farther until you hear the waterfall.

At this point, you won't be able to see the falls, but you should see a small clearing with a rock outcrop on your right. Head about 20 feet off-trail, and the waterfall will come into view.

If you want to see Hawk Falls from the bottom, return to the trail and continue following it until you come to Mud Run. Just before the stream, you'll notice a well-worn path that heads off to your right and into the woods—take this unmarked path to the bottom of the falls. From here, Hawk Falls' true beauty and size are evident.

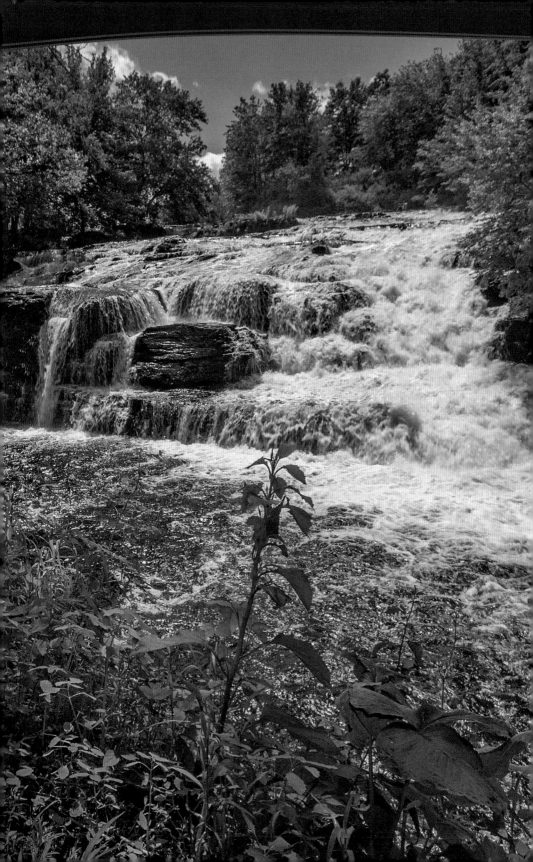

Shohola Falls

LOCATION: State Game Lands 180

ADDRESS/GPS FOR THE FALLS: 41.391333, -74.969194

DIRECTIONS: Take US 6 W. out of Milford for 9.5 miles. Turn left onto Brooks Rd. When it dead-ends in 0.2 mile, turn right and park at the end of the road.

WEBSITE: www.uncoveringpa.com/how-to-get-to-shohola-falls-in-pike-county-pennsylvania

WATERWAY: Shohola Creek

HEIGHT: 50–60 feet **CREST:** 70–75 feet

NEAREST TOWN: Milford

HIKE DIFFICULTY: Moderate

TRAIL QUALITY: Worn dirt trail and a few wooden steps

ROUND-TRIP DISTANCE: 0.2 mile

TRIP REPORT & TIPS:

Shohola Falls can be viewed from three sides thanks to a 90-degree turn that the creek makes just below the bottom of the falls. The best views are from the ledge directly in front of the waterfall, giving you a head-on view of the falls from about 20 feet above the water.

From the parking lot, follow the trail downstream for just a minute or two. To access the narrow ledge, follow the trail past the large rock as the trail goes downhill and then uphill to the ledge. If you opt to venture out on the ledge, please use extreme caution, especially in wet weather—*do not attempt to go out on the ledge if it is at all icy.*

There are also nice views of the waterfall from the opposite bank, which can be reached by parking in the state game lands parking area, about 0.1 mile farther down US 6 from the turn for Brooks Road.

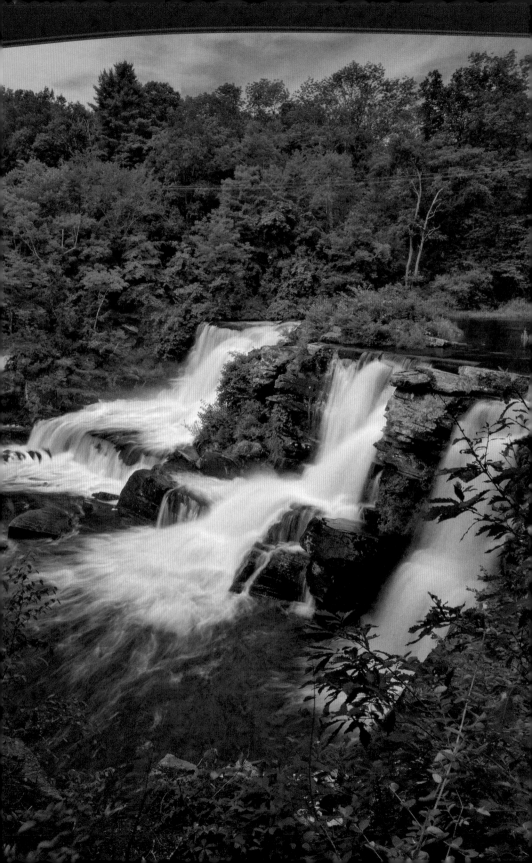

Resica Falls

LOCATION: Resica Falls Scout Reservation

ADDRESS/GPS FOR THE FALLS: 41.110417, -75.094306

DIRECTIONS: From I-80, take Exit 309 and follow US 209 N. for 3 miles. At the traffic circle, take the second exit onto Seven Bridge Rd., and travel for 0.75 mile. Turn right onto Milford Rd., and then take an immediate left onto Marshalls Creek Rd., followed by an immediate right onto Resica Falls Rd. In 5.5 miles, turn into the Resica Falls Scout Reservation, and park in the small lot on the right along the road.

WEBSITE: www.uncoveringpa.com/resica-falls

WATERWAY: Bushkill Creek

HEIGHT: 25–30 feet **CREST:** 50–60 feet

NEAREST TOWN: Stroudsburg

HIKE DIFFICULTY: Easy

TRAIL QUALITY: A flat path over some smooth rocks

ROUND-TRIP DISTANCE: 0.2 mile

TRIP REPORT & TIPS:

Resica Falls is one of the most powerful waterfalls in the Poconos and is also one of the easiest to visit. It's located on the property of the Resica Falls Scout Reservation, but a public-access point has been created for the falls—please don't venture beyond this viewing area.

From the parking area, a path leads along the creek for roughly 100 feet until the waterfall comes into view.

A fixed rope has been set up around the area near the falls; again, remember that this is private property, and stay within this designated area.

Thanks to Bushkill Creek narrowing just downstream of the falls, there's a nice frontal view of the waterfall from the rocks in the viewing area. There is also a nice side view of the waterfall on the path from the parking area.

The best views of Resica Falls require you to be able to climb sloped rocks, but there are still good views, especially from the side, for those who have trouble with uneven terrain.

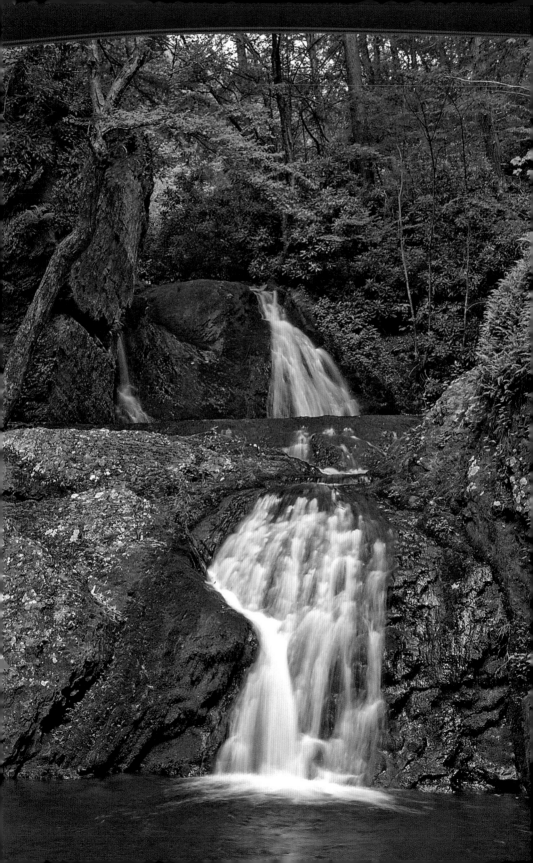

Tumbling Waters

LOCATION: Delaware Water Gap National Recreation Area

ADDRESS/GPS FOR THE FALLS: 41.158444, -74.920194

DIRECTIONS: From Milford, take US 209 S. for 8.6 miles. Turn right onto Wilson Hill Rd. After 2.4 miles, turn left onto Emery Rd. The Pocono Environmental Education Center will be on your left in 2.5 miles.

WEBSITE: www.peec.org/about/hiking-trails.html

WATERWAY: Unnamed

HEIGHT: 30 feet **CREST:** 10–15 feet

NEAREST TOWN: Milford

HIKE DIFFICULTY: Moderate–difficult

TRAIL QUALITY: Well-trod trails with steps down to falls

ROUND-TRIP DISTANCE: 3 miles

TRIP REPORT & TIPS:

The trail starts a few yards behind the PEEC building and runs with the Fossil Trail for a short distance—don't follow the blue blazes. After hiking for about 5–10 minutes, you'll cross a road, with the trail continuing on the far side.

The Tumbling Waters Trail winds its way through the forest, reaching the ridge-line roughly 1 mile into the hike. The views are nice from this vantage point.

The trail continues another 0.5 mile before reaching the switchbacks down to the waterfalls. This is the most difficult section of the trail, though there is a railing along most of the path to steady yourself.

There are two drops here, with a small pool in the middle. The top waterfall is the larger of the two at roughly 20 feet tall. The bottom waterfall, approximately 10 feet tall, is located at nearly a 90-degree angle to the top falls.

After enjoying the waterfall, make your way back to the top of the switchbacks, and turn left to continue along the Falling Waters Trail. Shortly after the waterfall, the forest makes a noticeable switch, going from mostly hemlocks to more of a mixed forest with many birch and pine trees. The last bit of the trail passes a lake and through several different wetlands. After you walk along a short boardwalk, the trail deposits you directly across the street from the PEEC.

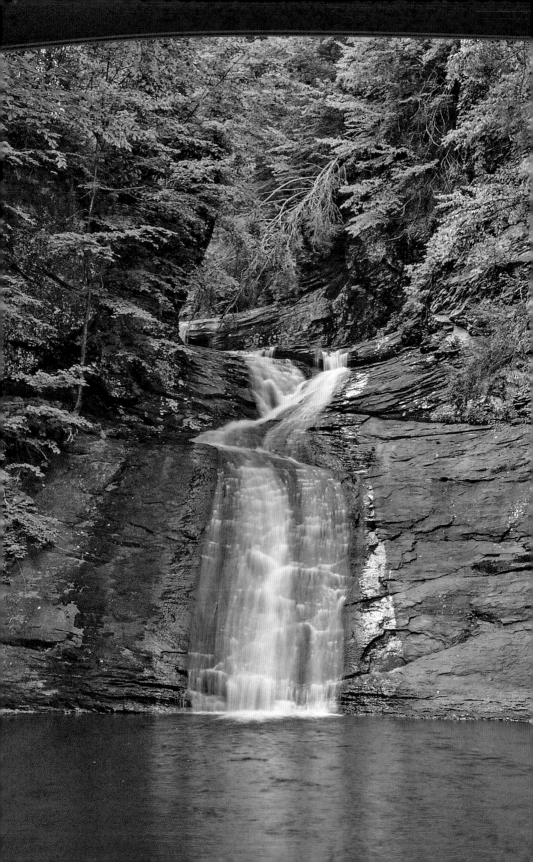

Hornbecks Falls

LOCATION: Delaware Water Gap National Recreation Area

ADDRESS/GPS FOR THE FALLS: 41.194778, -74.903056

DIRECTIONS: From Milford, take US 209 S. for 10.5 miles. The parking area will be on your right just after Chestnut Hill Rd.

WEBSITE: www.uncoveringpa.com/how-to-get-to-hornbecks-creek-waterfalls -delaware-water-gap

WATERWAY: Hornbecks Creek

HEIGHT: 20–25 feet **CREST:** 10–15 feet

NEAREST TOWN: Milford

HIKE DIFFICULTY: Moderate

TRAIL QUALITY: Dirt trail and a few stone steps

ROUND-TRIP DISTANCE: 2 miles

TRIP REPORT & TIPS:

The Hornbecks Trail is one of the hidden gems of the Delaware Water Gap. After significant storm damage in early 2018, the trail was completely rebuilt.

From the parking area along US 209, the hike to Hornbecks Falls is 1 mile long. The trail is easy to follow, as there are no side trails in this section of the Delaware Water Gap, and the trail features several bridges and a stone staircase. While the hike starts off fairly easily, it does get somewhat challenging in places.

Hornbecks Falls is a slide waterfall that falls in two drops totaling about 20–25 feet. In front of the falls is a large, circular pool that makes getting a close look at the falls a bit challenging. Be careful here, as the rocks around the creek, even the dry ones, tend to be very slippery.

In the past, the Hornbecks Trail continued to another great waterfall upstream. Due to erosion issues and lack of a safe trail, however, this portion of the trail has been closed.

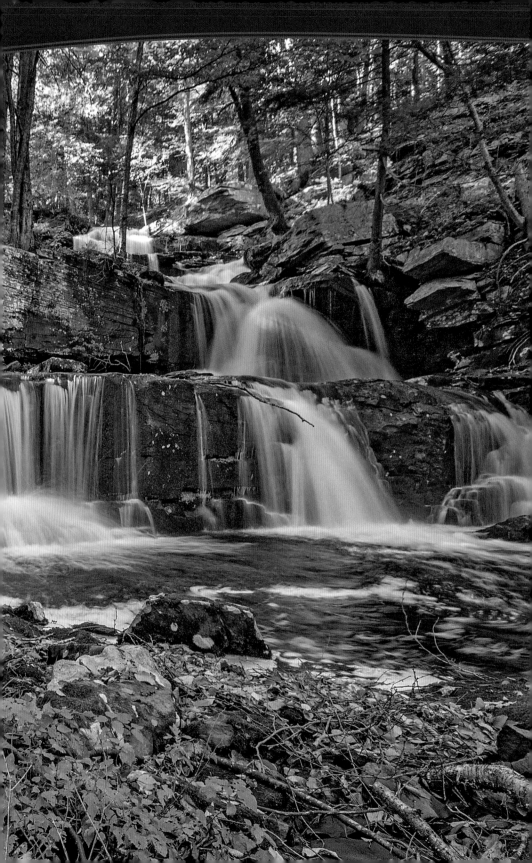

Savantine Falls and Sawkill Falls

LOCATION: Delaware State Forest

ADDRESS/GPS FOR THE FALLS: Savantine Falls, 41.353694, -74.868139;
Sawkill Falls, 41.353528, -74.872222

DIRECTIONS: From Milford, head west on US 6 for 4 miles. Turn left onto Old Town
Rd., and park along the street.

WEBSITE: www.uncoveringpa.com/savantine-falls-sawkill-falls

WATERWAYS: Savantine Creek and Sawkill Creek

HEIGHT: 15–20 feet/25–30 feet **CREST:** 5–7 feet/40–50 feet

NEAREST TOWN: Milford

HIKE DIFFICULTY: Strenuous

TRAIL QUALITY: Off-trail hiking with several stream crossings

ROUND-TRIP DISTANCE: 0.75 mile

TRIP REPORT & TIPS:

Savantine Falls and Sawkill Falls are two waterfalls hidden away in Delaware
State Forest just a few hundred yards from each other. From Old Town Road,
very carefully cross busy US 6 and turn left (heading west) for a few hundred
feet until the guardrail ends. From here, the rest of the hike will be off-trail.

Head into the woods and down the hill. At the bottom of the hill, you'll come
to Sawkill Creek. Find the best place to cross this stream—this may be difficult
or impossible when water levels are high, such as after heavy rains.

After crossing the creek, walk a few feet to a second stream, which is Savantine
Creek. Don't cross this creek, but head upstream on it for a few hundred yards
until you reach 15- to 20-foot Savantine Falls. Once you've had your fill of this
waterfall, walk away from it back toward Sawkill Creek.

When you reach Sawkill Creek, follow this waterway upstream for a few hun-
dred yards until you reach the base of the 25–30-foot Sawkill Falls.

Retrace your steps to your car when done. As with all of the off-trail hikes in
this guide, bringing along a GPS unit is highly recommended, and it makes
this return trek much easier.

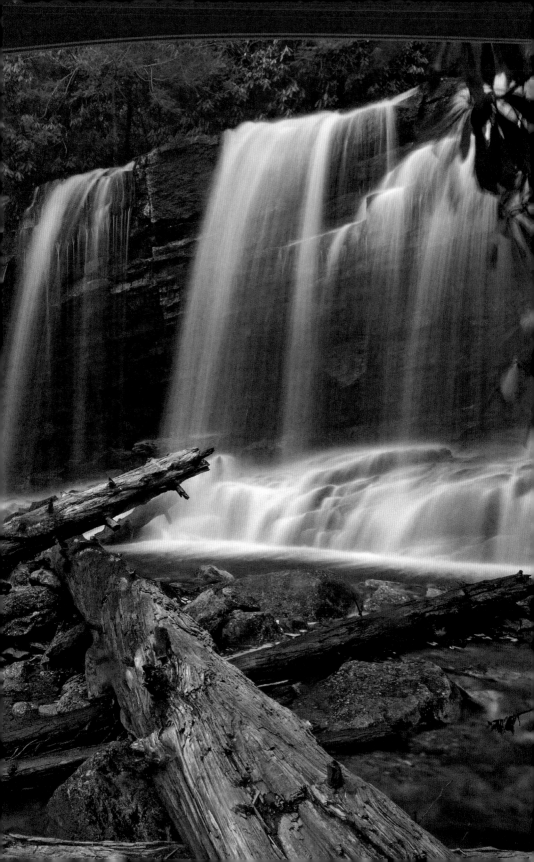

Cave Falls

LOCATION: State Game Lands 141

ADDRESS/GPS FOR THE FALLS: 40.888083, -75.767194

DIRECTIONS: From US 209 in Jim Thorpe, turn northeast onto North St., and cross the Lehigh River. Just across the bridge, turn left onto W. Front St. Follow this road for 0.4 mile, and then take a slight left turn onto the road into Lehigh Gorge State Park. Drive this road for 2 miles, and park as close to the end as possible.

WEBSITE: www.uncoveringpa.com/hiking-glen-onoko

WATERWAY: Glen Onoko Run

HEIGHT: 15 feet **CREST:** 25–30 feet

NEAREST TOWN: Jim Thorpe

HIKE DIFFICULTY: Strenuous

TRAIL QUALITY: Dirt trails with some rocks and steep sections

ROUND-TRIP DISTANCE: 2.75 miles

TRIP REPORT & TIPS:

Cave Falls is the uppermost waterfall on Glen Onoko Run. This popular hike once featured three waterfalls, but portions of it are currently closed. If the trail opens farther beyond what is described here, consider hiking the rest of the trail as well.

From the parking area, walk down to the end of the road, which is just across the bridge over the Lehigh River. Take the stairwell to the right, and then walk under the bridge, taking the trail to your right just after the bridge.

Shortly up this trail, bear to your right and follow the trail uphill. It can be rather steep and rocky in places, so use care while hiking here.

After about 0.5 mile, the trail will split—take the trail to your left, and continue hiking for another 0.5 mile. Near the top of the hill, you'll notice an obvious trail to your left that will take you to the top of Cave Falls.

While there are two more waterfalls downstream from here, the trail is currently closed, so do not continue down this way. Instead, either retrace your steps back to the parking lot or continue the loop for a slightly longer hike that includes a nice vista.

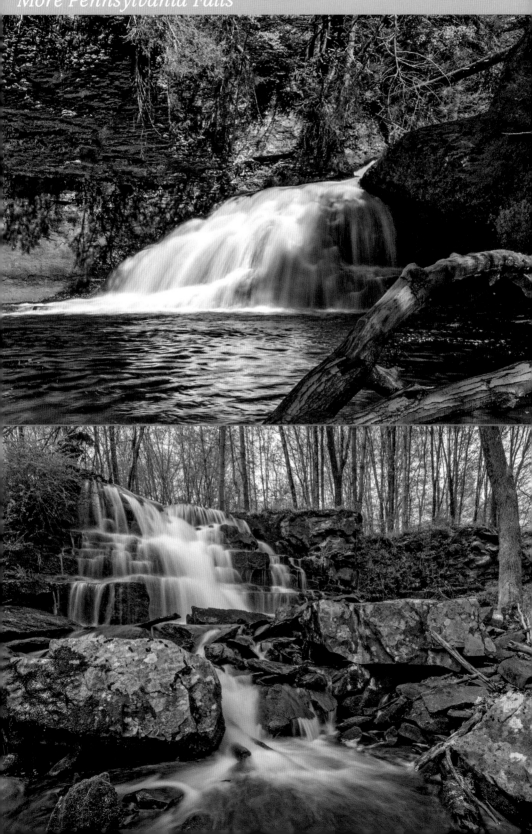

Hackers Falls

LOCATION: Delaware Water Gap National Recreation Area

ADDRESS/GPS FOR THE FALLS: 41.299417, -74.838556

DIRECTIONS: From US 6 in Milford, turn west onto Mill St. After 2.2 miles, turn left onto Cliff Park Rd. After 0.2 mile, turn right onto an unnamed dirt road, and park at the lot when it ends.

WEBSITE: www.uncoveringpa.com/hiking-cliff-park-trails-delaware-water-gap

WATERWAY: Raymondskill Creek

HEIGHT: 10–12 feet **CREST:** 5–7 feet

NEAREST TOWN: Milford

HIKE DIFFICULTY: Moderate

TRAIL QUALITY: Well-marked dirt trails

ROUND-TRIP DISTANCE: 1.8 miles

TRIP REPORT & TIPS:

Scenic Hackers Falls is located upstream of Raymondskill Falls, the tallest waterfall in Pennsylvania (see page 18). From the parking lot, take the Buchanan Trail, making sure to stay to the right instead of taking the loop to the left. After 0.4 mile, take a right onto the yellow-blazed Hackers Trail, which is a bit steep in spots but not too challenging.

After winding its way through the forest for about 0.5 mile, the trail comes to Hackers Falls. Though only about 10 feet tall, the waterfall is quite powerful and marked by imposing cliffs on one side.

There are 8 total miles of trail here, so you can opt to extend your hike and make a big loop, including a few great vistas, or return the way you came.

Camp Hidden Falls

LOCATION: Delaware Water Gap National Recreation Area

ADDRESS/GPS FOR THE FALLS: 41.177139, -74.934500

DIRECTIONS: From Milford, take US 209 S. for 8.5 miles. Turn right onto Wilson Hill Rd., and travel for 6 miles. Then turn left onto Milford Rd., and go 2.8 miles before turning right onto Sunset Lake Rd. In 0.5 mile, park in a dirt driveway on your left.

WEBSITE: www.uncoveringpa.com/camp-hidden-falls

WATERWAY: Unnamed

HEIGHT: 10–12 feet **CREST:** 5–7 feet

NEAREST TOWN: Milford

HIKE DIFFICULTY: Easy

TRAIL QUALITY: No trail but easy to find

ROUND-TRIP DISTANCE: 0.25 mile

TRIP REPORT & TIPS:

There are said to be eight waterfalls in this former Girl Scout camp; I was able to find just three during my visit, however.

From the parking area, head away from the road, and you'll see the stream about 100 feet ahead of you, as well as an old bridge. The first waterfall, with two drops totaling 6–8 feet, is just above the bridge.

The other two waterfalls can be found downstream. There are no trails, but I made my way downstream on the same side of the stream that I parked on.

About 150 feet downstream from the bridge, you'll see an old dam waterfall that's maybe 5 feet tall. Another 100 feet downstream is the largest waterfall, Camp Hidden Falls, at about 10–12 feet tall.

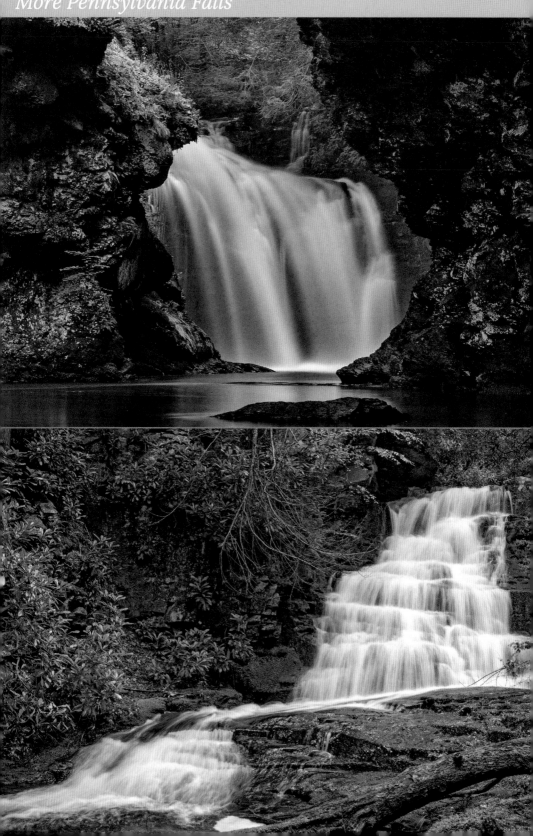

Marshalls Falls

LOCATION: Marshalls Falls Park

ADDRESS/GPS FOR THE FALLS: 41.053000, -75.136694

DIRECTIONS: From I-80, take Exit 309 and follow US 209 N. for 3 miles. At the traffic circle, take the second exit onto Seven Bridge Rd. After 0.75 mile, turn right onto Milford Rd., and then make an immediate left onto Marshalls Creek Rd. After 1 mile, park in a small pull-off on the right side of the road at a curve.

WEBSITE: www.uncoveringpa.com/marshall-falls -poconos

WATERWAY: Marshall Creek

HEIGHT: 12–15 feet **CREST:** 8–10 feet

NEAREST TOWN: Stroudsburg

HIKE DIFFICULTY: Moderate

TRAIL QUALITY: Dirt trails

ROUND-TRIP DISTANCE: 0.2 mile

TRIP REPORT & TIPS:

A hidden gem of the Poconos, Marshalls Falls Park is owned by Smithfield Township. Note that there may be an official parking area in the future instead of the pull-off you must use currently.

From the road, take the small, unmarked path down the hill, right to the top of the waterfall. Notice the supports for an old bridge.

To reach the bottom of the falls, backtrack slightly, and take the trail that passes between two large boulders and heads to the base of the falls.

Marshalls Falls is nearly hidden behind two opposing rock faces, giving it a very unusual look. The best views of the falls can be had by crossing the bridge to the opposite bank of the creek.

Rattlesnake Falls

LOCATION: State Game Lands 221

ADDRESS/GPS FOR THE FALLS: 41.182583, -75.306111

DIRECTIONS: From PA 390 south of Mountainhome, turn left onto PA 191 N. After 0.2 mile, turn left onto Monomonock Rd. After 0.1 mile, turn right onto Pleasant Ridge Rd., and follow it to a parking area at the end of the road in about 1 mile.

WEBSITE: www.uncoveringpa.com/rattlesnake -falls-poconos

WATERWAY: Rattlesnake Creek

HEIGHT: 12–15 feet **CREST:** 5–7 feet

NEAREST TOWN: Mountainhome

HIKE DIFFICULTY: Strenuous

TRAIL QUALITY: Easy hike but difficult descent

ROUND-TRIP DISTANCE: 2.5 miles

TRIP REPORT & TIPS:

From the parking area, head past the gate and continue up the road. Within a few minutes, you'll make an unbridged stream crossing and then continue up the road for another mile. Follow a trail to your left into the woods for 0.1 mile until you come to a large circular clearing.

From the clearing, the trail to the waterfall continues to your right; Rattlesnake Falls lies at the bottom of a steep trail adjacent to this clearing. *This descent is difficult, so be very careful.*

The trail ends at the bottom of the main drop of Rattlesnake Falls but just above a smaller drop. The best views of the waterfalls, however, can be had from this spot and without crossing the creek.

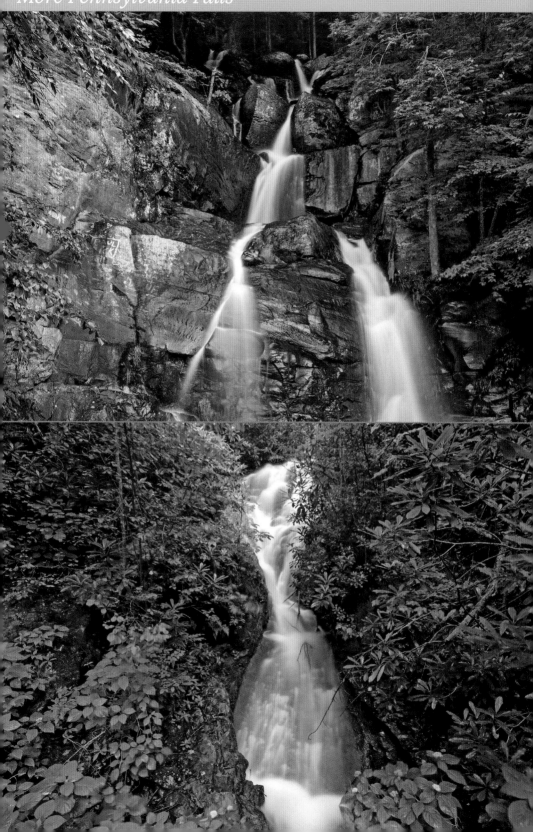

Buttermilk Falls

LOCATION: Lehigh Gorge State Park

ADDRESS/GPS FOR THE FALLS: 40.971083, -75.753556

DIRECTIONS: From Weatherly, head east out of town on E. Main St. In 3 miles, take a slight right onto Rockport Rd., and follow it for 1 mile until the road ends in a parking area. If this lot is full, you may have to use another parking area farther up the road.

WEBSITE: www.dcnr.pa.gov/stateparks /findapark/lehighgorgestatepark

WATERWAY: Unnamed

HEIGHT: 50–60 feet **CREST:** 3–5 feet

NEAREST TOWN: Weatherly

HIKE DIFFICULTY: Easy

TRAIL QUALITY: A wide rail-trail

ROUND-TRIP DISTANCE: 0.66 mile

TRIP REPORT & TIPS:

From where you parked, make your way to the D&L Trail, at the bottom of the hill. Turn left and walk for 0.3 mile to the base of Buttermilk Falls.

This waterfall is incredibly impressive during times of high water as it cascades down the hillside and around many rocks. It's actually impossible to figure out from the base of the falls exactly how far up the hillside the waterfall continues.

While in the area, don't miss Luke's Falls (see next hike), which is located along the same trail but in the opposite direction.

Luke's Falls

LOCATION: Lehigh Gorge State Park

ADDRESS/GPS FOR THE FALLS: 40.965556, -75.750472

DIRECTIONS: From Weatherly, head east out of town on E. Main St. In 3 miles, take a slight right onto Rockport Rd., and follow it for 1 mile until the road ends in a parking area. If this lot is full, you may have to use another parking area farther up the road.

WEBSITE: www.dcnr.pa.gov/stateparks /findapark/lehighgorgestatepark

WATERWAY: Unnamed

HEIGHT: 25–30 feet **CREST:** 3–5 feet

NEAREST TOWN: Weatherly

HIKE DIFFICULTY: Easy

TRAIL QUALITY: A wide rail-trail

ROUND-TRIP DISTANCE: 0.66 mile

TRIP REPORT & TIPS:

From where you parked, make your way to the D&L Trail, at the bottom of the hill. Turn right and walk for 0.3 mile to Luke's Falls.

A bridge crosses Luke's Falls just upstream from where it cascades into the Lehigh River. When there are leaves on the trees, the waterfall fills the entire small opening created by the creek as it cascades down the hillside toward the river.

Adjacent to Luke's Falls is a stone structure that is likely left over from the days when the railroad traversed what is now a great walking and biking trail.

While in the area, don't miss Buttermilk Falls (see previous hike), located along the same trail but in the opposite direction.

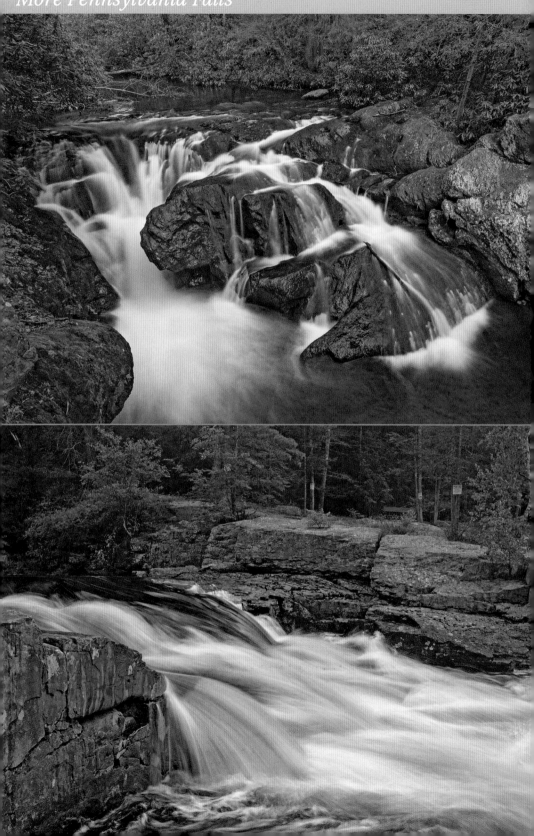

Wild Creek Falls

LOCATION: Beltzville State Park

ADDRESS/GPS FOR THE FALLS: 40.890361, -75.561361

DIRECTIONS: From Lehighton, take US 209 N. across the Lehigh River, and in 2.1 miles turn left onto N. Harrity Rd. After crossing Pohopoco Creek, take the first right onto Pohopoco Dr., and travel 6.9 miles. The parking area for the waterfall will be on your right.

WEBSITE: www.dcnr.pa.gov/stateparks /findapark/beltzvillestatepark

WATERWAY: Wild Creek

HEIGHT: 12–15 feet **CREST:** 12–15 feet

NEAREST TOWN: Lehighton

HIKE DIFFICULTY: Moderate

TRAIL QUALITY: Dirt trail with one steep section

ROUND-TRIP DISTANCE: 0.75 mile

TRIP REPORT & TIPS:

From the parking area along Pohopoco Drive, a short trail takes you through Beltzville State Park's beautiful forest. The trail to Wild Creek Falls is the blue-blazed Falls Trail, which initially follows the same path as the yellow-blazed Christman Trail. After about 5 minutes of walking, the Falls Trail takes a left turn and immediately heads down a short but steep hill.

At the base of the hill, the trail turns left and immediately crosses a very scenic wooden bridge over Wild Creek. Turn left and head upstream to see Wild Creek Falls. The trail passes over some large rocks; if you scramble around these, you can get to a variety of additional viewpoints.

If you follow the trail a bit farther, you'll reach a nice vantage point looking out over Wild Creek Falls.

Tobyhanna Falls

LOCATION: Austin T. Blakeslee Natural Area

ADDRESS/GPS FOR THE FALLS: 41.083306, -75.590417

DIRECTIONS: At Exit 284 off I-80, take PA 115 northwest for 0.5 mile. The parking area will be on your left just after you cross Tobyhanna Creek.

WEBSITE: www.uncoveringpa.com/how-get -tobyhanna-falls-austin-t-blakeslee-natural-area

WATERWAY: Tobyhanna Creek

HEIGHT: 5 feet **CREST:** 15 feet

NEAREST TOWN: Blakeslee

HIKE DIFFICULTY: Easy

TRAIL QUALITY: Flat dirt trail

ROUND-TRIP DISTANCE: 1 mile

TRIP REPORT & TIPS:

Tobyhanna Falls is probably no more than 5 feet tall. But the power with which Tobyhanna Creek rushes over it makes this one of the most impressive water-falls in the region.

From the parking area, follow the red-blazed trail past the pavilion and through a stand of tall evergreens. The trail mainly follows the banks of the creek, veering away briefly in a few spots. After about 0.5 mile, you will reach Tobyhanna Falls.

It's possible to get a very close look at Tobyhanna Falls because of the rocks that extend out along the side of the falls. This area is very popular with anglers, as the very deep pool below the falls is filled with surprisingly large trout.

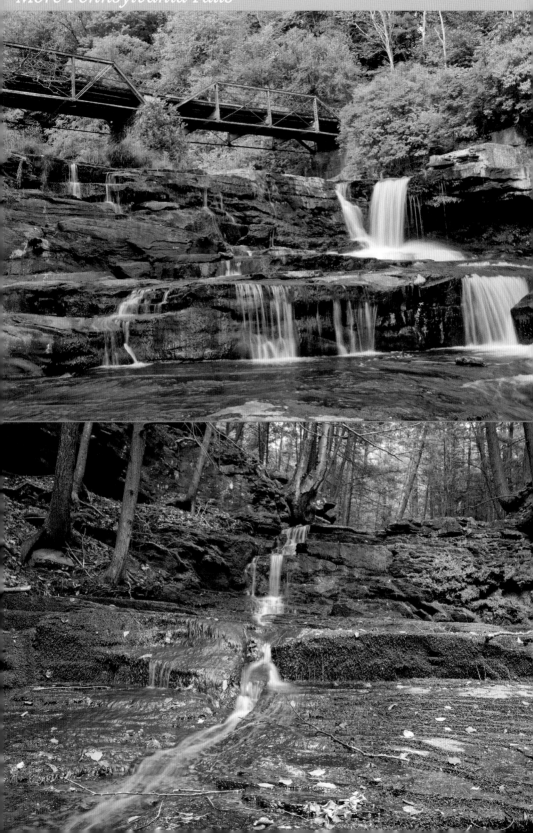

Tanners Falls

LOCATION: State Game Lands 159

ADDRESS/GPS FOR THE FALLS: 41.662889, -75.297889

DIRECTIONS: From Honesdale, take PA 191 N. for 4 miles. Turn left onto Dug Rd., and after 0.3 mile turn right to stay on Dug Rd. Continue north for 2.8 miles, during which Dug Rd. becomes Upper Woods Rd.; then turn left onto Tanners Falls Rd., and follow it 0.5 mile to its end at a closed bridge.

WEBSITE: www.uncoveringpa.com/how-to-get-to-tanners-falls-wayne-county-pa

WATERWAY: Dyberry Creek

HEIGHT: 20 feet **CREST:** 30–40 feet

NEAREST TOWN: Honesdale

HIKE DIFFICULTY: Easy–moderate

TRAIL QUALITY: Difficult dirt trail to bottom of the falls, which can also be viewed from above

ROUND-TRIP DISTANCE: Roadside

TRIP REPORT & TIPS:

Tanners Falls is unique for the 1885 bridge (now closed to traffic) across Dyberry Creek, as well as for its many stone ruins, remnants of mills from the 1830s. (*Tanners* refers to the prevalence of leather tanning here in the 1850s.)

The falls can be viewed from above, or you can follow a narrow trail to the bottom. From the parking area, this path leads down to a rocky outcrop just downstream of the top tier of the falls.

Getting to the bottom of the falls from here is a bit more difficult, and you'll likely need to use both hands to scramble up and down the trail. Nevertheless, those who make it to the bottom are rewarded with some interesting stone foundation ruins in addition to the falls.

Prompton Falls

LOCATION: Prompton State Park

ADDRESS/GPS FOR THE FALLS: 41.631194, -75.338556

DIRECTIONS: From US 6 just west of Prompton, turn north onto PA 170. After 3.7 miles, turn right onto Beech Grove Rd. In 0.1 mile, park in the dirt area next to the Prompton State Park sign on your right.

WEBSITE: www.dcnr.pa.gov/stateparks /findapark/promptonstatepark

WATERWAY: Pine Creek

HEIGHT: 12–15 feet **CREST:** 1–3 feet

NEAREST TOWN: Prompton

HIKE DIFFICULTY: Moderate

TRAIL QUALITY: Overgrown old road and dirt trails

ROUND-TRIP DISTANCE: 2 miles

TRIP REPORT & TIPS:

From the parking area, follow the old road along the banks of the Lackawaxen River. After hiking about 0.5 mile, you'll come to the Sidewinder Trail, the second trail off the East Shore Trail. The turn, just after a small bridge, is not well marked, but a sign about 100 feet ahead will let you know that you're on the right track.

The trail snakes its way uphill in a series of steep switchbacks. Though only about 0.5 mile long, this section is easily the most challenging part of the hike. Near the top of the trail, you'll reach Prompton Falls.

The viewing area for the waterfall is about 25 feet above the stream. If you want to get a closer look, a very steep trail heads down to the creek below.

Falls Trail

With 21 majestic waterfalls, this is one of the best hikes on the East Coast.

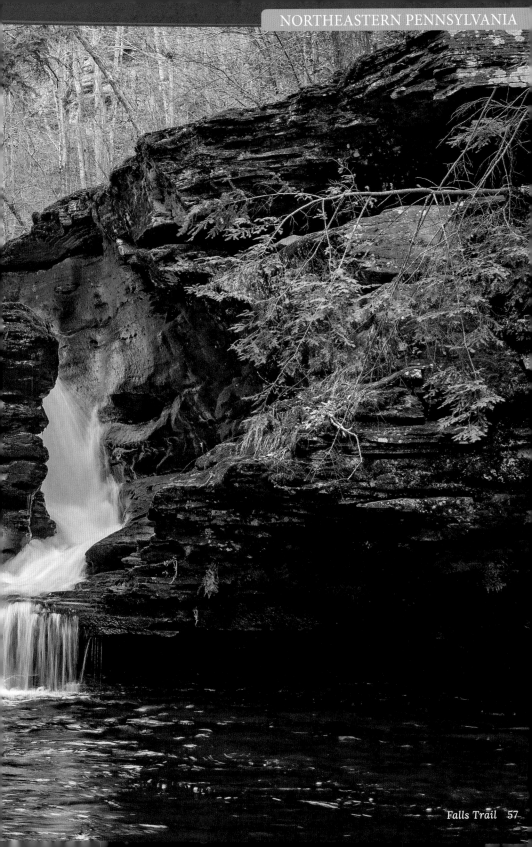

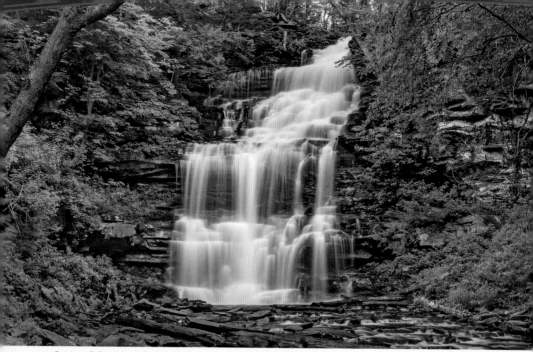

Ganoga Falls is the tallest waterfall at Ricketts Glen State Park.

Falls Trail

There are several ways to hike the Falls Trail, but our route saves 3 miles of hiking and still passes all the waterfalls.

LOCATION: Ricketts Glen State Park

ADDRESS/GPS FOR THE FALLS: 41.321333, -76.275528

DIRECTIONS: From Benton, head north on PA 487 for 7.5 miles. Turn right on PA 118, and drive 0.8 mile before turning left to return to PA 487. After 3.7 miles, turn right into the park. Follow the road 0.5 mile, and take the first right turn after the lake. Follow this road to the parking lot at the end.

WEBSITE: www.dcnr.pa.gov/stateparks/findapark/rickettsglenstatepark

WATERWAY: Kitchen Creek

HEIGHT: 11–94 feet **CREST:** 2–25 feet

NEAREST TOWN: Benton

HIKE DIFFICULTY: Strenuous

TRAIL QUALITY: A series of old stone steps and well-trod dirt trails

ROUND-TRIP DISTANCE: 3.2–7.2 miles

TRIP REPORT & TIPS:

The Falls Trail at Ricketts Glen State Park—arguably the most popular waterfall hike in all of Pennsylvania—passes 21 waterfalls ranging from 11 to 94 feet in height over the trail's official 7.2-mile length. I've created a route that allows you to see all the waterfalls while shaving roughly 3 miles off the hike.

Starting in the Lake Rose Parking Lot, follow the trail for approximately 0.1 mile. At the trail split, turn right to head into Ganoga Glen.

Ganoga Glen encompasses 10 waterfalls, including Ganoga Falls, the tallest in the park. While neither side of this hike is an easy descent, my experience is that it is safer and easier to head down this side and return via Glen Leigh.

After a little over 1 mile, you'll reach an area known as Waters Meet—here, the two branches of Kitchen Creek come together. Waterfalls can be seen in both directions from this spot, which is also home to the only bench on the trail.

While you can head straight up Glen Leigh from here, I highly recommend hiking 0.5 mile farther downstream. This will allow you to see the other three waterfalls along the Falls Trail. The three waterfalls below Waters Meet are three of my favorites in the whole park; seeing them is worth the extra bit of hiking.

Whether you decide to hike down to the waterfalls below Waters Meet or not, continue your hike by crossing the stream and hiking up Glen Leigh. While this side is both shorter and steeper than Ganoga Glen, the elevation gains are interspersed with sections of flat trail, making it a bit easier to ascend.

Glen Leigh is home to eight majestic waterfalls over less than 1 mile of hiking. When you get to the top of the seventh waterfall, you'll see a sign that indicates a shortcut to the Highland Trail, which returns you to the parking area. Instead of immediately taking this trail, however, walk 100 yards farther along the Falls Trail to the last waterfall. Then turn around and head back to take this shortcut.

After about 0.1 mile, you'll reach the Highland Trail. This relatively flat mile-long hike takes you back to the Lake Rose Parking lot; it also serves as a trail across the plateau for those who still need to descend the Ganoga Glen side.

Note: The Falls Trail is closed from early November through mid-April (exact dates vary based on weather). When the trail is closed, it's accessible only to ice hikers with crampons, ice axes, and ropes who have checked in at the park office.

Waterfalls of Heberly Run

Skip the crowds at Ricketts Glen and see these three secluded waterfalls.

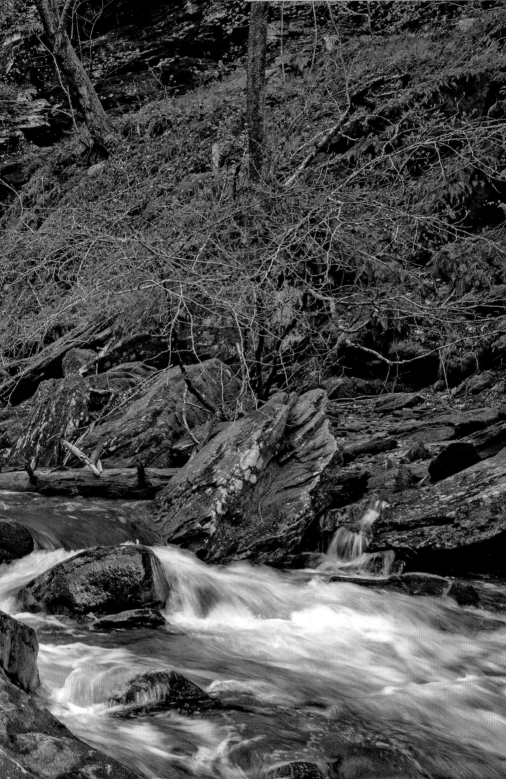

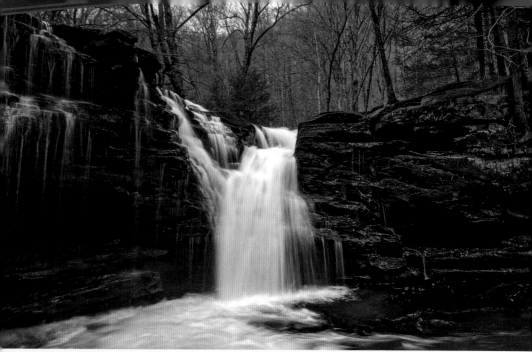

The upper drop of Twin Falls

Waterfalls of Heberly Run

Visit when the state game lands gate is open in May, or visit in the fall and drive to each waterfall.

LOCATION: State Game Lands 13

ADDRESS/GPS FOR THE FALLS: 41.328583, -76.352306

DIRECTIONS: From PA 118 north of Benton, turn north onto Central Rd. In 1.8 miles, turn right onto Jamison City Rd.; in another 2.2 miles, turn left onto Grassy Hollow Rd. If the gate is open, continue 0.6 mile to the parking area for Big Falls; otherwise, park outside the gate and walk.

WEBSITE: www.uncoveringpa.com/heberly-run-waterfalls-state-game-lands-13

WATERWAY: Heberly Run

HEIGHT: 12–35 feet **CREST:** 5–15 feet

NEAREST TOWN: Jamison City

HIKE DIFFICULTY: Strenuous

TRAIL QUALITY: Unmarked dirt trails

ROUND-TRIP DISTANCE: 1 mile

TRIP REPORT & TIPS:

Located adjacent to the popular Ricketts Glen State Park, State Game Lands 13 is a magical place. Dozens of beautiful waterfalls lie hidden in the woods here. Heberly Run is home to three of these.

Note: The best time to visit is May or mid-September–mid-November, when the gate on Grassy Hollow Road is open. This saves you several miles of road hiking, but driving beyond the gate requires a high-clearance vehicle like an SUV.

About 0.6 mile past the gate is the parking area for the 30-foot Big Falls—leave the road here and head into the woods. The descent to the base of Big Falls is steep and trailless, making this the hardest of the hikes on Heberly Run, but it's worth the effort. Find the best way down the hillside, but use care and remember that you have to come back up—and that any help is a long way away.

Driving another 0.6 mile up Grassy Hollow Road brings you to the parking area for Twin Falls. From here, take the trail from the back right corner of the parking lot as you face away from the road. This trail, about 0.25 mile long, descends through the woods back toward Twin Falls. In places it's a bit hard to follow, but as long as you're heading downstream on Heberly Run, you can't get lost.

On the way back, this trail is a little trickier, so make sure to pay close attention to the trail, which is intermittently blazed white.

Both tiers of Twin Falls can be viewed from above, though only the upper portion is easy to reach the bottom of. If you opt to descend for a closer look at the upper tier of Twin Falls, use extreme caution, as the rocks are flat and slippery.

Lewis Falls, the third major waterfall on Heberly Run, is just before the stream's confluence with Quinn Run. While it's the easiest of the three waterfalls to see, it's the hardest to reach the bottom of. The parking area is at the end of the passable portion of Grassy Hollow Road, about 0.4 mile from the Twin Falls parking.

To reach Lewis Falls, follow the old dirt road that branches off of this parking area (not the continuation of Grassy Hollow Road). Within about 100 yards, you'll come to the top of Lewis Falls.

Roughly 20–25 feet tall, Lewis Falls is a very impressive and beautiful waterfall. Like Big Falls, it is completely surrounded by cliffs. However, these cliffs are even more difficult to descend than those at Big Falls.

Angel Falls

Angel Falls was named because it reminded people of the famous Venezuelan waterfall.

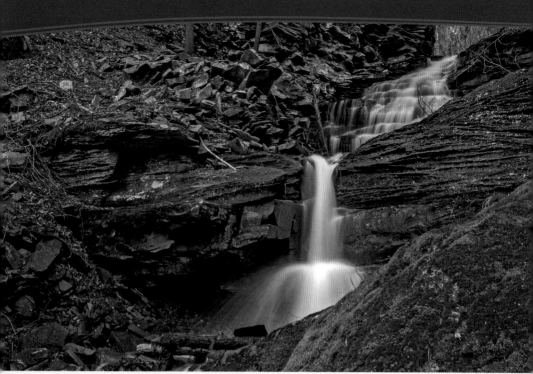

Gibson Falls is located just downstream of Angel Falls.

Angel Falls

Just downstream of Angel Falls is the 30-foot Gibson Falls.

LOCATION: Loyalsock State Forest

ADDRESS/GPS FOR THE FALLS: 41.394194, -76.677028

DIRECTIONS: From Eagles Mere, take PA 42 S. for 3.5 miles. Make a sharp right onto Brunnerdale Rd. After 4 miles, the parking area will be on your right.

WEBSITE: www.uncoveringpa.com/angel-falls-loyalsock-state-forest

WATERWAY: Falls Creek

HEIGHT: 70 feet **CREST:** 3–5 feet

NEAREST TOWN: Eagles Mere

HIKE DIFFICULTY: Strenuous

TRAIL QUALITY: An overgrown dirt road and a scramble up a hillside

ROUND-TRIP DISTANCE: 2 miles

TRIP REPORT & TIPS:

Angel Falls is one of the most majestic waterfalls in Northeastern Pennsylvania, and two other beautiful waterfalls lie just downstream. From the parking area, hike the Loyalsock Trail, crossing Brunnerdale Run just after the parking area, and follow it about 0.5 mile. Here, the Loyalsock Trail makes a hard right turn, and you'll see an unblazed forest road in front of you. Follow this old road.

The old road, easy to follow though a bit overgrown in places, travels relatively close to Ogdonia Run. After a few minutes of hiking, the old road will end near the confluence of Ogdonia Run and Falls Creek. Follow Falls Creek up the mountain, sticking primarily to the left side of the stream.

A short way up the stream, you'll come to the lowest waterfall on Falls Run. This waterfall is only about 12 feet tall, which pales compared with the two falls farther upstream. Nevertheless, it's well worth taking a few minutes to enjoy.

When you're ready to continue upstream, head up the left bank (if you're looking upstream). There's not really a trail at this point, so pick the way that seems best to you, making sure to stay away from the cliffs.

Once you get to the top of the rise, take a small trail to your right that goes through a gap in the cliffs. Here you'll find 30-foot Gibson Falls, featuring two main drops, with the upper one being the largest and most impressive. Be careful if you opt to get a closer look, as the rocks here are very slippery.

Once you're ready to continue, stay on the left bank, head back to the trail remnants you were previously following, and head to the left of the cliffs, again making sure to not get too close to the edge.

Once you reach the top of the cliffs, the impressive Angel Falls comes into view. It features a 60- to 70-foot straight drop, plus a small drop just below it. When it's flowing well, this is one of the most impressive waterfalls in Pennsylvania, but it tends to be very seasonal, so it's best to visit when water levels are high.

To return to your car, you could backtrack, but it's easier to follow the trail to the top of Angel Falls and follow the blue blazes to the Loyalsock Trail. When you get to the Loyalsock Trail, turn right and hike for a little over 1 mile back to the main parking area on Brunnerdale Road. You could also use this return route as a longer but easier route to the top of the waterfall.

Ketchum Run Gorge

There are four beautiful waterfalls on Ketchum Run.

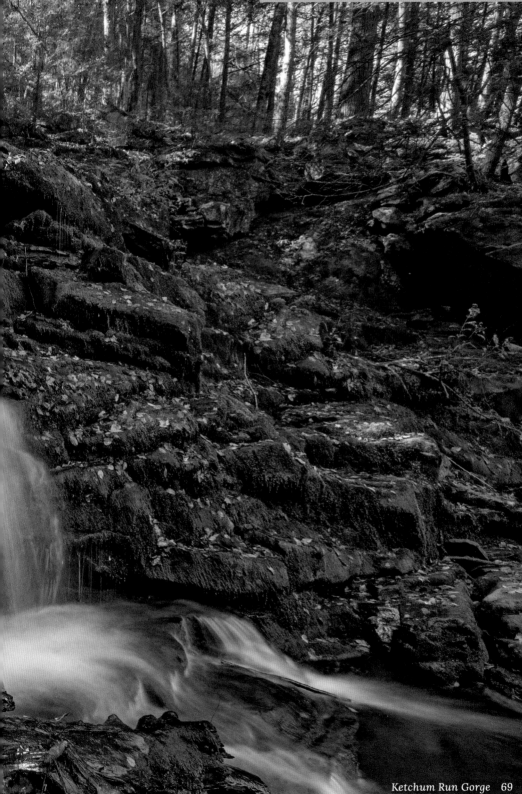

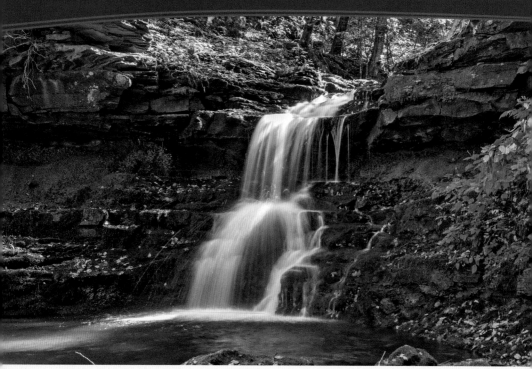

Rode Falls is the final waterfall on Ketchum Run.

Ketchum Run Gorge

To reach the bottom of the last waterfall on Ketchum Run, you'll have to descend a wooden ladder.

LOCATION: Loyalsock State Forest

ADDRESS/GPS FOR THE FALLS: 41.455972, -76.634333

DIRECTIONS: Take PA 42 S. out of Eagles Mere. After about 1.5 miles, make a sharp right onto Worlds End Rd. Follow this road north for 3 miles, and then turn left onto High Knob Rd. Drive 1.3 miles farther, and park adjacent to the gated road.

WEBSITE: www.uncoveringpa.com/ketchum-run-gorge-waterfalls-in-loyalsock -state-forest

WATERWAY: Ketchum Run

HEIGHT: Four waterfalls, 7–20 feet **CREST:** 1–10 feet

NEAREST TOWN: Eagles Mere

HIKE DIFFICULTY: Moderate

TRAIL QUALITY: A combination of off-trail hiking and hiking on established trails

ROUND-TRIP DISTANCE: 4 miles

TRIP REPORT & TIPS:

The lightly trafficked Ketchum Run Trail starts behind a gate on High Knob Road. The trail is wide and easy to follow. Several trails come off from the side, but you want to continue following the yellow and blue blazes.

After about 0.7 mile, the trail dead-ends. To your left is a small bridge over Ketchum Run—instead of crossing it, continue following Ketchum Run off-trail.

This off-trail section is relatively easy, as there is little undergrowth along the banks of Ketchum Run. There's no trail, but you simply follow the creek for the next 0.3 mile, making sure to stay on the right bank. Along the way, you'll pass a 7- to 8-foot waterfall and then the impressive 20-foot Ketchum Run Falls.

Just downstream of Ketchum Run Falls, the Loyalsock Trail will come in from your left and continue downstream on the same side you've been hiking down.

Follow the Loyalsock Trail down Ketchum Run, past several scenic campsites. After 5–10 minutes of hiking, the trail will seem to dead-end as the Loyalsock Trail makes an abrupt right turn up a steep hill and away from the creek.

At this point, you'll likely be able to hear but not see the 15-foot Lee Falls—to see it, carefully pick your way down the hillside along Ketchum Run. The waterfall is mere steps off of the Loyalsock, but it's hard to see well from the trail.

Climb back to the top of Lee Falls, and follow the Loyalsock Trail uphill. The uphill section here is short but quite steep. Eventually, it reaches the top of the hill and travels along the ridgeline for about 0.5 mile.

Eventually, you'll reach a sign that indicates a choice: you can follow the Loyalsock Trail downhill toward Rode Falls, or you can take the detour on the RX-5 Trail. To get from the top to the bottom of Rode Falls, you'll have to descend a sturdy wooden ladder. If you or members of your party (such as dogs) are unable to do this, take the detour and then double back to Rode Falls, where you'll reach the Loyalsock Trail again.

Rode Falls is only about 12 feet tall but has carved itself an impressive horseshoe-shaped hollow. From here you can see how the sheer rock walls make the ladder necessary to reach the base of the falls.

To get back to your car, simply retrace your steps.

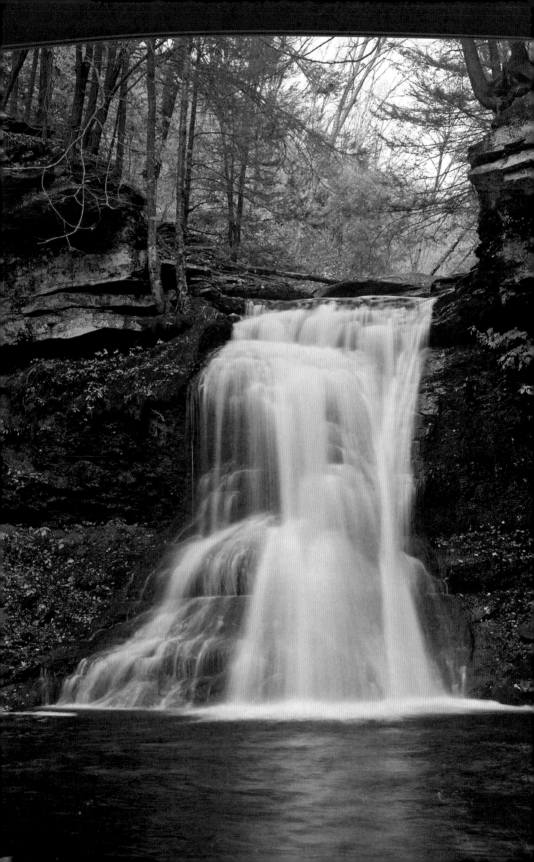

Sullivan Falls

LOCATION: State Game Lands 13

ADDRESS/GPS FOR THE FALLS: 41.335861, -76.340056

DIRECTIONS: From northbound PA 487 just past Ricketts Glen State Park, turn left onto Sullivan Falls Rd. Take this for 2.1 miles, and park in the state game lands parking lot on your right.

WEBSITE: www.uncoveringpa.com/sullivan-falls-state-game-lands-13

WATERWAY: East Branch Fishing Creek

HEIGHT: 30–35 feet **CREST:** 8–10 feet

NEAREST TOWN: Jamison City

HIKE DIFFICULTY: Easy to top of falls, difficult to bottom

TRAIL QUALITY: Unmarked dirt trail to top of falls, tricky trailless descent to bottom

ROUND-TRIP DISTANCE: 0.25 mile

TRIP REPORT & TIPS:

Hidden away just a couple of hundred yards down an unmarked trail, Sullivan Falls is well worth seeing even if you've just completed the nearby Falls Trail at Ricketts Glen State Park (see page 56).

Sullivan Falls is located in a large circular hollow in the woods, and the setting of this waterfall makes it easily one of the most impressive waterfalls in Pennsylvania. At roughly 30–35 feet tall, Sullivan Falls is just as imposing as many of the waterfalls in Ricketts Glen, but the wooded setting and lack of crowds make it feel much more peaceful.

From the parking area, follow the obvious trail straight back about 100 yards to the top of Sullivan Falls.

Getting to the top of this waterfall is easy, but getting to the bottom requires a steep and very sketchy descent—depending on how muddy it is, it may be impossible to safely reach the bottom of the falls. If you want to reach the bottom, look for an obvious spot just downstream of the falls where others have scrambled down in the past.

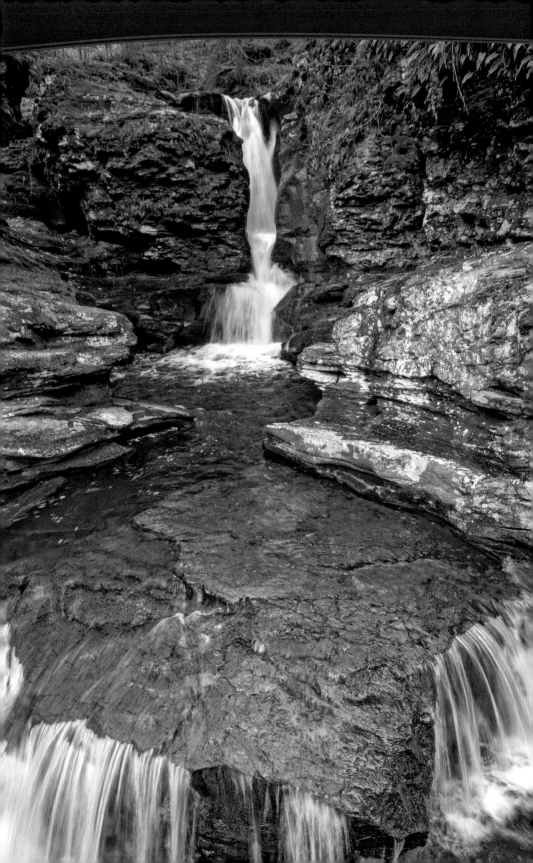

Adams Falls

LOCATION: Ricketts Glen State Park

ADDRESS/GPS FOR THE FALLS: 41.299361, -76.273889

DIRECTIONS: From Benton, head north on PA 487 for 7.5 miles. Turn right on PA 118. Park in the parking area on the right in 2.4 miles.

WEBSITE: www.dcnr.pa.gov/stateparks/findapark/rickettsglenstatepark

WATERWAY: Kitchen Creek

HEIGHT: 36 feet **CREST:** 2–3 feet

NEAREST TOWN: Benton

HIKE DIFFICULTY: Easy

TRAIL QUALITY: Dirt trail and stone steps

ROUND-TRIP DISTANCE: 0.2 mile

TRIP REPORT & TIPS:

Located in the southern part of Ricketts Glen State Park, Adams Falls is downstream of the waterfalls on the Falls Trail (see page 56). If you're visiting the park or simply driving through the area, this waterfall is not to be missed. It requires almost no hiking to see and is a favorite of many park visitors.

From the parking area, look for signs for the Evergreen Trail. Adams Falls is only about 100 feet from the parking lot along the trail, so you don't need to go far.

Adams Falls features three drops, the uppermost of which is the tallest at approximately 20 feet tall. This upper drop falls through a very narrow chute in the rock walls and is quite beautiful to see.

If you look just upstream from Adams Falls, you can also catch a glimpse of Kitchen Creek Falls. Located directly under the PA 118 bridge, it's very hard to see from any angle other than this one.

The upper part of Adams Falls and the lower two drops are somewhat separated. The second drop is a roughly 3-foot drop, while the third is a 10- to 15-foot drop into a deep pool below the falls.

The lowest drop is hard to see without getting your feet wet, but there are several vantage points from along the rocks from which you can easily view the upper and middle drops of this waterfall.

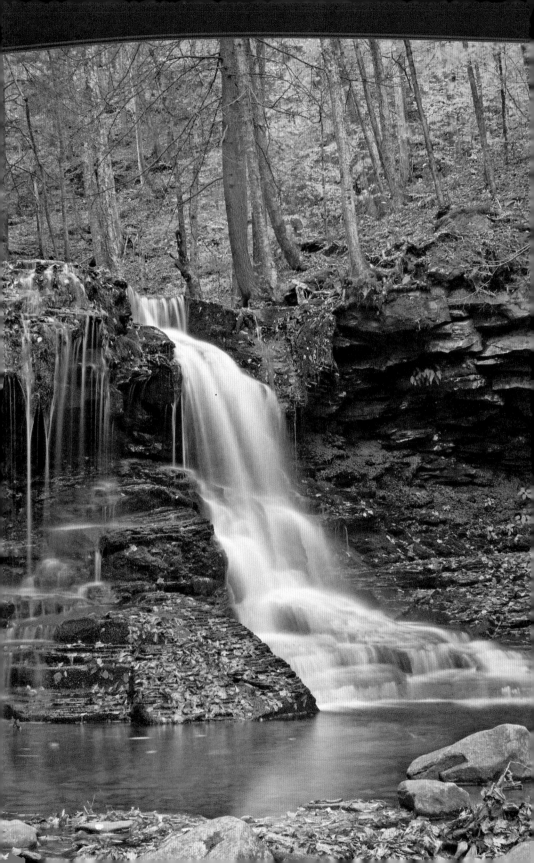

Dry Run Falls

LOCATION: Loyalsock State Forest

ADDRESS/GPS FOR THE FALLS: 41.430222, -76.670611

DIRECTIONS: Take PA 87 S. out of Forksville. Turn left onto Dry Run Rd., and follow it 2 miles. Parking is on the right just above the waterfall.

WEBSITE: www.uncoveringpa.com/visiting-dry-run-falls-loyalsock-state-forest

WATERWAY: Dry Run

HEIGHT: 20 feet **CREST:** 5 feet

NEAREST TOWN: Forksville

HIKE DIFFICULTY: NA

TRAIL QUALITY: NA

ROUND-TRIP DISTANCE: Roadside

TRIP REPORT & TIPS:

There are many roadside waterfalls in Pennsylvania, but Dry Run Falls might be my favorite. This waterfall can be seen from the road, but a closer inspection is possible by descending the short but steep path to creek level.

Despite the name of this waterfall, Dry Run Falls is actually one of the last waterfalls in the area to go dry—there's usually water here even in the middle of the summer.

Just above the falls is a picnic table. I love swinging by here when I'm in the area and eating my lunch or dinner while enjoying the beauty of this waterfall.

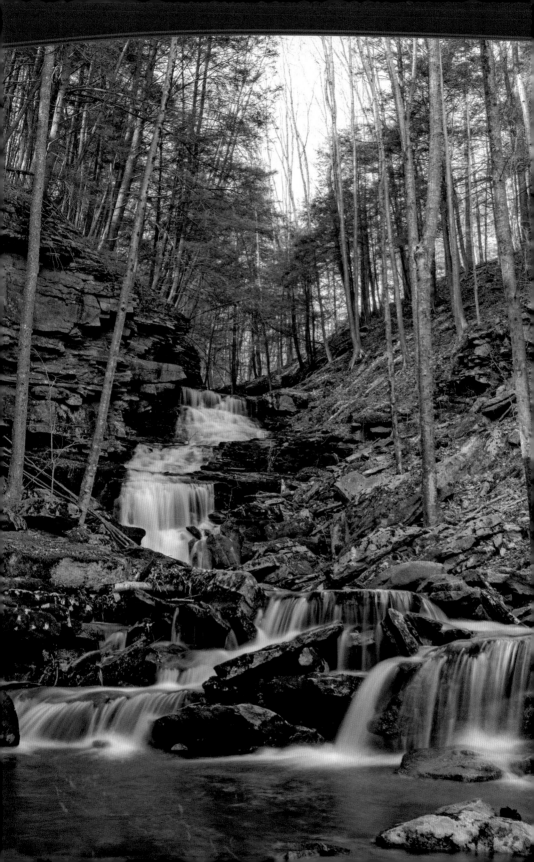

Alpine Falls

LOCATION: Loyalsock State Forest

ADDRESS/GPS FOR THE FALLS: 41.478056, -76.553611

DIRECTIONS: Take PA 87 N. out of Forksville. After 6 miles, turn right onto Rock Run Rd. After crossing the bridge, turn right to stay on Rock Run Rd. Follow this road for 3.5 miles, and then turn right onto Loyalsock Rd. Follow this road for 3.9 miles, and park adjacent to a gated road on your left.

WEBSITE: www.uncoveringpa.com/alpine-falls-loyalsock-state-forest

WATERWAY: Unnamed

HEIGHT: 25 feet **CREST:** 10–12 feet

NEAREST TOWN: Forksville

HIKE DIFFICULTY: Moderate

TRAIL QUALITY: An overgrown old road, a dirt trail, and a bit of creek walking

ROUND-TRIP DISTANCE: 1.5 miles

TRIP REPORT & TIPS:

From the parking area, walk past the gate and follow this old dirt road for approximately 0.5 mile. This road is overgrown in places but is easy to follow. Eventually, you will come to the Loyalsock Trail. Turn right on this trail and hike for less than 0.25 mile. You will soon come to a wet stream crossing above Upper Alpine Falls.

Continue following the Loyalsock Trail a short distance farther until you descend the hill and reach stream level.

To see Alpine Falls, simply bushwhack your way 100 yards upstream—depending on water levels, this may be difficult or even impossible to do safely, so use your best judgment when you visit.

From this vantage point, you can see the bottom two drops of Alpine Falls. Another small waterfall is located just above the main falls, but getting to it is dangerous.

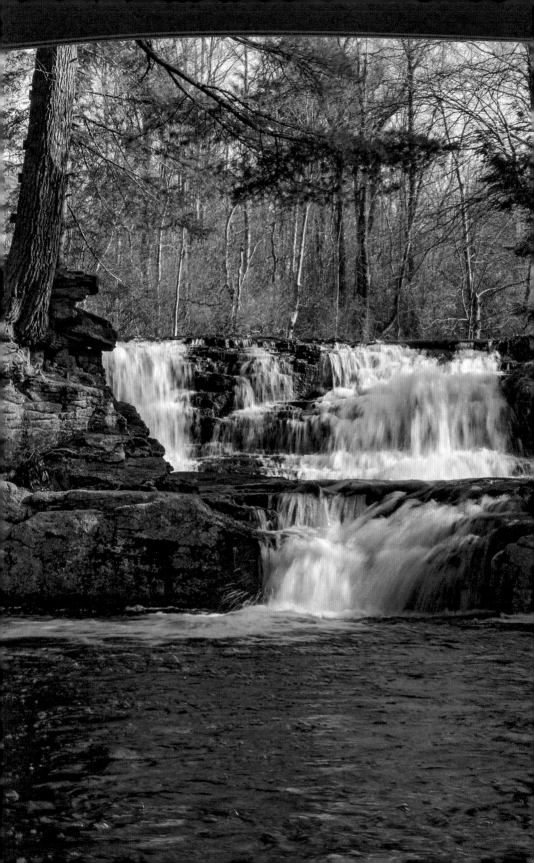

Choke Creek Falls

LOCATION: Pinchot State Forest

ADDRESS/GPS FOR THE FALLS: 41.171444, -75.618083

DIRECTIONS: From Exit 284 off I-80, follow PA 115 N. for 5.7 miles. Turn right onto Buck River Rd., and follow that for 5 miles before turning left on Bear Lake Rd. After 2 miles, turn left onto Tannery Rd.; then, after another 1.2 miles, turn left onto Phelps Rd. Follow Phelps Rd. for 2.4 miles, staying to the right when the road splits. Park next to a gate at a bend in the road.

WEBSITE: www.uncoveringpa.com/how-to-get-to-choke-creek-falls-pinchot-state-forest

WATERWAY: Choke Creek

HEIGHT: 20 feet **CREST:** 20 feet

NEAREST TOWN: Blakeslee

HIKE DIFFICULTY: Moderate

TRAIL QUALITY: A combination of trails and old dirt roads

ROUND-TRIP DISTANCE: 1.5 miles

TRIP REPORT & TIPS:

Choke Creek Falls is located along Choke Creek, which serves as the dividing line between Lackawanna and Luzerne Counties. The waterfall is about 20 feet in total height spread out over two drops. It's at least as wide as it is tall. The hike to Choke Creek Falls is a pleasant 0.75-mile walk through this beautiful forest. You hike mostly along old access roads, but that doesn't take away from the beauty of the forest.

Start your walk past the gate and hike down the access road. You'll pass another road on your left, but keep walking for about 0.25 mile until you reach a clearing.

You'll see a gated road straight ahead across the clearing and another gate to your right—follow the trail past the gate to the right, and head downhill.

After another 0.25 mile, you'll come to a wooden bridge over Butler Run. This bridge is just above the confluence of Butler Run and Choke Creek. Cross the bridge and head along the obvious trail that follows Butler Run downstream. After just a few yards, the trail will veer to the right and follow Choke Creek upstream to the waterfall.

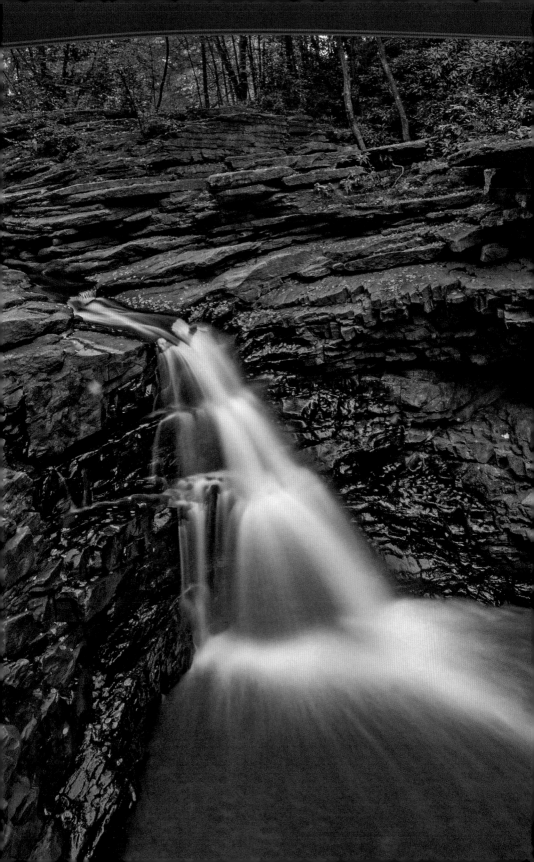

Nay Aug Falls

LOCATION: Nay Aug Park

ADDRESS/GPS FOR THE FALLS: 41.401472, -75.639611

DIRECTIONS: Follow Mulberry St. southeast out of Scranton for 1 mile. Park in the large lot just past the Everhart Museum.

WEBSITE: www.uncoveringpa.com/nay-aug-falls

WATERWAY: Roaring Brook

HEIGHT: 20 feet **CREST:** 5 feet

NEAREST TOWN: Scranton

HIKE DIFFICULTY: Easy

TRAIL QUALITY: A combination of well-maintained dirt trails and steps

ROUND-TRIP DISTANCE: 0.5 mile

TRIP REPORT & TIPS:

Nay Aug Falls is located only 1 mile from the heart of downtown Scranton, making it one of the most popular waterfalls in the region.

From the parking area, access the Davis Trail, and follow it until you reach the Overlook Trail. This trail will head down into the impressive gorge to a viewing platform for Nay Aug Falls.

Nay Aug Falls flows throughout the year and is a very powerful waterfall. It is surrounded by sheer stone cliffs that make the setting of this waterfall very dramatic.

There is also a viewing area on the top of the cliff on the opposite bank of Roaring Brook. Follow the Davis Trail, and then turn right onto the Rodman Trail. Follow this across a covered bridge and up to a viewing area overlooking the falls. This second viewing area requires a roughly 1-mile round-trip hike.

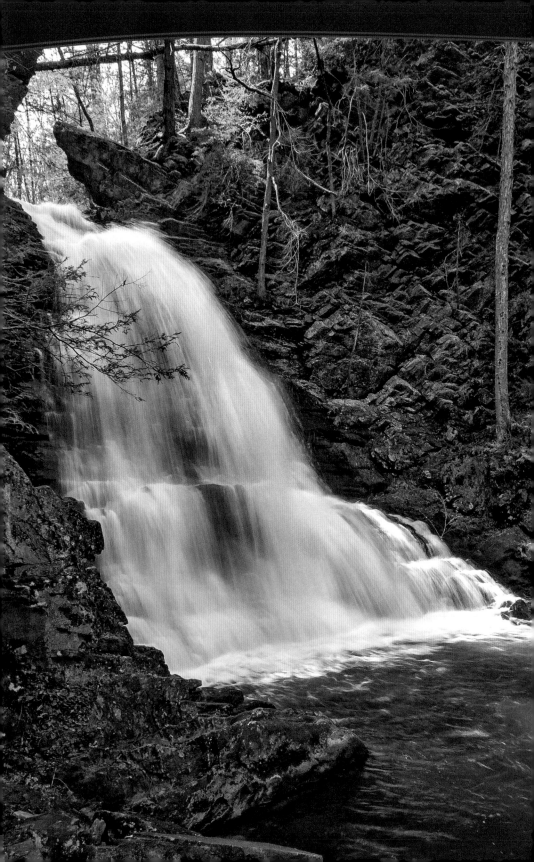

Little Shickshinny Falls

LOCATION: State Game Lands 260

ADDRESS/GPS FOR THE FALLS: 41.148722, -76.172917

DIRECTIONS: From US 11 in Shickshinny, head west on W. Butler St. for 1 mile. Park in the state game lands parking area, on the right. *Note:* The hike to Paddy Run Falls (see page 97) starts from the same parking lot.

WEBSITE: www.uncoveringpa.com/little-shickshinny-falls

WATERWAY: Little Shickshinny Creek

HEIGHT: 25–30 feet **CREST:** 5 feet

NEAREST TOWN: Shickshinny

HIKE DIFFICULTY: Easy

TRAIL QUALITY: Unmarked but obvious dirt trails

ROUND-TRIP DISTANCE: 1 mile

TRIP REPORT & TIPS:

Little Shickshinny Falls is hidden in State Game Lands 260, just west of the community of Shickshinny and the Susquehanna River. From the parking area, follow the road for about 20 feet away from town. Walk past the gate, and follow the obvious trail to the top of Little Shickshinny Falls. If water levels are high, parts of the trail can get quite wet.

While getting to the top of Little Shickshinny Falls is easy, getting to the base of the falls is more challenging, and caution is encouraged.

Just above the waterfall, there are the remains of an old dam, which may have served a mill in the area, as well as another small waterfall that is at least partially man-made.

If you're feeling especially intrepid, another small waterfall is located about 100 feet downstream of the main waterfall. It is also quite beautiful, but it's hard to reach.

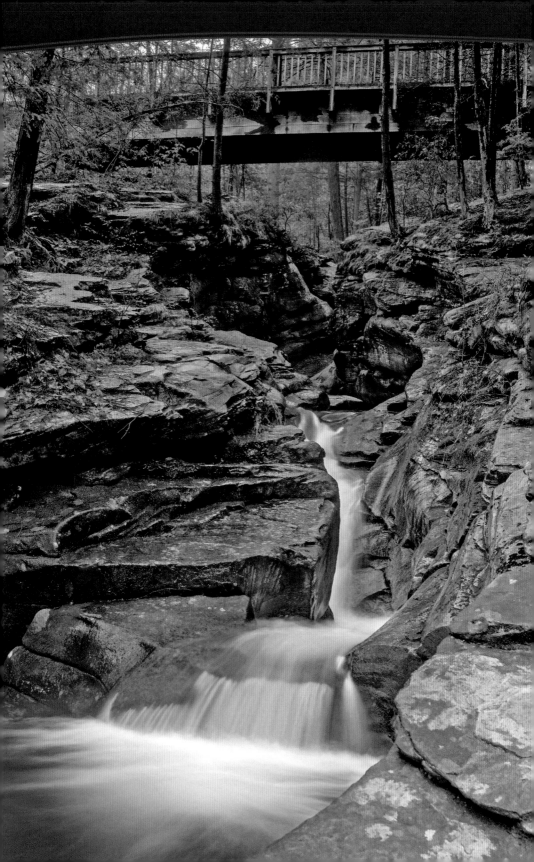

Seven Tubs

LOCATION: Seven Tubs Recreation Area, Pinchot State Forest

ADDRESS/GPS FOR THE FALLS: 41.234722, -75.810611

DIRECTIONS: From I-81, take Exit 170A and follow US 115 S. for 1.5 miles. Turn right onto Bear Creek Blvd., and follow that for 0.3 mile until the road ends at a parking area.

WEBSITE: www.dcnr.pa.gov/stateforests/findaforest/pinchot

WATERWAY: Wheelbarrow Run

HEIGHT: 15 feet **CREST:** 3 feet

NEAREST TOWN: Wilkes-Barre

HIKE DIFFICULTY: Easy

TRAIL QUALITY: Good-quality dirt trail

ROUND-TRIP DISTANCE: 0.6 mile

TRIP REPORT & TIPS:

Seven Tubs is one of the most unusual geological sites in Pennsylvania. Along Wheelbarrow Run, a series of seven tubs have been carved into the rock, and flowing from each tub is a small waterfall. The largest of these waterfalls is just above where Wheelbarrow Run meets Laurel Run.

From the parking area, cross the road and follow the path to the bridge over Wheelbarrow Run. Just a few steps downstream of the bridge is the largest waterfall at Seven Tubs.

To see more waterfalls, follow the hiking trail upstream along Wheelbarrow Run. After about 0.25 mile, you'll come to a 10-foot waterfall and then, just downstream of that, an amazing twisting cavern carved into the rocks.

There are two other waterfalls to see in Seven Tubs Recreation Area. Return to the parking area, and walk uphill on the road. Directly across from the overflow parking lot, you'll notice a trail leading into the forest. Head into the woods and turn right, following the trail as it runs parallel to the road. After a short distance, the trail will turn steeply down away from the road. Follow this trail to the bottom of the hill. From here, these two hidden waterfalls will be a short distance to the right.

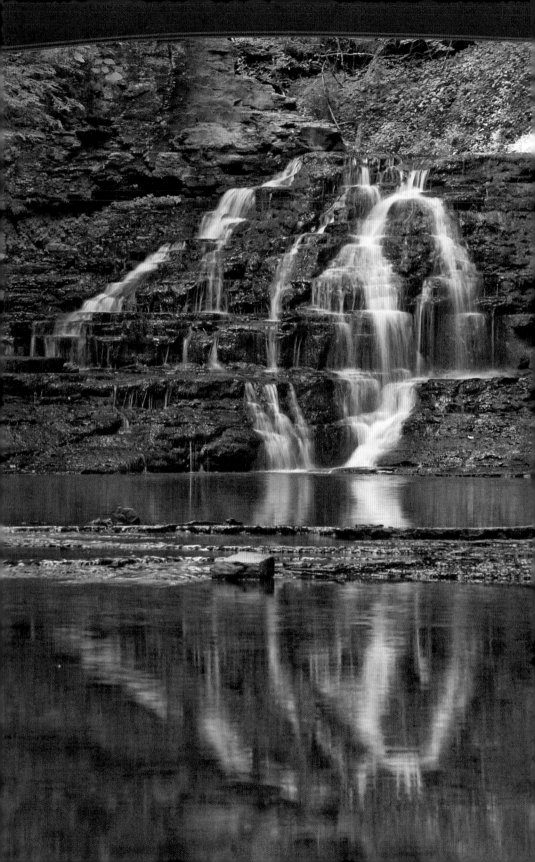

Waterfalls of Fall Brook

LOCATION: Salt Springs State Park

ADDRESS/GPS FOR THE FALLS: 41.910944, -75.865472

DIRECTIONS: From Montrose, take PA 29 N. for 6.5 miles; then turn left onto Silver Creek Rd./SR 4008, and follow that for 0.3 mile. Turn left into Salt Springs State Park, and park in the lot next to the Wheaton House.

WEBSITE: www.dcnr.pa.gov/stateparks/findapark/saltspringsstatepark

WATERWAY: Fall Brook

HEIGHT: Three waterfalls, 8–15 feet **CREST:** 10–15 feet

NEAREST TOWN: Montrose

HIKE DIFFICULTY: Strenuous

TRAIL QUALITY: Mostly hiking up a stream and climbing over small waterfalls

ROUND-TRIP DISTANCE: 1.5 miles

TRIP REPORT & TIPS:

From the Wheaton House, follow the Fall Brook Trail across a bridge over the waterway. From here, simply follow the trail upstream along the banks of Fall Brook. If water levels are higher, the trail may be overflowing with water— make sure to use caution if hiking in the stream is required. Over the course of about 0.5 mile, you'll encounter (and have to climb over) three different waterfalls ranging from 8 to 15 feet tall.

Climbing over these waterfalls isn't overly difficult, as they have natural steps, but use caution when climbing wet rocks.

Once past the third waterfall, continue hiking upstream until the Fall Brook Trail meets the Hemlock Trail. Turn onto this trail, and follow it for about 0.75 mile downstream back to the trailhead. Along the way, you'll pass a nice overlook for one of the waterfalls as well as the unique Penny Rock. Stuff a penny into the rock's crevices for good luck.

If you'd rather not get your feet wet, or if hiking in the stream is too dangerous, you can see two of the three waterfalls from the Hemlock Trail.

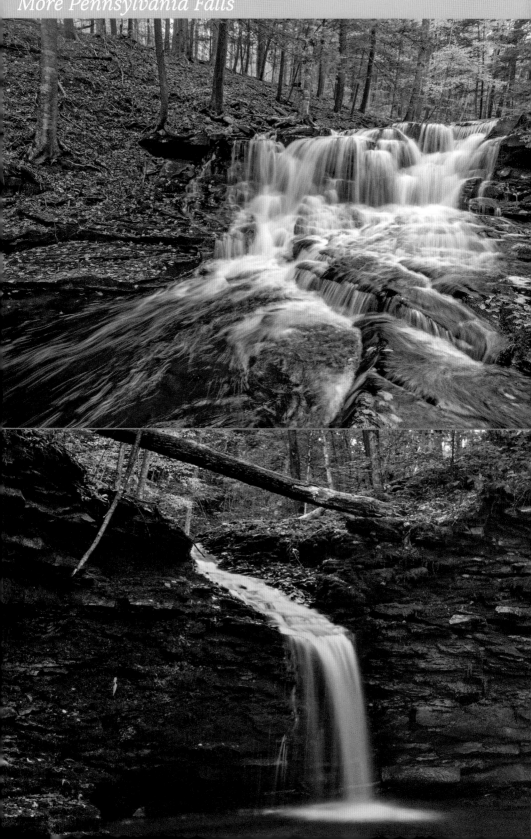

Rusty Falls

LOCATION: Loyalsock State Forest

ADDRESS/GPS FOR THE FALLS: 41.422167, -76.552083

DIRECTIONS: From US 220 N., turn left onto PA 154. After 3.5 miles, turn left onto Shanerburg Rd. Follow this for 2 miles, and park near the gated road on your left.

WEBSITE: www.uncoveringpa.com/rusty-falls

WATERWAY: Shanerburg Run

HEIGHT: 8 feet **CREST:** 10 feet

NEAREST TOWN: Eagles Mere

HIKE DIFFICULTY: Easy

TRAIL QUALITY: An old dirt road with a bit of off-trail hiking

ROUND-TRIP DISTANCE: 2.5 miles

TRIP REPORT & TIPS:

Rusty Falls is a small waterfall set in a little-visited corner of Loyalsock State Forest. While it's fairly close to Eagles Mere, private property makes it impossible to access this waterfall from town.

Instead, from the parking area mentioned above, hike past the gate and follow the old dirt road approximately 1.2 miles.

When you arrive at Rusty Run, don't make the wet stream crossing—instead, head into the woods upstream for a couple of hundred yards until you come to Rusty Falls.

Just upstream is another small waterfall, usually dubbed Upper Rusty Falls.

Cottonwood Falls

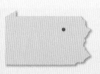

LOCATION: Loyalsock State Forest

ADDRESS/GPS FOR THE FALLS: 41.462583, -76.584833

DIRECTIONS: From Forksville, take PA 154 E. for 2.5 miles. Just past the Worlds End State Park office, park in a small area on the right with a large sign that says DOUBLE RUN NATURE TRAIL.

WEBSITE: www.dcnr.pa.gov/stateparks/findapark/worldsendstatepark

WATERWAY: Double Run

HEIGHT: 10 feet **CREST:** 3 feet

NEAREST TOWN: Forksville

HIKE DIFFICULTY: Easy

TRAIL QUALITY: Well-maintained dirt trails

ROUND-TRIP DISTANCE: 1 mile

TRIP REPORT & TIPS:

From the parking area at Worlds End State Park, follow the Double Run Nature Trail about 0.25 mile to where it intersects the Loyalsock Trail. Take the trail to the right, and follow the Loyalsock Trail a short distance. After a few minutes, the Double Run Nature Trail turns left and leaves the Loyalsock Trail—continue following the Double Run Trail to the base of Cottonwood Falls, in Loyalsock State Forest.

Cottonwood Falls cuts an amazing hollow with its dramatic rock walls. Another small waterfall is just upstream, and you can make a nice 1.2-mile loop by continuing to follow the Double Run Nature Trail. You can also shorten this hike slightly by retracing your steps to the trailhead.

Mill Creek Falls

LOCATION: Loyalsock State Forest

ADDRESS/GPS FOR THE FALLS: 41.456556, -76.725333

DIRECTIONS: From PA 187 in Hillsgrove, turn northwest onto Mill Creek Rd. Follow this road for 1.5 miles, and park in a small pull-off on the left side of the road.

WEBSITE: www.uncoveringpa.com/mill-creek-falls-loyalsock-state-forest

WATERWAY: Mill Creek

HEIGHT: 8–10 feet **CREST:** 5–7 feet

NEAREST TOWN: Hillsgrove

HIKE DIFFICULTY: Easy

TRAIL QUALITY: An unmarked but easy-to-follow path

ROUND-TRIP DISTANCE: 0.6 mile

TRIP REPORT & TIPS:

From the parking area, you should see a narrow trail that heads downhill—follow this trail, making sure to turn left about halfway down the hill, until you get to Mill Creek Falls at the bottom. The trail isn't blazed but is easy to follow.

Mill Creek Falls isn't large, but it has carved a beautiful pool with cliffs above it, making for a very dramatic setting. Looking down on the falls from above gives you a great view of the pool below them.

To reach the bottom of the falls, head about 100 yards downstream, and pick your way down the hillside. Getting to the base of the falls can be a bit tricky if you want to keep your feet dry.

East Branch Falls

LOCATION: Loyalsock State Forest

ADDRESS/GPS FOR THE FALLS: 41.491222, -76.752694

DIRECTIONS: From PA 87 in Hillsgrove, turn northwest onto Mill Creek Rd., and drive 4 miles. Turn right onto Camels Rd., and then make an almost immediate left onto Walkers Rd. Park in the pull-off on the left, 0.8 mile up Walkers Rd.

WEBSITE: www.uncoveringpa.com/how-to-get-to-east-branch-falls-loyalsock-state-forest

WATERWAY: East Branch of Mill Creek

HEIGHT: 20–25 feet **CREST:** 5–7 feet

NEAREST TOWN: Hillsgrove

HIKE DIFFICULTY: Moderate

TRAIL QUALITY: No trail—requires steep descent to bottom of falls

ROUND-TRIP DISTANCE: 0.25 mile

TRIP REPORT & TIPS:

Three waterfalls flow next to each other on the East Branch of Mill Creek, less than 200 feet from the parking area. While there is no trail to the top of the falls, the open forest makes the hiking easy.

Making your way to the bottom of the uppermost waterfall is fairly easy. This 10- to 12-foot-tall slide falls into a small notch in the rocks (watch your step here). The 6-foot middle waterfall drops into a small pool. The only viewpoint is from above.

The main waterfall, 20–25 feet tall, slides beautifully down the rock face. It can be viewed from above—a good idea if you're uncomfortable on narrow, slippery trails. Othewise, look for a steep, narrow trail snaking its way to the bottom of the falls.

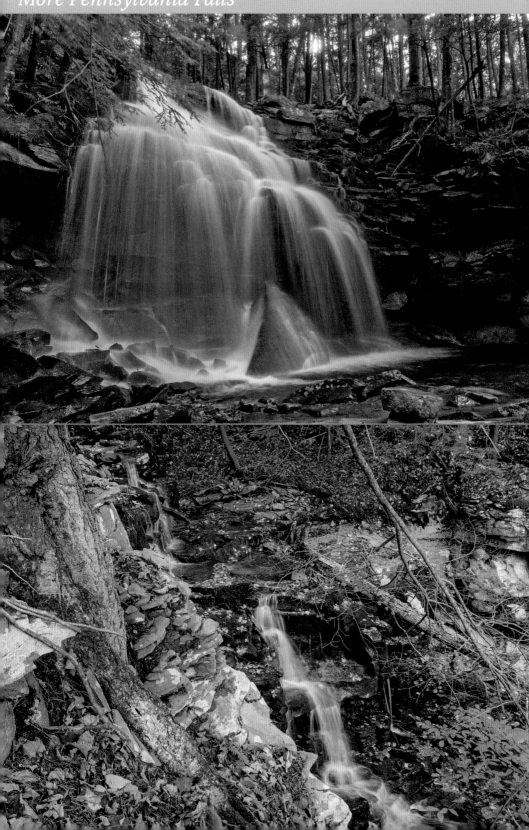

Dutchman Falls

LOCATION: Loyalsock
State Forest

**ADDRESS/GPS FOR THE
FALLS:** 41.450000, -76.450750

DIRECTIONS: From Laporte, head north on
US 220 for 3 miles. Turn left onto Mead Rd., and
follow it to the parking lots just up the hill. Park in
the lot to the right near the restrooms, if possible.

WEBSITE: www.uncoveringpa.com/how-to-get
-to-dutchman-falls

WATERWAY: Dutchman Run

HEIGHT: 20–25 feet **CREST:** 5–7 feet

NEAREST TOWN: Laporte

HIKE DIFFICULTY: Moderate

TRAIL QUALITY: A steep descent on a trail and
then a short off-trail hike to the base of the falls

ROUND-TRIP DISTANCE: 0.3 mile

TRIP REPORT & TIPS:

Dutchman Falls, located steps from the
start of the popular Loyalsock Trail, can
be heard but not seen from the trail.

From the parking area, which also serves
as a parking area for long-distance hikers
on the trail, look for a narrow trail behind
the restrooms that descends the short
but steep distance to the Loyalsock Trail.

Instead of turning onto the Loyalsock
Trail, however, cross over it and pick
your way down toward Loyalsock Creek.
Dutchman Falls flows almost directly
into the creek just down the hill from the
Loyalsock Trail.

Dutchman Falls features two beautiful
drops, with the lower falls being the
larger of the two.

Cold Run Falls

LOCATION: Loyalsock
State Forest

**ADDRESS/GPS FOR THE
FALLS:** 41.459806, -76.559556

DIRECTIONS: From Forksville, take PA 154 E. for
2.7 miles. Turn right onto Mineral Springs Rd., and
travel for 1.5 miles. Turn left onto Cold Run Rd.,
and park on either side of the road in 0.75 mile.

WEBSITE: www.uncoveringpa.com/cold-run
-trail-worlds-end-state-park

WATERWAY: Cold Run

HEIGHT: 18–20 feet **CREST:** 3–5 feet

NEAREST TOWN: Forksville

HIKE DIFFICULTY: Moderate

TRAIL QUALITY: Good-quality dirt trail

ROUND-TRIP DISTANCE: 4 miles

TRIP REPORT & TIPS:

From the parking, head down to the
Loyalsock Canyon Vista; then go right on
the Loyalsock Trail. After about 1 mile, pass
an access point for the Cold Run Trail.

In 0.3 mile, past a series of switchbacks,
reach a second access for the yellow-
blazed Cold Run Trail—go straight onto it.

After 0.25 mile, reach Cold Run Vista. The
trail then dips 0.15 mile into the valley.

The hike up Cold Run is about 0.5 mile.
Shortly after meeting it, pass a 10-foot
falls and cross a bridge. Eventually, reach
a confluence of two streams. Cross Cold
Run, and climb the hill along the left side
to the split. The trail rises a few hundred
feet and recrosses this branch of Cold Run.

From here, hike to another stream
crossing and the tallest falls on Cold Run
in Loyalsock State Forest. When you once
again reach the Loyalsock Trail, continue
straight for 1 mile back to your car.

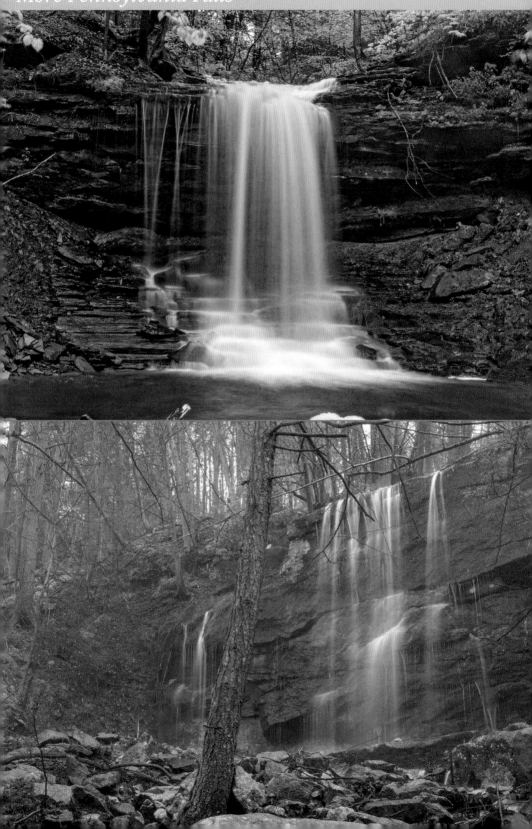

Lost Falls

LOCATION: State Game Lands 140

ADDRESS/GPS FOR THE FALLS: 41.945111, -76.080667

DIRECTIONS: From Montrose, take Owego St. north for 2.3 miles. Turn left onto SR 4007, and follow it for 7.5 miles; then turn left onto PA 267. In 2 miles, turn right onto Friendship Hill Rd. In 5.3 miles, park on the right just past the bridge.

WEBSITE: www.uncoveringpa.com/lost-falls -susquehanna-county

WATERWAY: Apalachin Creek

HEIGHT: 12–15 feet **CREST:** 3–5 feet

NEAREST TOWN: Montrose

HIKE DIFFICULTY: Strenuous

TRAIL QUALITY: No trail—must bushwhack or creek-walk your way to the bottom

ROUND-TRIP DISTANCE: 0.2 mile

TRIP REPORT & TIPS:

From the parking area, look for a faint trail that heads down toward the stream. Once you get to Apalachin Creek, you'll have to pick your way up the water-way to the base of Lost Falls. In some situations, the easiest route is directly through the stream, as the hillsides are rather steep.

Located only about 200 yards from the road, beautiful Lost Falls plunges into a shallow pool before continuing to cascade down the hill.

Paddy Run Falls

LOCATION: State Game Lands 260

ADDRESS/GPS FOR THE FALLS: 41.146278, -76.151278

DIRECTIONS: From US 11 in Shickshinny, head west on W. Butler St. for 1 mile. Park in the state game lands parking area on the right.

WEBSITE: www.uncoveringpa.com/paddy -run-falls

WATERWAY: Paddy Run

HEIGHT: 10–12 feet **CREST:** 5–7 feet

NEAREST TOWN: Shickshinny

HIKE DIFFICULTY: Strenuous

TRAIL QUALITY: A combination of old dirt roads, a dirt path, and off-trail hiking

ROUND-TRIP DISTANCE: 2.5 miles

TRIP REPORT & TIPS:

From the same parking area for Little Shickshinny Falls (see page 85), cross the road and follow the gated road down the hillside. After a little less than 0.5 mile, pass through a clearing, and continue straight back into the woods. Soon you'll cross a small bridge over Paddy Run.

You'll now have to pick your way down-stream without a trail. Fortunately, the woodland is fairly open and navigable as long as you don't lose sight of the creek.

You'll see several smaller drops, including the 6- to 8-foot Upper Paddy Run Falls. After about 0.66 mile of off-trail hiking, descend a steep hill to see the unique Paddy Run Falls. The water drops straight off a sheer, rectangular rock wall.

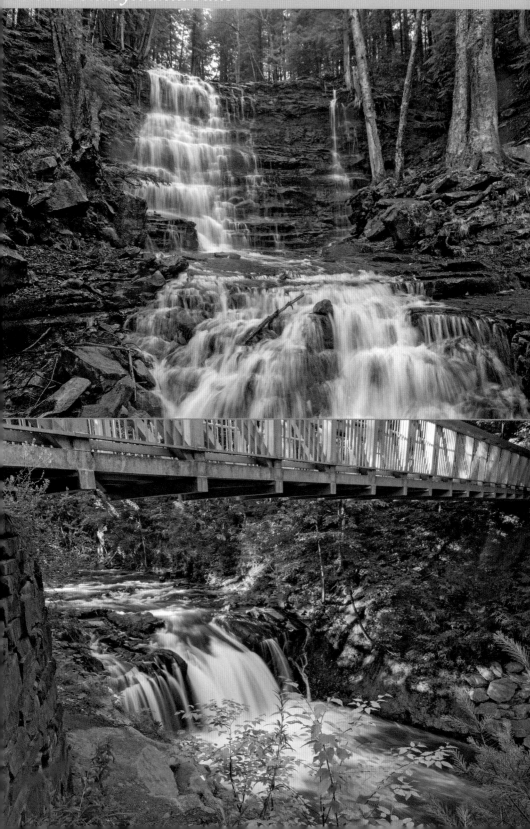

Buttermilk Falls

LOCATION: Bear Creek Preserve

ADDRESS/GPS FOR THE FALLS: 41.166889, -75.742611

DIRECTIONS: From Bear Creek Village, turn southeast onto White Haven Rd. and follow it for 1.1 miles. There is a pull-off on the left side of the road, but the waterfall can also be seen from the road.

WEBSITE: www.natlands.org/bear-creek-preserve

WATERWAY: Unnamed

HEIGHT: 30–35 feet **CREST:** 8–10 feet

NEAREST TOWN: Bear Creek Village

HIKE DIFFICULTY: NA

TRAIL QUALITY: NA

ROUND-TRIP DISTANCE: Roadside

TRIP REPORT & TIPS:

Buttermilk Falls, also known as Bear Creek Falls even though it's not on that waterway, is located on the edges of Bear Creek Preserve. The waterfall can be seen from the road and is located less than 200 feet from it. If you'd like to get a closer look, a pull-off is adjacent to the falls.

It should be noted that Buttermilk Falls tends to be very seasonal and flows well only during times of high water— if you visit during the summer, it may be nothing more than a trickle.

Sweet Arrow Falls

LOCATION: Sweet Arrow Lake County Park

ADDRESS/GPS FOR THE FALLS: 40.569556, -76.365139

DIRECTIONS: From Pine Grove, head east out of town on E. Pottsville St. After 1.3 miles, turn left onto Waterfall Rd. After 0.25 mile, park in the parking lot on your right.

WEBSITE: www.sweetarrowlakepark.com

WATERWAY: Upper Little Swatara Creek

HEIGHT: 12–15 feet **CREST:** 15 feet

NEAREST TOWN: Pine Grove

HIKE DIFFICULTY: Easy

TRAIL QUALITY: Flat and paved

ROUND-TRIP DISTANCE: 0.25 mile

TRIP REPORT & TIPS:

Sweet Arrow Lake County Park is home to a beautiful lake and a small but very pretty waterfall. Located about 100 yards below the outflow of the park's lake, Sweet Arrow Falls drops just before a 90-degree turn in the creek, creating some nice vantage points.

From the parking area, follow the paved path for just over 0.1 mile. This path leads to a bridge that passes directly over Sweet Arrow Falls, offering great views. For more views, follow the trail to the right for about 100 yards.

Slateford Creek Falls

The three waterfalls on Slateford Creek are hidden gems of the Delaware Water Gap.

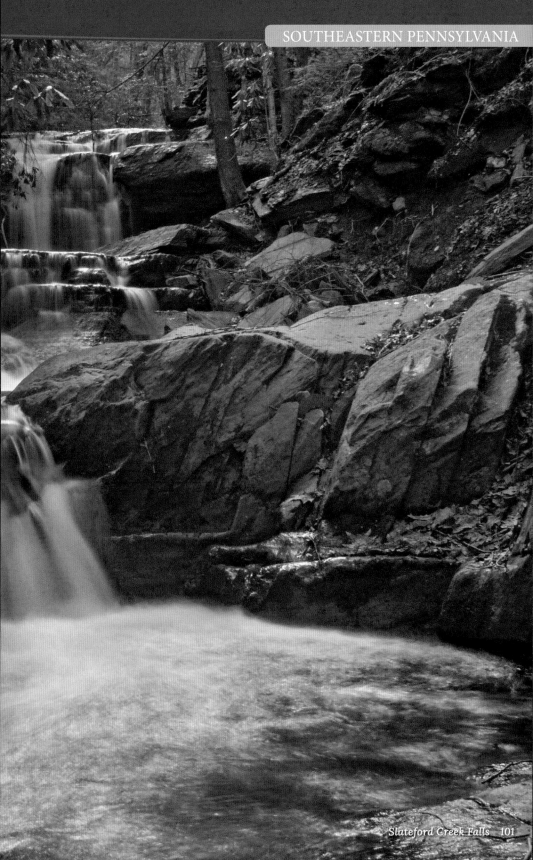

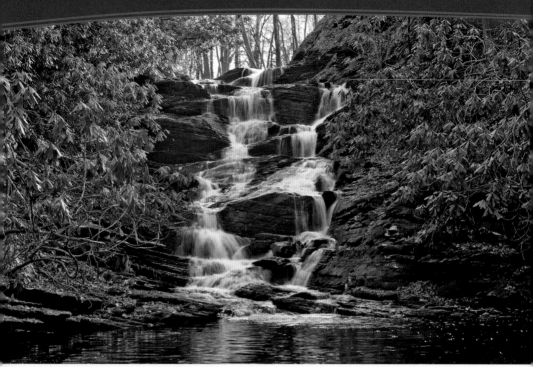

Upper Slateford Creek Falls is the easiest of the waterfalls to reach.

Slateford Creek Falls

The tallest waterfall on Slateford Creek is 50 feet tall, while the two shorter ones are 20 and 15 feet tall.

LOCATION: Delaware Water Gap National Recreation Area

ADDRESS/GPS FOR THE FALLS: 40.945667, -75.122472

DIRECTIONS: From Exit 307 off I-80, take PA 611 S. for 6.5 miles, and turn right onto National Park Dr. After 0.1 mile, park in a pull-off on the left side of the road, just before a 180-degree turn. For the uppermost falls, continue on National Park Dr. for 1 mile, and park in a pull-off just before the bridge.

WEBSITE: www.nps.gov/dewa

WATERWAY: Slateford Creek

HEIGHT: 50 feet **CREST:** 5 feet

NEAREST TOWN: Stroudsburg

HIKE DIFFICULTY: Moderate

TRAIL QUALITY: Unmarked but well trod

ROUND-TRIP DISTANCE: 1 mile

TRIP REPORT & TIPS:

The three waterfalls on Slateford Creek are located just south of Stroudsburg in the southern reaches of Delaware Water Gap National Recreation Area. While these waterfalls are incredibly beautiful, they aren't nearly as well known as many other waterfalls in the area. Seeing these three waterfalls in one hike is possible, but most visitors opt to break the trip into two shorter and easier hikes.

From an unmarked pull-off on National Park Drive, climb over the berm and you'll see an obvious trail leading into the woods. The first waterfall on Slateford Creek will soon come into view far down in the gorge. (It's possible to descend to stream level, but this is quite difficult and not recommended.) This waterfall is three tiers and roughly 15 feet in combined height. Continuing along this unmarked but well-worn trail for another 5–7 minutes will bring you to the largest waterfall on Slateford Creek. This 50-foot waterfall flows in a narrow stream before fanning out at the the base of the falls. The trail takes you right to the bottom of the falls, making it easy to really enjoy this beautiful spot.

To see the third waterfall on the creek, you can try to pick your way up the hill and continue above the second waterfall, but your better bet is to return to your car and drive 1 mile up the road to a second pull-off. From here, it's a short 2- to 3-minute hike downhill to the base of the uppermost falls on Slateford Creek. This 20-foot drop is located opposite a large, shallow pool. Note the remnants of an old dam just downstream of the falls.

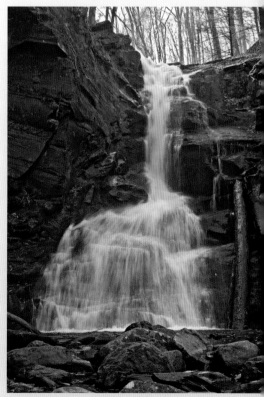

The tallest waterfall on Slateford Creek

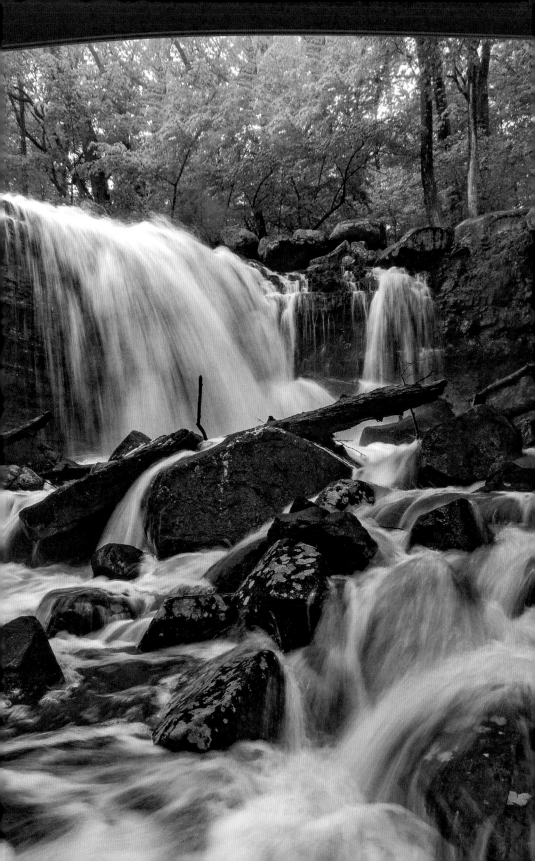

High Falls

LOCATION: Ringing Rocks County Park

ADDRESS/GPS FOR THE FALLS: 40.562222, -75.125944

DIRECTIONS: From Kintnersville, take PA 32 S. for 2 miles. Turn right on Narrows Hill Rd. After 0.4 mile, turn left onto Ringing Rocks Rd. The park entrance is 1 mile down the road on the left.

WEBSITE: www.buckscounty.org/government/parksandrecreation/parks/ringingrocks

WATERWAY: High Falls Creek

HEIGHT: 15 feet **CREST:** 30 feet

NEAREST TOWN: Kintnersville

HIKE DIFFICULTY: Easy

TRAIL QUALITY: Dirt trail through large boulders

ROUND-TRIP DISTANCE: 1 mile

TRIP REPORT & TIPS:

Despite being relatively small, High Falls is the tallest waterfall in Bucks County and in the entire Philadelphia metro area. Located inside Ringing Rocks County Park, this is actually a secondary attraction to the more famous and very odd Ringing Rocks. The park features a loop trail that runs past the waterfall, though the fastest way is to go and return along the same route. To reach the falls, follow the trail from the parking lot. When you reach an information sign and a split in the trail, head to the right and hike 5–7 minutes to the falls.

High Falls is seasonal and can dry up entirely during the drier months, so it's best to view it in the spring or after a heavy rain. This waterfall is unique in that its crest is a large slab of rock that slopes to one side. Even when the waterfall is flowing at its best, most of the crest is totally dry as the water is pushed to one side.

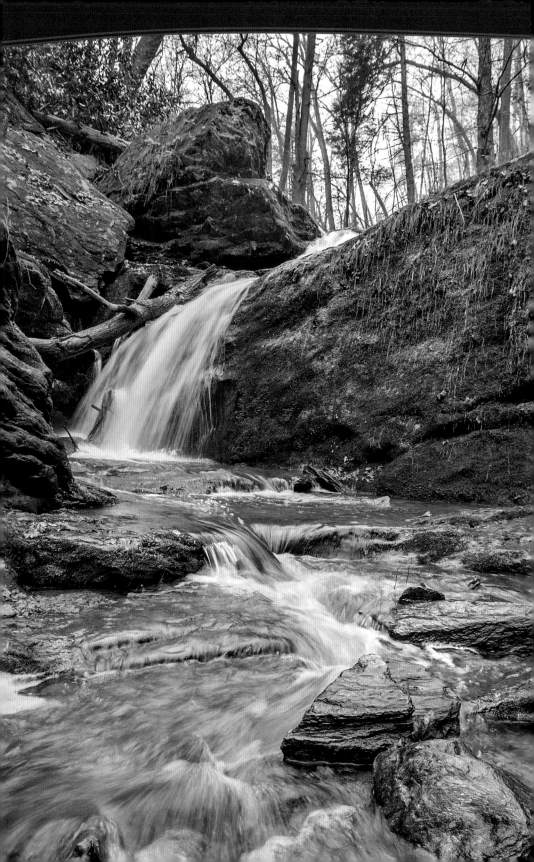

Mill Creek Falls

LOCATION: Holtwood Environmental Preserve

ADDRESS/GPS FOR THE FALLS: 39.818222, -76.336944

DIRECTIONS: From Old Pinnacle Rd./River Rd. in Holtwood, take PA 372 W. for 1.5 miles, crossing the Susquehanna River; then take the first right after the bridge onto River Rd. Park in the second, smaller parking area about 0.25 mile down the road on the right.

WEBSITE: www.uncoveringpa.com/mill-creek-falls-in-york-county

WATERWAY: Mill Creek

HEIGHT: 15 feet **CREST:** 3 feet

NEAREST TOWN: Holtwood

HIKE DIFFICULTY: Easy

TRAIL QUALITY: Walking along a dirt road and a blazed trail

ROUND-TRIP DISTANCE: 1.2 miles

TRIP REPORT & TIPS:

Small but scenic Mill Creek Falls is located along the nearly-200-mile Mason-Dixon Trail. Park in one of the lots for Lock 12, a historical site worth exploring, and continue down the dirt road. When you reach the first bridge on the road, cross it, and head upstream on the blue-blazed Mason-Dixon Trail. The waterfall is visible below the trail within a few hundred yards. This three-tiered waterfall features one larger drop and several smaller ones. Getting to creek level for a closer look is a challenging, but the falls can be easily seen from the trail.

A second 8-foot waterfall, 5 minutes farther along the trail, is worth taking the time to see. Beyond this, a nice vista overlooks the nearby dam for a few minutes farther along the trail.

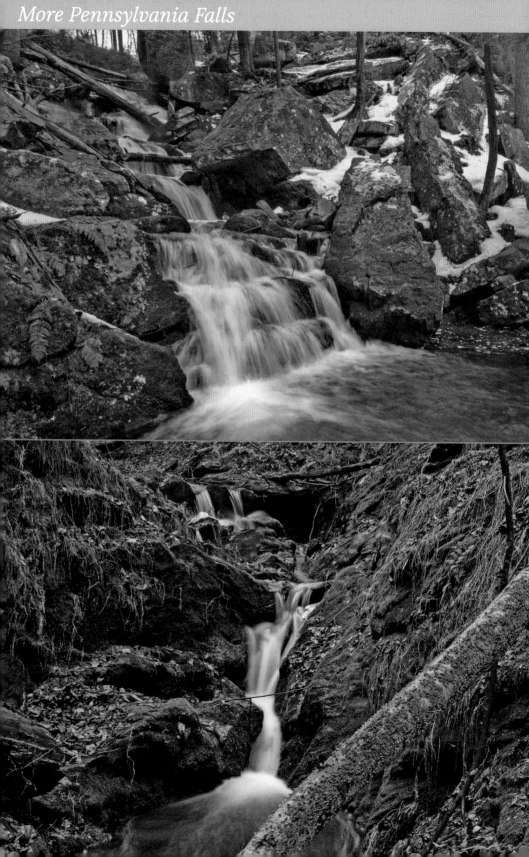

Aycrigg's Falls

LOCATION: Swatara State Park

ADDRESS/GPS FOR THE FALLS: 40.504250, -76.501833

DIRECTIONS: From Exit 100 off I-81, head west on PA 443. In 5.2 miles, turn left onto Sand Siding Rd., and take that 0.5 mile until it dead-ends at a parking area.

WEBSITE: www.dcnr.pa.gov/stateparks /findapark/swatarastatepark

WATERWAY: Unnamed

HEIGHT: 40 feet **CREST:** 3–5 feet

NEAREST TOWN: Fort Indiantown Gap

HIKE DIFFICULTY: Easy

TRAIL QUALITY: Wide and flat rail-trail

ROUND-TRIP DISTANCE: 3 miles

TRIP REPORT & TIPS:

Aycrigg's Falls is located along the Bear Hole Trail in Swatara State Park. This old road is now open only to hikers, bikers, and horses. Despite not being on the park map, this waterfall and Bordner's Cabin next to it are the park's highlights. The hand-built cabin is now a great resting spot adjacent to the falls. It should be noted that Aycrigg's Falls is seasonal, so it's best seen in the spring.

The fastest route to the falls is to park at the end of Sand Siding Road. Head to the right on the Swatara Rail Trail, and then take the first trail on your left to the bridge crossing of Swatara Creek. At the Bear Hole Trail, turn left and hike for 10 minutes to the cabin.

Duncan Falls

LOCATION: State Game Lands 181

ADDRESS/GPS FOR THE FALLS: 39.847972, -76.354083

DIRECTIONS: From Airville, drive 1 mile north on PA 74. Turn right onto E. Posey Rd., and drive 3.5 miles until it dead-ends at a parking area.

WEBSITE: None

WATERWAY: Duncan Run

HEIGHT: 15 feet **CREST:** 3 feet

NEAREST TOWN: Airville

HIKE DIFFICULTY: Strenuous

TRAIL QUALITY: An unmarked trail to the stream and then a bushwhack downstream with no trail

ROUND-TRIP DISTANCE: 1 mile

TRIP REPORT & TIPS:

Hidden deep in State Game Lands 181, Duncan Run drops 300 feet in elevation in its last 0.5 mile before it tumbles into the Susquehanna River. Starting the hike with your back to the road you came in on, take a worn trail to your left. Hike this until you reach the stream, and then carefully pick your way downstream.

There is no trail for the second half of this hike. Along the 0.3-mile streamside hike, there is an upper waterfall of 7 feet and a lower waterfall with three drops totaling about 15 feet. Just below this second waterfall is a third on private property, so please only enjoy it from above and don't cross the private-property markers.

Yost Run Falls and Kyler Fork Falls

Yost Run Falls and Kyler Fork Falls are two nearly identical waterfalls within sight of each other.

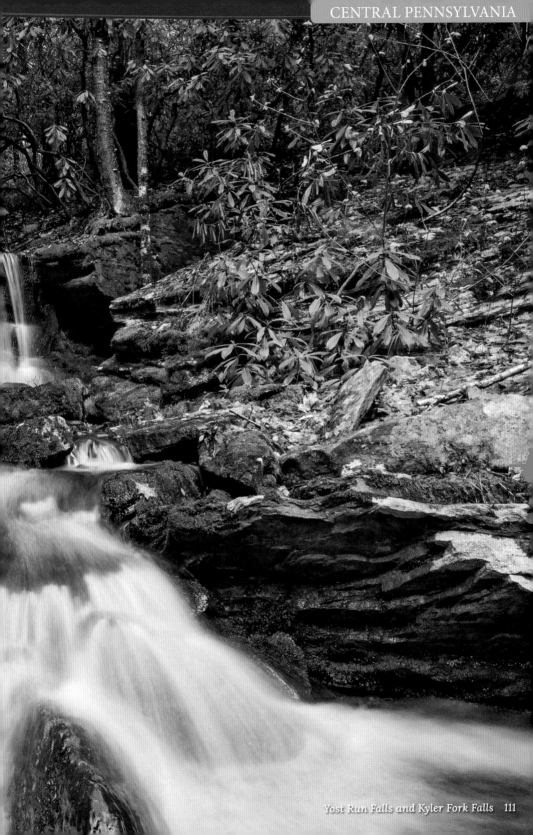

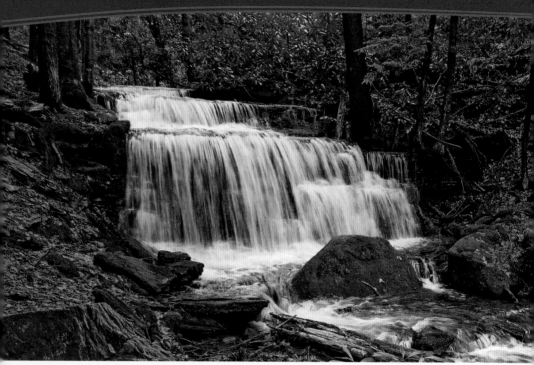

Yost Run Falls is located along the Chuck Keiper Trail.

Yost Run Falls and Kyler Fork Falls

A beautiful hike along the Chuck Keiper Trail brings you to these two small but beautiful waterfalls.

LOCATION: Sproul State Forest

ADDRESS/GPS FOR THE FALLS: 41.173889, -77.900611

DIRECTIONS: From Exit 147 off I-80, head west on PA 144 for 4 miles. In Moshannon, turn right to stay on PA 144 N., and continue for 13.8 miles. When you see a small sign for the Chuck Keiper Trail, turn left and park in the dirt lot.

WEBSITE: www.uncoveringpa.com/how-to-get-to-yost-run-falls-sproul-state-forest

WATERWAY: Yost Run and Kyler Fork

HEIGHT: 12–15 feet both **CREST:** 8–10 feet both

NEAREST TOWN: Renovo

HIKE DIFFICULTY: Moderate

TRAIL QUALITY: Good, with about 500 feet of elevation change along a forest road and a well-maintained trail

ROUND-TRIP DISTANCE: 3 miles

TRIP REPORT & TIPS:

Yost Run Falls and Kyler Fork Falls are located within about 100 yards of each other in northern Centre County along the 53-mile Chuck Keiper Trail. From the parking area along PA 144, it's about a 1.5-mile hike to these two beautiful waterfalls.

From the parking area, follow the well-defined gravel road away from PA 144. After hiking for a couple of minutes, you'll come to a split in the trail. Straight ahead is a rusty brown gate, and to your left is a yellow-and-black gate—head left to follow the road past the yellow-and-black gate.

Continue following this road for around 1 mile. You'll pass a hunting camp about halfway down and a second camp adjacent to Yost Run. Note that these hunting camps are privately owned: please do not approach the cabins, and stay on the public road.

At the second camp, turn right to follow the small but well-defined trail downstream for the rest of the hike to Yost Run Falls and Kyler Fork Falls.

While Yost Run Falls isn't a large waterfall, only about 12–15 feet tall, it makes up for it in sheer beauty. Honestly, this is one of the prettiest waterfalls I've seen in Pennsylvania. I just love the way the water cascades directly off the falls in a near-perfect stream. Surrounding the waterfall are a beautiful forest and moss-covered rocks.

There are many different angles from which to view and photograph this waterfall, including both banks and in the middle of the stream. In fact, it's kind of hard to take a bad photo of this waterfall.

To see Kyler Fork Falls, continue down the trail 100 yards farther. Although it's visible from the Chuck Keiper Trail, you must cross Yost Run to get a closer look. Note that it might be impossible to cross the stream without getting your feet wet, depending on when you visit.

I always find it both interesting and odd how much Kyler Fork Falls looks like Yost Run Falls, even though they're on two different waterways.

Round Island Run Falls

Round Island Run Falls is one of the most remote waterfalls in Pennsylvania.

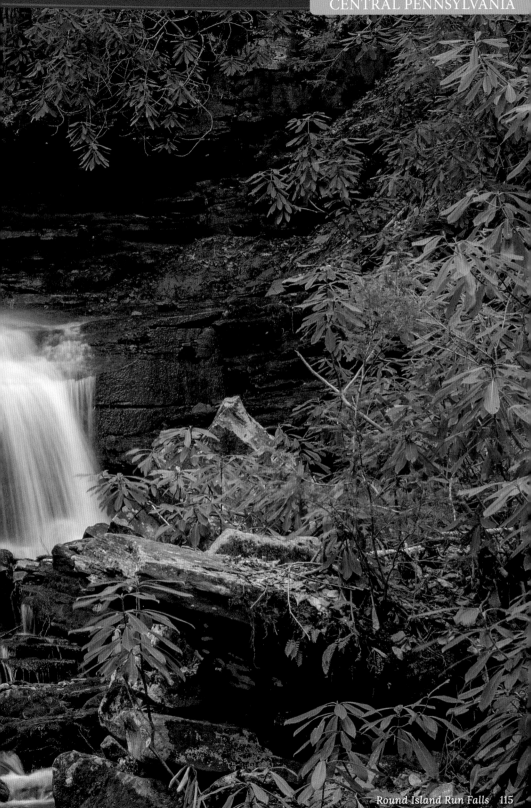

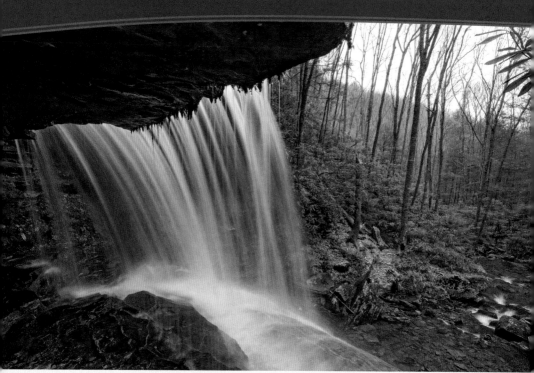

It's possible to go behind the uppermost drop at Round Island Run Falls.

Round Island Run Falls

The three drops here create an amazingly beautiful scene.

LOCATION: Sproul State Forest

ADDRESS/GPS FOR THE FALLS: 41.271806, -78.005944

DIRECTIONS: From Karthaus, head north on Quehanna Hwy. for 2.7 miles. Turn right onto Pottersdale Rd., drive 5.5 miles, and turn left onto Keating Mountain Rd. Travel for 2.25 miles, and turn left onto Dutchman Rd. After 1.7 miles, turn right onto Round Island Ridge Rd. In 2.2 miles, park in the large power-line clearing.

WEBSITE: www.uncoveringpa.com/round-island-run-falls

WATERWAY: Round Island Run

HEIGHT: 20–25 feet **CREST:** 6–8 feet

NEAREST TOWN: Karthaus

HIKE DIFFICULTY: Strenuous

TRAIL QUALITY: Steep but good-quality dirt trail

ROUND-TRIP DISTANCE: 2.4 miles

TRIP REPORT & TIPS:

Few waterfalls in Pennsylvania are more remote than Round Island Run Falls—not because it's especially hard to hike to the falls, but because of the driving distance involved. Nevertheless, this is a fantastic spot to visit.

This hike is listed as difficult because of two steep hill climbs/descents that are required to see the falls. Other than these two spots, the trail is easy to moderate.

From the parking area under the power lines, head west (to the left if facing away from the direction you came in). Walk on the right side of the power lines, past a yellow gate, and follow an ATV trail along the edge of the woods.

The trail crosses a small stream and goes up and back down a small hill. This portion of the trail can get quite soggy, so be prepared to get your feet wet.

In 0.4 mile, you'll reach the top of a steep, rocky hill. At the bottom of this hill, you'll find Round Island Run. At the stream, take the obvious trail to the right. Follow this trail for 0.5 mile as it passes through an incredibly beautiful forest and along this scenic waterway.

After 0.5 mile, you should be able to hear Round Island Run Falls off to your left. The narrow trail to the falls is marked with a rope strung up to a tree on the left side of the trail you're currently following. Carefully make your way down to the base of the hillside, where you'll find Round Island Run Falls.

Round Island Run Falls features three beautiful drops. Two are part of the main falls, and the third is just a few feet downstream. For obvious reasons, this waterfall is also called Three Falls.

It's possible to get behind the uppermost tier of the falls for an interesting look behind the veil of the falls. If you do this, use extreme caution: the rocks can be slippery, and a fall would send you 10 feet into the water below.

While driving and hiking to the falls, keep your eyes out for Pennsylvania's famous elk herd. While I've never seen elk here myself, I've heard from other visitors to the falls that they are commonly seen in the area.

Note that some routes to Round Island Run Falls take you via Three Runs Road off Quehanna Highway—a portion of this roadway is heavily rutted and can be difficult to drive, even in a high-clearance vehicle. The route listed on the opposite page (see Directions) avoids this portion of roadway.

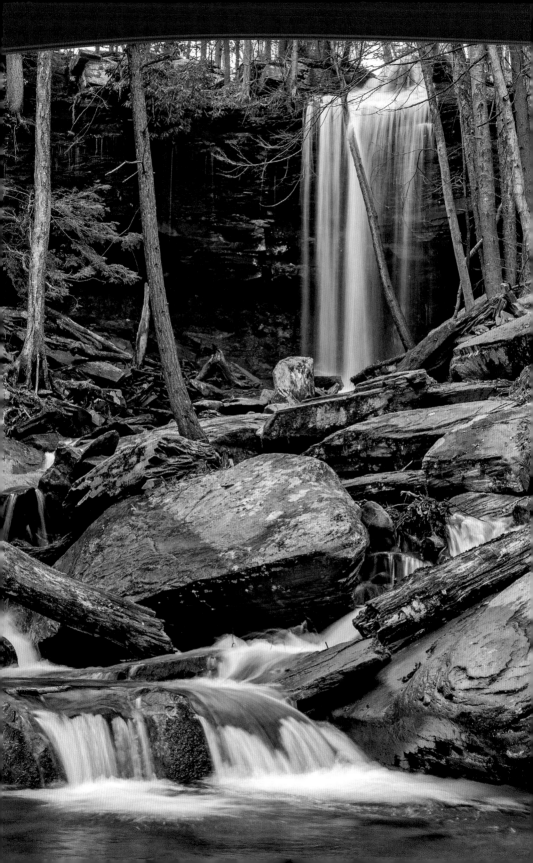

Jacoby Falls

LOCATION: Loyalsock State Forest

ADDRESS/GPS FOR THE FALLS: 41.390056, -76.901444

DIRECTIONS: From Exit 21 off I-180, head north on PA 87 for 4.5 miles. Turn left onto PA 973 W., and then take an immediate right onto Wallis Run Rd. Follow this for 4.3 miles to the parking area, on your right.

WEBSITE: www.uncoveringpa.com/jacoby-falls-loyalsock-state-forest

WATERWAY: Jacoby Hollow Run

HEIGHT: 29 feet **CREST:** 8–10 feet

NEAREST TOWN: Montoursville

HIKE DIFFICULTY: Easy

TRAIL QUALITY: A mixture of obvious but often muddy trails and walking along a pipeline

ROUND-TRIP DISTANCE: 3.2 miles

TRIP REPORT & TIPS:

Jacoby Falls is one of those waterfalls that will either look spectacular when you visit them or be completely dry—there really doesn't seem to be any in between. That's because Jacoby Falls frequently has very little water flowing over its edge. But if you can catch this waterfall after a heavy rain or during the spring thaw, it's truly one of the most beautiful waterfalls in Pennsylvania.

The yellow-blazed Jacoby Falls Trail is relatively easy to follow for most of its route. The trail ascends 400 feet through undulating woods on its way to the falls. Along the way, the trail crosses one stream and several other areas that are often quite wet and muddy.

Roughly two-thirds of the way into the hike, the trail connects with a pipeline roadway and follows the pipeline to the left.

After walking along the roadway for a short distance, you'll come to a yellow aerial marker that reads 095. At this point, look to your left to see the yellow-blazed Jacoby Falls Trail again. Break from the roadway, and stay on the left-hand bank of Jacoby Hollow Run for the short distance up to the base of the waterfall.

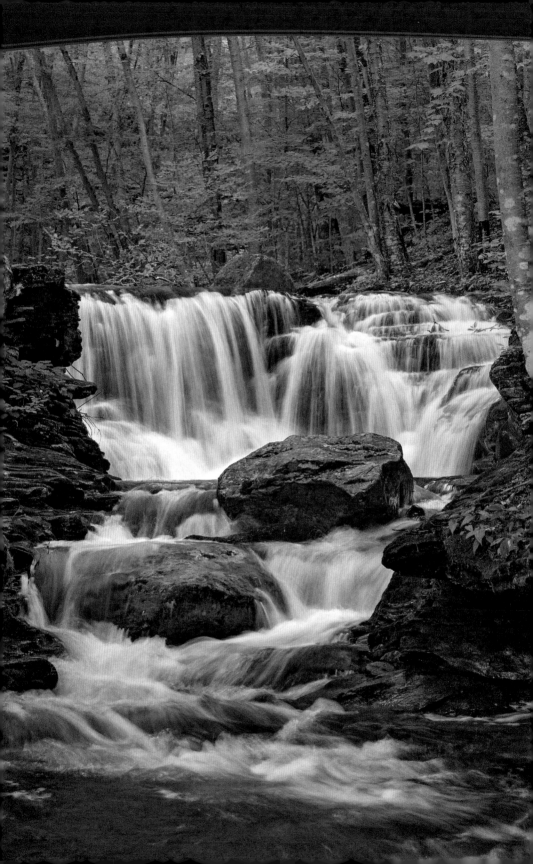

Miners Run Falls

LOCATION: McIntyre Wild Area, Loyalsock State Forest

ADDRESS/GPS FOR THE FALLS: 41.516083, -76.916694

DIRECTIONS: From US 15 north of Williamsport, exit onto PA 14 N., and drive 11 miles. Turn right onto Thompson St. in the community of Ralston, and follow that across the bridge over Lycoming Creek. Stay right at the fork to continue on Rock Run Rd., and in 1.7 miles park in a small area just before the first bridge.

WEBSITE: www.uncoveringpa.com/miners-run-waterfalls

WATERWAY: Miners Run

HEIGHT: 5–40 feet **CREST:** 3–15 feet

NEAREST TOWN: Ralston

HIKE DIFFICULTY: Very strenuous

TRAIL QUALITY: While the first waterfall can be seen from the road, the rest require a 0.5-mile off-trail hike up the streambed; an overgrown and unmarked trail makes the return trip easier

ROUND-TRIP DISTANCE: 1 mile

TRIP REPORT & TIPS:

There are at least seven waterfalls on Miners Run; of these, six are upstream of the bridge that carries Rock Run Road over the creek, while one is just downstream. These seven waterfalls all occur within less than 0.5 mile of the road. There is no trail that will take you up Miners Run—meaning that a trip to see the waterfalls on the creek requires hiking directly up the streambed.

If you opt to tackle this trail, I recommended that you do so with a friend. To reach the waterfalls, simply hike directly up the streambed and banks, picking the side that is most navigable on the given day that you're hiking.

Keep in mind that in addition to getting your feet wet, you'll have to climb steep banks around waterfalls, including some that are up to 40 feet tall.

Once you reach the sixth waterfall, you'll see a trail on your right (when looking upstream). While unblazed and very overgrown in places, this trail is easy enough to follow back downstream to your car.

If off-trail hiking isn't your thing, the first waterfall on Miners Run is visible from Rock Run Road.

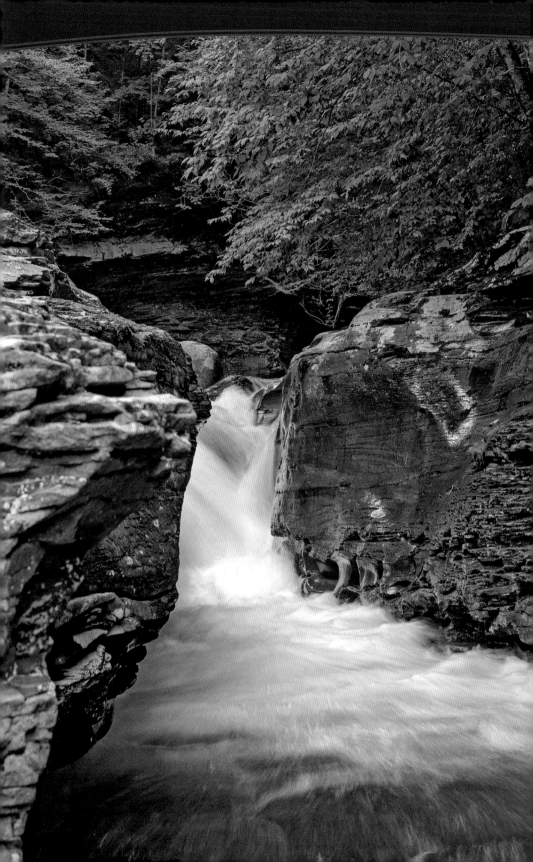

Rock Run Falls

LOCATION: Loyalsock State Forest

ADDRESS/GPS FOR THE FALLS: Upper Falls, 41.522222, -76.906556; Lower Falls, 41.517611, -76.913083

DIRECTIONS: From US 15 north of Williamsport, exit onto PA 14 N., and drive 11 miles. Turn right onto Thompson St. in the community of Ralston, and follow that across the bridge over Lycoming Creek. Stay right at the fork to continue on Rock Run Rd., and in 1.7 miles park in a small area just before the first bridge. Walk 0.1 mile farther down the road, and take the trail on the right down to the Lower Falls. To see the Upper Falls, continue 0.6 mile farther down the road, and follow the path on the right down to the falls.

WEBSITE: www.uncoveringpa.com/rock-run-pa

WATERWAY: Rock Run

HEIGHT: 8–10 feet **CREST:** 3–5 feet

NEAREST TOWN: Ralston

HIKE DIFFICULTY: Easy

TRAIL QUALITY: Unmarked but easy-to-follow trails

ROUND-TRIP DISTANCE: Less than 0.5 mile combined

TRIP REPORT & TIPS:

Considered by many to be the most beautiful waterway in Pennsylvania, Rock Run carves a series of narrow chutes through the bedrock with its crystal-clear waters.

In this area, two small but beautiful waterfalls can be seen via two short trails down from Rock Run Road to the stream. Neither trail is marked, but both are obvious and lead directly to the falls.

Lower Falls is the smaller but more impressive of the two waterfalls. While it's only about 8 feet tall, watching water crash through the narrow flume it has carved in the rock is impressive. Below the waterfall is an incredibly clear pool.

About 0.5 mile upstream of Lower Falls, Upper Falls requires a slightly longer hike to reach, though it's still less than 0.5 mile round-trip. The trail, unmarked but obvious, passes a storage building of some kind. Upper Falls is about 10 feet tall and slightly wider than Lower Falls. There are views of this waterfall both adjacent to it and from the rock walls surrounding the stream.

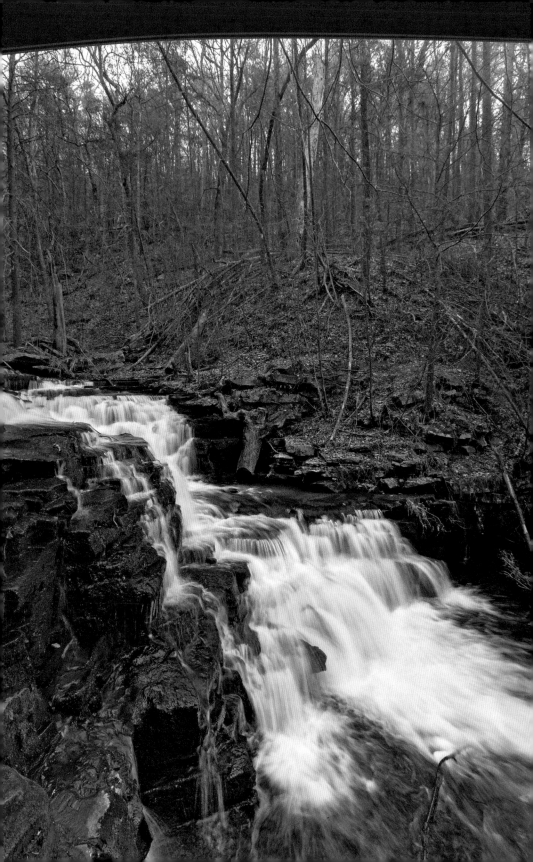

Jarrett Falls

LOCATION: State Game Lands 53

ADDRESS/GPS FOR THE FALLS: 39.886528, -78.062694

DIRECTIONS: Head west out of McConnellsburg on Lincoln Way W. After 1 mile, turn left onto Back Run Rd. After another mile, turn right onto Meadow Ground Rd. Go 1.7 miles, and then turn left onto Mountain Dr. Follow Mountain Dr. until it dead-ends near the old dam.

WEBSITE: www.uncoveringpa.com/how-to-get-to-jarrett-falls-near-mcconnellsburg

WATERWAY: Roaring Run

HEIGHT: 15 feet **CREST:** 6–8 feet

NEAREST TOWN: McConnellsburg

HIKE DIFFICULTY: Moderate

TRAIL QUALITY: Relatively flat but overgrown in places; two wet stream crossings required

ROUND-TRIP DISTANCE: 3.6 miles

TRIP REPORT & TIPS:

Jarrett Falls, located on state game lands near McConnellsburg, is little known, even to many locals. This means that the trail can be overgrown in places, but it's still a great hike to a beautiful waterfall.

After parking your car, cross to the dam's western side. Even though the lake is nearly completely empty, there's still some water at the base of the dam.

Just as you are coming to the flood spillway, you'll see a marker for the Jarrett Trail. Turn left and soon cross over the spillway; then continue hiking down the trail. In places, you may see red blazes on trees, but these are intermittent enough to not provide much help while you navigate the trail.

After approximately 0.5 mile of hiking, you'll come to a large clearing in the woods and a narrow footbridge over a feeder stream. At the clearing, turn left and cross the bridge over Roaring Run. Head back into the woods on the left bank of the stream.

From here, the trail is easy to follow, but be aware that it includes one bridge crossing and two wet stream crossings—you're unlikely to avoid getting your feet wet on this hike. The trail ends at the top of Jarrett Falls.

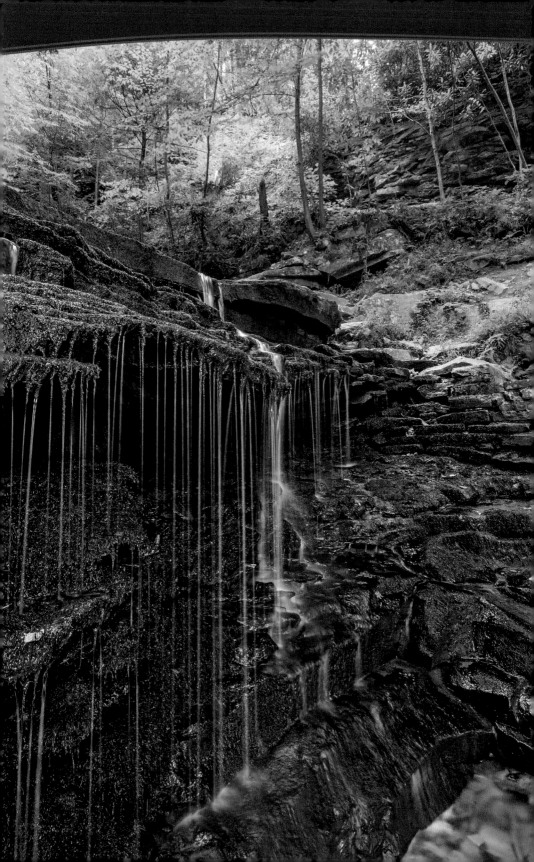

Rainbow Falls

LOCATION: Trough Creek State Park

ADDRESS/GPS FOR THE FALLS: 40.322306, -78.131056

DIRECTIONS: Take PA 26 S. out of Huntingdon, and travel for 15.5 miles. Turn left onto PA 994 E., and travel for 5.2 miles; then turn left onto SR 3031. After 1.7 miles, turn left onto Trough Creek Dr., and go 1.8 miles. Parking will be on your left.

WEBSITE: www.dcnr.pa.gov/stateparks/findapark/troughcreekstatepark

WATERWAY: Abbot Run

HEIGHT: 20 feet **CREST:** 5 feet

NEAREST TOWN: Huntingdon

HIKE DIFFICULTY: Easy

TRAIL QUALITY: A wide trail crosses Trough Creek on a swinging bridge

ROUND-TRIP DISTANCE: 0.5 mile

TRIP REPORT & TIPS:

Rainbow Falls is a fantastic spot in Trough Creek State Park. The waterfall is located along the Balanced Rock Trail, roughly 0.25 mile from the road. To reach it, park in the small lot adjacent to the trailhead. Shortly after you start hiking, you'll cross Trough Creek on a very cool swinging bridge.

Once across the bridge, turn right and follow the trail downstream for 2–3 minutes until you come to Rainbow Falls.

Rainbow Falls is series of slides and small drops that cascade down the hill, under the bridge, and directly into Trough Creek. Note that this waterfall can be seasonal and is best seen during periods of high water.

After seeing Rainbow Falls, I highly recommend following the Balanced Rock Trail the short distance to the top of the hill to see the wondrous Balanced Rock, a giant boulder somehow hanging on to the edge of the cliff.

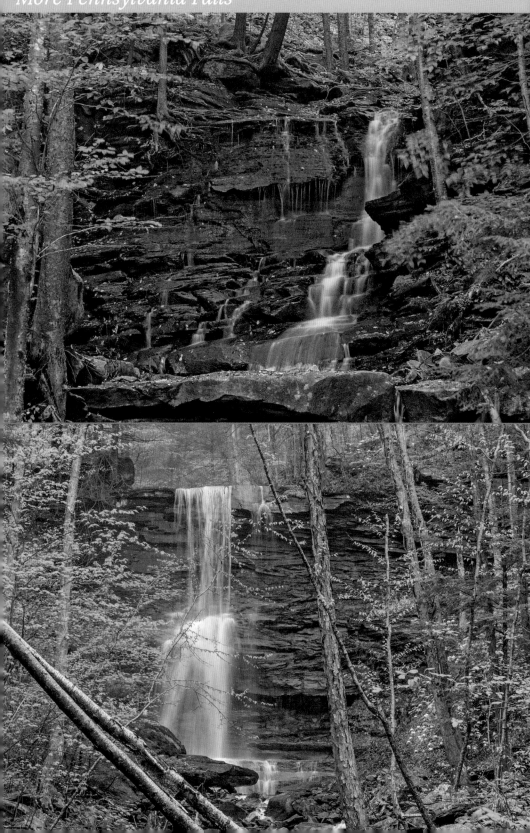

Hound Run Falls

LOCATION: McIntyre Wild Area, Loyalsock State Forest

ADDRESS/GPS FOR THE FALLS: 41.537111, -76.898139

DIRECTIONS: From US 15 north of Williamsport, exit onto PA 14 N., and drive 11 miles. Turn right onto Thompson St. in the community of Ralston, and follow that across the bridge over Lycoming Creek. Stay right at the fork to continue on Rock Run Rd. After 3.4 miles, park in a small area just before the second bridge you come to along Rock Run Rd.

WEBSITE: www.uncoveringpa.com/how-get-hounds-run-falls-mcintyre-wild-area

WATERWAY: Hound Run

HEIGHT: 40 feet **CREST:** 3–5 feet

NEAREST TOWN: Ralston

HIKE DIFFICULTY: Strenuous

TRAIL QUALITY: There is no trail—you pick your way upstream, walking through the water to the base of the falls.

ROUND-TRIP DISTANCE: 0.75 mile

TRIP REPORT & TIPS:

While there is only one waterfall of note on Hound Run, it's one of the most impressive in the region.

From the parking area, simply head upstream, picking your way through the stream and along the banks at the spots that seem safest to you. About halfway to the falls, you'll encounter a small 5-foot waterfall that must be climbed over, but otherwise the hike is fairly straightforward.

After about 0.3 mile, Hound Run Falls comes into view. You can hike to the base and enjoy the spray from a close distance.

Dutchman Run Falls

LOCATION: McIntyre Wild Area, Loyalsock State Forest

ADDRESS/GPS FOR THE FALLS: 41.525167, -76.948944

DIRECTIONS: From US 15 north of Williamsport, exit onto PA 14 N., and drive 11 miles. Turn right onto Thompson St. in Ralston, and follow it across the bridge over Lycoming Creek. Then park in the dirt area on the left side of the road.

WEBSITE: www.uncoveringpa.com/dutchman-run-falls-mcintyre-wild-area

WATERWAY: Dutchman Run

HEIGHT: 25–30 feet **CREST:** 5–8 feet

NEAREST TOWN: Ralston

HIKE DIFFICULTY: Strenuous

TRAIL QUALITY: Overgrown dirt trails and off-trail hiking

ROUND-TRIP DISTANCE: 3 miles

TRIP REPORT & TIPS:

This hike takes you past remnants of the region's mining past. From the parking area, follow the old grade to the left away from the road. The trail, overgrown but obvious, follows Lycoming Creek. After 0.5 mile, power lines intersect the trail, which becomes more overgrown—pick your way along the power lines as best you can.

The trail then skirts the edge of the state forest, coming within a few dozen yards of a home on its way through the woods.

About 1 mile into the hike, pass through a clearing and continue into the woods a short distance. Eventually, you'll come to Dutchman Run. From here, pick your way as best you can upstream for about 0.25 mile to the base of Dutchman Run Falls.

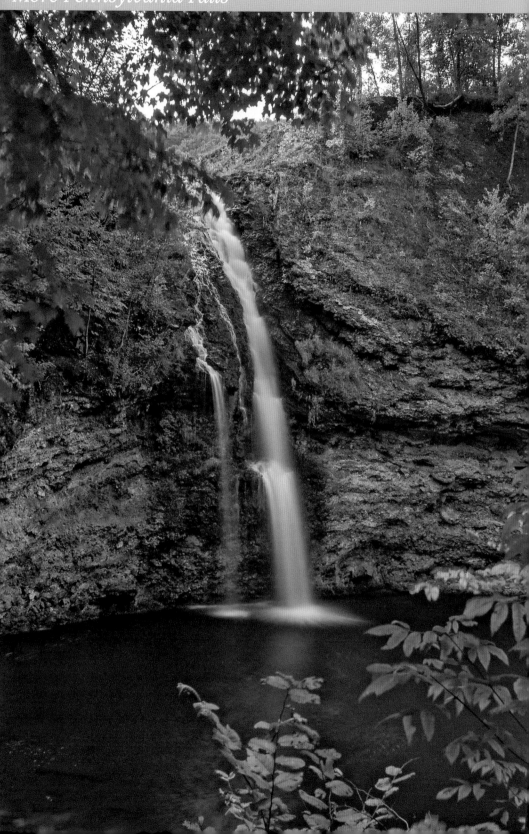

Hinckston Run Falls

LOCATION: Roadside north of Johnstown

ADDRESS/GPS FOR THE FALLS: 40.371194, -78.890694

DIRECTIONS: From Roosevelt Blvd./Power St. in Johnstown, take 4th Ave. northeast across the Conemaugh River. In 0.1 mile, turn left onto Iron St.; in another 0.1 mile, bear right at the fork onto Middle Taylor Rd., which becomes Benshoff Hill Rd. In 2.5 miles, turn right onto Waterfall Dr., and continue for 2 miles until the road makes a 90-degree left turn at the waterfall.

WEBSITE: www.uncoveringpa.com/hinkston-run -falls-johnstown-pennsylvania

WATERWAY: Hinckston Run

HEIGHT: 60 feet **CREST:** 6–8 feet

NEAREST TOWN: Johnstown

HIKE DIFFICULTY: NA

TRAIL QUALITY: NA

ROUND-TRIP DISTANCE: Roadside

TRIP REPORT & TIPS:

Hinckston Run Falls, located a short drive from downtown Johnstown, is one of the tallest waterfalls in the western half of the state. While it appears natural, this waterfall is actually man-made, having been created when the lake above was dammed in 1904. That said, the cliff face is natural and the waterfall beautiful.

The land around the waterfall is owned by the local water company, so it can be viewed only from the dirt road that runs adjacent to the falls. Fortunately, this road is not only lightly trafficked, but it's also likely the best viewing area for the falls even if you could access the surrounding land.

The water of Hinckston Run Falls drops into a beautiful pool, and its dark-green coloration really stands out in photos, especially in contrast with the white waterfall and dark rock walls behind it.

Waterfalls of
Little Fourmile Run

The waterfalls of Little Fourmile Run tumble down the walls of the Pennsylvania Grand Canyon.

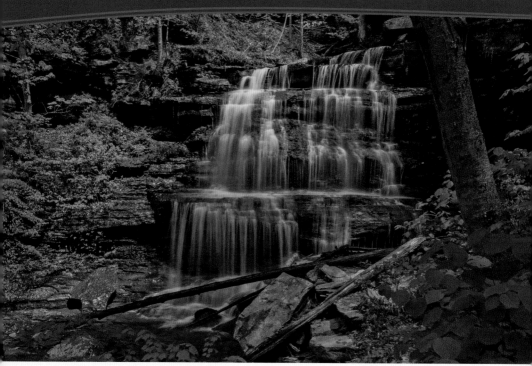

The hike to the waterfalls on Fourmile Run is tough but worth the effort.

Waterfalls of Little Fourmile Run

The trail is very steep, but it's worth it to see these three beautiful waterfalls.

LOCATION: Leonard Harrison State Park

ADDRESS/GPS FOR THE FALLS: 41.699444, -77.456306

DIRECTIONS: From Wellsboro, head west out of town on PA 660. After 2.5 miles, turn left to stay on PA 660. In 7.5 miles, the road will end in the parking area for the state park.

WEBSITE: www.dcnr.pa.gov/stateparks/findapark/leonardharrisonstatepark

WATERWAY: Little Fourmile Run

HEIGHT: 10–30 feet **CREST:** 5–10 feet

NEAREST TOWN: Wellsboro

HIKE DIFFICULTY: Strenuous

TRAIL QUALITY: Well-maintained dirt trail and wooden steps

ROUND-TRIP DISTANCE: 2 miles

TRIP REPORT & TIPS:

The Pennsylvania Grand Canyon is home to many waterfalls, most of which are all but inaccessible. The three waterfalls along the Turkey Path in Leonard Harrison State Park are among the easiest to reach, though a rather steep hike to the base of the canyon is required to see them.

From the parking area, head toward the end of the road and the visitor center for the park. Just beyond this, an observation area provides amazing views of the canyon, which is officially known as Pine Creek Gorge. At this point, you're 800 feet above the canyon floor, and a 1-mile hike to the bottom is required to see the waterfalls along the trail.

Once you're done enjoying the view, head to the far-right corner of the viewing area. A large sign denotes this as the start of the Turkey Path. The first half of this trail winds it way through the forested hillside along a series of steep switchbacks. While they aren't too challenging to descend, coming back up is another story.

After approximately 0.5 mile of hiking, Little Fourmile Run comes into view, and the trail becomes primarily a series of wooden steps and viewing platforms for the rest of the way down to the base of the canyon.

Soon, the first and tallest waterfall on Little Fourmile Run comes into view. This 25- to 30-foot-tall waterfall is, in my opinion, the most beautiful of the falls along the waterway. A small viewing platform adjacent to the falls affords great views.

Just before coming to the base of the canyon, you'll come to the final waterfall on Little Fourmile Run. Depending on how you look at it, this is either one double-drop waterfall of about 20 feet or two waterfalls that are each about 10 feet tall. Either way, they're incredibly scenic when flowing well.

Because you're nearly at the base of the Pennsylvania Grand Canyon at this point, it's worth the few extra steps to officially reach the bottom. The trail at the bottom is the Pine Creek Rail Trail, an incredibly scenic 65-mile biking and walking trail along which you'll find several other waterfalls in this guide.

Unfortunately, the only way to return to your car is the difficult hike back up to the rim of the canyon. While the trail is well maintained, make sure to take your time on this steep hike.

Jerry Falls and Bohen Falls

The hike to these two waterfalls is one of the best in the Pennsylvania Grand Canyon.

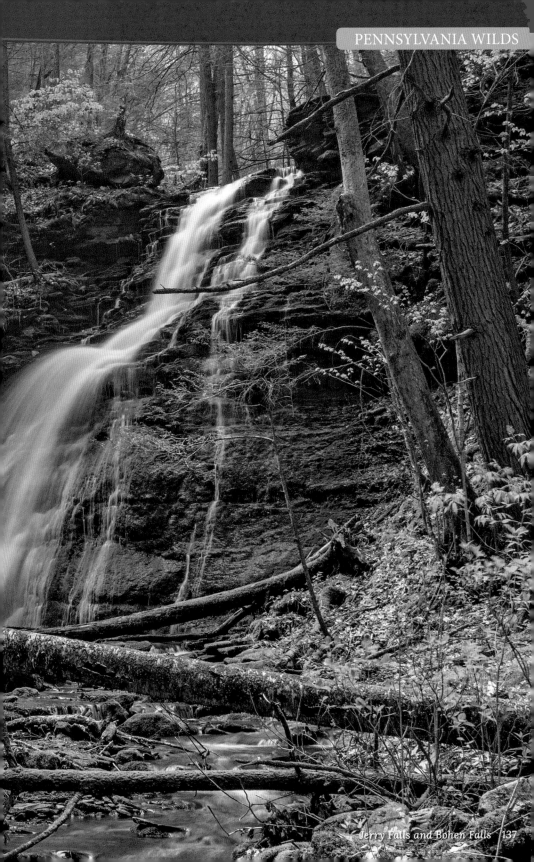

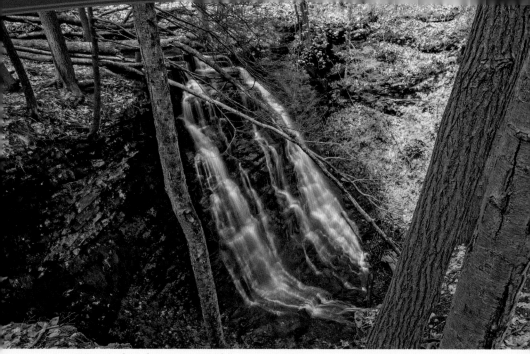

Jerry Falls is the first of two great waterfalls along this hike.

Jerry Falls and Bohen Falls

Jerry Falls is located along the trail, while Bohen Falls requires some off-trail hiking.

LOCATION: Tioga State Forest

ADDRESS/GPS FOR THE FALLS: Jerry Falls, 41.566611, -77.387306; Bohen Falls, 41.573833, -77.388167

DIRECTIONS: From US 15 in Liberty, take PA 414 W. for 9.7 miles. Turn left to stay on PA 414, and in 0.7 mile take a slight right turn to once again stay on PA 414. In 5.3 miles, park in the lot on your left just before crossing Pine Creek.

WEBSITE: www.uncoveringpa.com/bohen-falls-trail

WATERWAYS: Jerry Run and Bohen Run

HEIGHT: 25–30 feet **CREST:** 4–6 feet

NEAREST TOWN: Slate Run

HIKE DIFFICULTY: Strenuous

TRAIL QUALITY: A combination of dirt trails and off-trail hiking

ROUND-TRIP DISTANCE: 3.8 miles

TRIP REPORT & TIPS:

Jerry Falls and Bohen Falls are two incredible waterfalls located on the western rim of the Pennsylvania Grand Canyon near Blackwell. While Jerry Falls is directly along the trail, Bohen Falls requires a bit of off-trail hiking along the banks of Bohen Run to see.

From the parking area, cross the bridge over Pine Creek. The road is lightly trafficked, but use caution as there's no sidewalk on the bridge. Once across the bridge, look to your right. You should see a sign for the Bohen Trail on the opposite side of the guardrail. Cross the guardrail and head up the trail.

Once the trail enters the woods, it starts a steep climb up the hillside. In total, the trail climbs about 300 feet in the next 0.3 mile. The trail here is quite narrow, with a rather steep slope toward Pine Creek to your right. Use caution when hiking here, especially if you have children with you.

It's also worth noting that this portion of the trail is somewhat prone to landslides and is closed for repairs from time to time.

About 0.67 mile into the hike, the trail crosses a normally dry streambed and then passes a nice rock outcrop at about 0.9 mile.

Jerry Falls is located approximately 1.1 miles from the parking area. This is a 20- to 25-foot-tall waterfall with a crest of approximately 5 feet.

The best viewing area is about 20 feet off-trail, along the rocks overlooking the falls. Use extreme care if you approach the edge of the rocks, as it's a 30-foot sheer drop here.

To continue, cross Jerry Run just above the falls (using extreme caution if water levels are high).

The trail then briefly climbs before starting to head downhill. About 0.3 mile after Jerry Falls, you'll see double yellow blazes on a tree, immediately followed by the trail making a 90-degree turn to the left and heading uphill.

Instead, head straight and then down toward Pine Creek at an angle. A light trail with intermittent blue blazes can be hard to find, but if you keep heading down toward the creek at a diagonal, you should be able to pick it up rather quickly.

TRIP REPORT CONTINUED: Once the trail reaches creek level, it follows upstream near the waterway and past two beautiful campsites. After the second campsite, again ignore the turn in the main trail, and follow a trail straight along the creek. In about 100 yards, you'll come to a third campsite at the confluence of Pine Creek and Bohen Run.

From here, simply head upstream along the left bank of Bohen Run for about 0.15 mile to the base of Bohen Falls. Use caution while creek-walking, as the rocks and banks can be slippery. Sometimes, walking directly in the creek may be the best way to reach the falls.

Bohen Falls is a 30-foot waterfall that has created a beautiful hollow. This is a fantastically beautiful spot, and it's easy to while away the day away just enjoying time here.

To return to your vehicle, simply retrace your steps. The trail split where you rejoin the Bohen Trail can be easy to miss, so be especially careful to return to that trail's yellow blazes.

The trail to Bohen Falls offers great views of the Pennsylvania Grand Canyon.

Sand Run Falls

Reaching Sand Run Falls requires a long hike along the popular Mid State Trail.

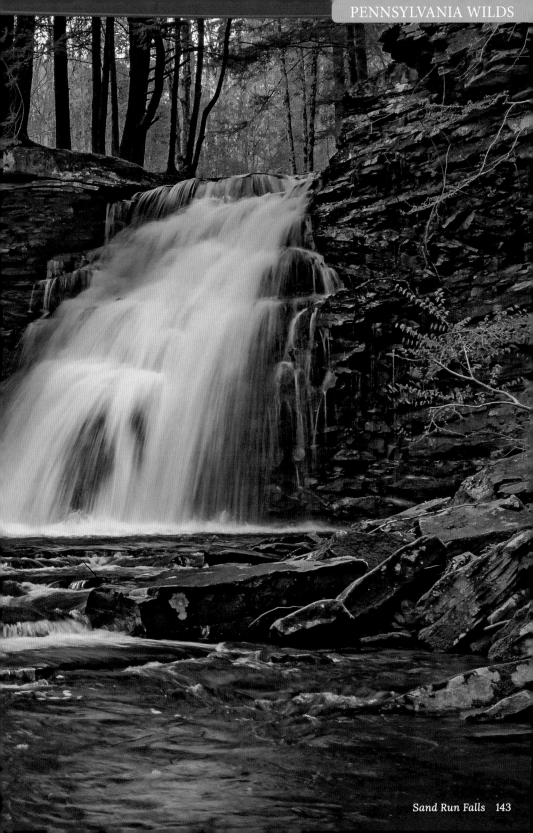

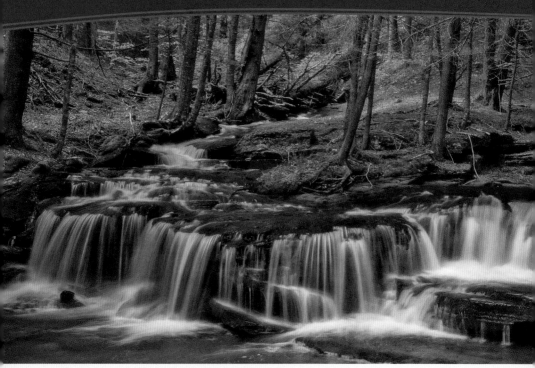

There are several other waterfalls near Sand Run Falls.

Sand Run Falls

When Sand Run Falls is flowing well, there are three other nearby waterfalls worth exploring.

LOCATION: Tioga State Forest

ADDRESS/GPS FOR THE FALLS: 41.661833, -77.194000

DIRECTIONS: Take Exit 172 off US 15 in Blossburg. From the exits, take a left (south-bound) or a right (northbound) onto Boone Run Rd.; then, when you see the gas station on your right, turn right onto Bloss Mountain Rd. In 1.4 miles, turn right again onto Arnot Rd. In 2.2 miles, bear right at the fork onto SR 2016. In 1.9 miles, turn left into the parking area, signed SAND RUN FALLS HIKING & SKI TRAIL. Park at the end of the short dirt road.

WEBSITE: www.uncoveringpa.com/hiking-sand-run-falls-tioga-county

WATERWAY: Sand Run

HEIGHT: 25 feet **CREST:** 8–10 feet

NEAREST TOWN: Blossburg

HIKE DIFFICULTY: Moderate

TRAIL QUALITY: Good-quality dirt trail to falls, tricky descent to base

ROUND-TRIP DISTANCE: 6 miles

TRIP REPORT & TIPS:

Sand Run Falls is located near the small community of Arnot in Tioga State Forest. This beautiful waterfall, roughly 25 feet tall, is set far from any road. But despite the 6-mile round-trip hike needed to see it, it's a popular location for hikers, photographers, and fishermen.

There are a few ways to hike to Sand Run Falls, but the easiest is along the Mid State Trail. This trail, which runs 325 miles across Pennsylvania, passes directly next to the parking area for Sand Run Falls.

To get to the waterfall, you'll be hiking on this orange-blazed trail for approximately 3 miles. Along the way, the trail passes through a beautiful forest. You may also encounter areas of the trail that are quite boggy. While this makes the hike a bit more of a challenge, it's also a good sign, as this means that the waterfalls at the end are flowing nicely.

After hiking for about 3 miles, you'll come to a turn in the trail. At this point, a sign points to the right toward the waterfall.

From this split in the trail, it's a short distance to the top of Sand Run Falls. It's possible to enjoy a nice view of Sand Run Falls from this vantage point, but the best views are from stream level. To be honest, there's no easy way to get to the bottom of the creek, as all options are rather steep. It's best to simply choose the point that looks best to you on the day you visit and carefully make your way down to the creek.

Sand Run Falls is located about 100 yards upstream of where Sand Run meets Babb Run. During times of high water, these can both be impressive waterways. Unfortunately, to get a close look at Sand Run Falls, a stream crossing is required. During times of low water, it's probably possible to do a dry crossing, but if you're visiting when the waterfall is flowing well, it's inevitable that your feet will get wet.

Since you've taken the time to hike to Sand Run Falls, there are several other nearby waterfalls that are worth checking out if the main falls is flowing well.

The first is just around the corner from Sand Run Falls. An unnamed stream enters Babb Run just a few yards downstream from its confluence with Sand Run. Less than 100 feet up this waterway is a small, 10-foot waterfall that can be quite photogenic.

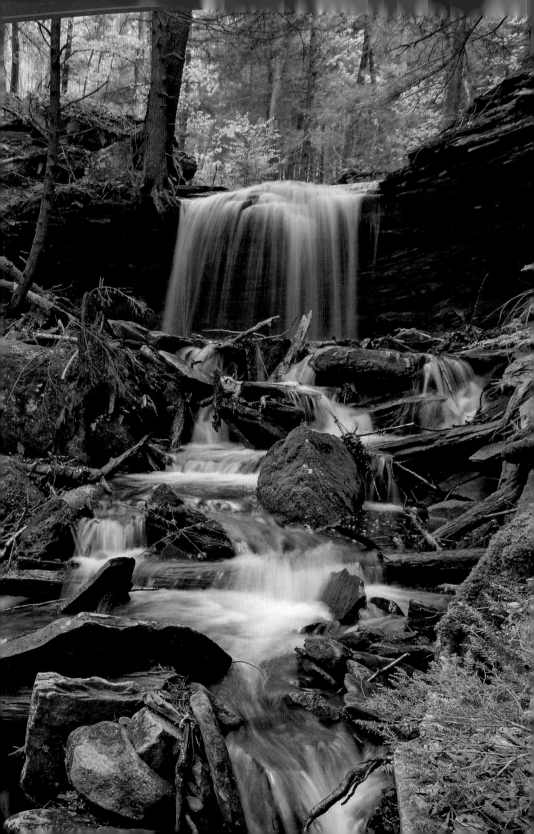

TRIP REPORT CONTINUED: To get to the second and third bonus waterfalls, find the steep trail near the campsite on the opposite side of Sand Run. Climb the hill and follow the trail over the hill and then back downhill. Within just a couple of minutes, you'll come to the top of a small but very beautiful waterfall on Babb Run.

The third waterfall is the hardest to see but worth it if you can safely cross Babb Run. The trail continues on the far side of Babb Run, but you don't want to follow it too far.

Rattlesnake Run enters Babb Run where you crossed the creek. The trail will climb away from the streams, but you'll want to pick your way upstream on Rattlesnake Run for a short distance.

Less than 100 yards upstream is a beautiful 10-foot waterfall that I've creatively dubbed Rattlesnake Run Falls. A good storm is needed to clean out the mess of branches below this waterfall, but it's still quite beautiful to see.

To return to your car, you have your choice of several different trails, but it's best to simply return the way you came—the other options are overgrown, difficult to follow, and just as long as the way you came in.

This hidden waterfall on Rattlesnake Run is worth seeking out.

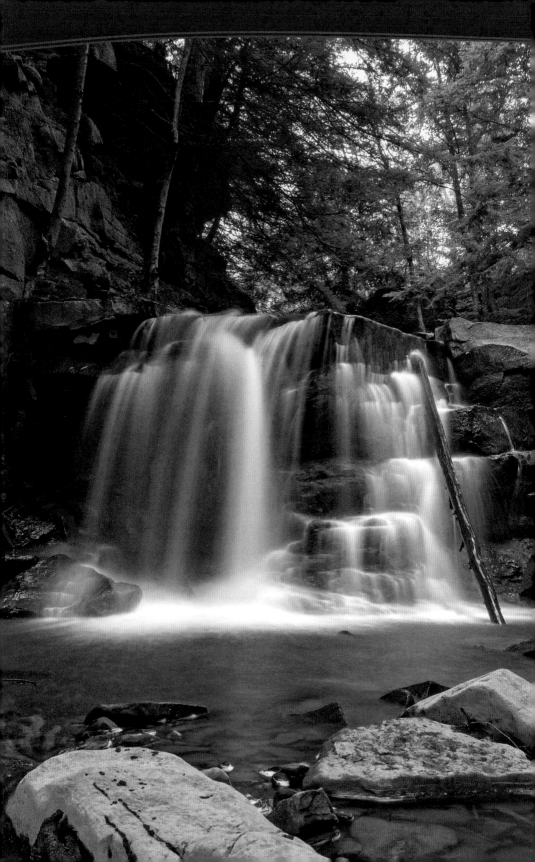

Fall Brook Falls

LOCATION: Tioga State Forest

ADDRESS/GPS FOR THE FALLS: 41.677639, -76.988111

DIRECTIONS: Take Exit 172 off US 15 in Blossburg. From the exits, take a left (south-bound) or a right (northbound) onto Boone Run Rd.; then, when you see the gas station on your right, turn right onto Bloss Mountain Rd. In 1.1 miles, turn left onto S. Williamson Rd. In 1.5 miles, turn right onto Gulick St.; then, in 1.2 miles, take a slight left onto Morris Run Rd., which becomes River Rd. In 4 miles, park in the pull-off on the right.

WEBSITE: www.uncoveringpa.com/how-to-get-fall-brook-falls-tioga-county

WATERWAY: Fall Brook

HEIGHT: 8–10 feet/10–12 feet **CREST:** 5–25 feet

NEAREST TOWN: Morris Run

HIKE DIFFICULTY: Easy to top of falls, difficult to bottom

TRAIL QUALITY: Good dirt trail and creek walking to bottom

ROUND-TRIP DISTANCE: 0.25–0.5 mile

TRIP REPORT & TIPS:

To reach the falls, follow the trail beyond the gate. After a short distance, a wide path will branch into the woods to the left and cross over a small bridge. Continue following this path for a couple of minutes until you see the metal fencing to your left. The waterfalls are just below this fence.

Upper Fall Brook Falls is roughly 8–10 feet tall and at least twice as wide. This creates a beautiful fan-shaped falls that's a pleasure to photograph.

To get to the bottom of the lower falls, follow the unmarked trail downstream into the woods beyond the fencing. After about 100 yards, the trail will turn slightly and head downhill toward the creek. There are no trail markings here, so make your way down at a spot that feels comfortable to you.

At the bottom, simply work your way the 100 or so yards back upstream to the base of the falls. This area can be quite slippery, with many rocks and fallen trees. *This section should be attempted only by those who are experienced and comfortable with off-trail hiking, and it should not be attempted in high water.*

Lower Fall Brook Falls is roughly 10–12 feet tall, but not nearly as wide which makes it look quite different than the upper falls.

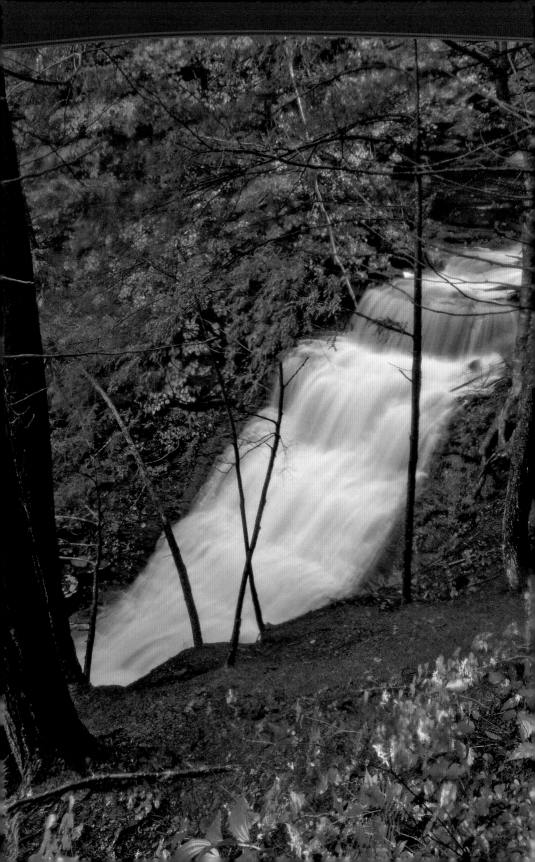

Rexford Falls

LOCATION: Colton Point State Park

ADDRESS/GPS FOR THE FALLS: 41.702500, -77.468250

DIRECTIONS: From Wellsboro, take PA 660 W. out of town for 2.5 miles. Keep straight to continue west on PA 362, and drive for 5.3 miles. When the road ends, turn left onto US 6, and drive for 0.4 mile. Turn left onto Colton Rd., and travel for 4.5 miles. Keep left to stay on Colton Rd., and park in the dirt lot on your right in 0.3 mile.

WEBSITE: www.dcnr.pa.gov/stateparks/findapark/coltonpointstatepark

WATERWAY: Rexford Branch of Fourmile Run

HEIGHT: 70 feet **CREST:** 6–8 feet

NEAREST TOWN: Wellsboro

HIKE DIFFICULTY: Moderate

TRAIL QUALITY: Good-quality dirt trail

ROUND-TRIP DISTANCE: 2 miles

TRIP REPORT & TIPS:

From the parking area, continue a few feet up the road to find the Turkey Path Trail. Follow this trail through the woods, being careful to stay on the trail, which can be a bit tricky to follow for the first few minutes of the hike.

Soon, the trail reaches the rim of the Pennsylvania Grand Canyon and starts descending on a series of steep switchbacks. In about 0.5 mile, you'll reach Rexford Falls.

This is an impressive waterfall, but given the steepness of the land, it's hard to get a good view of it. If you opt to try and get closer, use extreme caution.

Continuing down the trail for another very steep mile will take you to the base of the Pennsylvania Grand Canyon and past a small waterfall known as Logjam Falls.

Before leaving the park, take some time to check out the amazing views of the Pennsylvania Grand Canyon from the many viewing areas throughout Colton Point State Park.

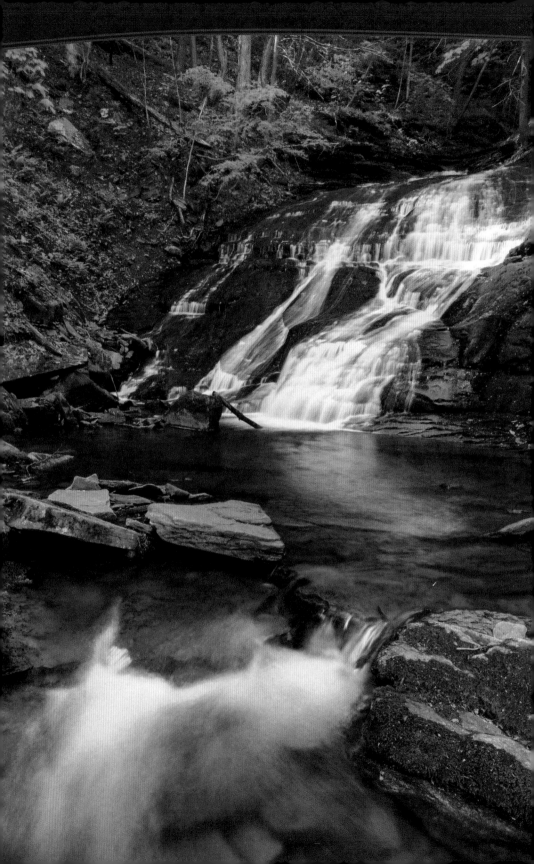

Pine Island Run Falls

LOCATION: Tioga State Forest

ADDRESS/GPS FOR THE FALLS: 41.612139, -77.406750

DIRECTIONS: From US 15 in Liberty, take PA 414 W. for 9.7 miles. Turn left to stay on PA 414, and in 0.7 mile bear right at the fork to continue west on PA 414. In 5.3 miles, park in the lot on your left just before crossing Pine Creek.

WEBSITE: www.uncoveringpa.com/pine-island-run-falls-pa-grand-canyon

WATERWAY: Pine Island Run

HEIGHT: 40–50 feet **CREST:** 10–15 feet

NEAREST TOWN: Slate Run

HIKE DIFFICULTY: Moderate

TRAIL QUALITY: Rail-trail and unblazed dirt trail

ROUND-TRIP DISTANCE: 9 miles

TRIP REPORT & TIPS:

Pine Island Run Falls features three drops of 10–20 feet that add up to about 40–50 feet in all. The falls is almost equidistant between the Blackwell and Tiadaghton Access Areas; I've routed the hike from Blackwell, which gives you access to several other waterfalls in the area, and the roads are in better condition.

From the Blackwell parking area, turn right and walk 200 feet. Cross the road and continue to follow the Pine Creek Rail Trail north for 4.2 miles. At 1.2 miles, you'll pass the small Stone Quarry Falls; at 2.3 miles, you'll pass Water Tank Run Falls.

You can certainly walk all the way to the falls, but a bicycle is recommended because of the distance. It's an easy ride along the Pine Creek Rail Trail.

When you reach Pine Island Run, which is marked with a sign, cross the bridge and look for an overgrown trail to your right. The waterfall can't be seen from the Pine Creek Rail Trail but is located only about 0.1 mile up Pine Island Run.

Follow the trail uphill a short distance. The trail will soon make a turn to the left. Just past the turn, you'll come to Pine Island Run Falls. Use caution around the falls, as the trail is a bit sketchy in a few spots.

From the same parking area listed above, you can also take the Bohen Trail to Jerry Falls and Bohen Falls (see page 136).

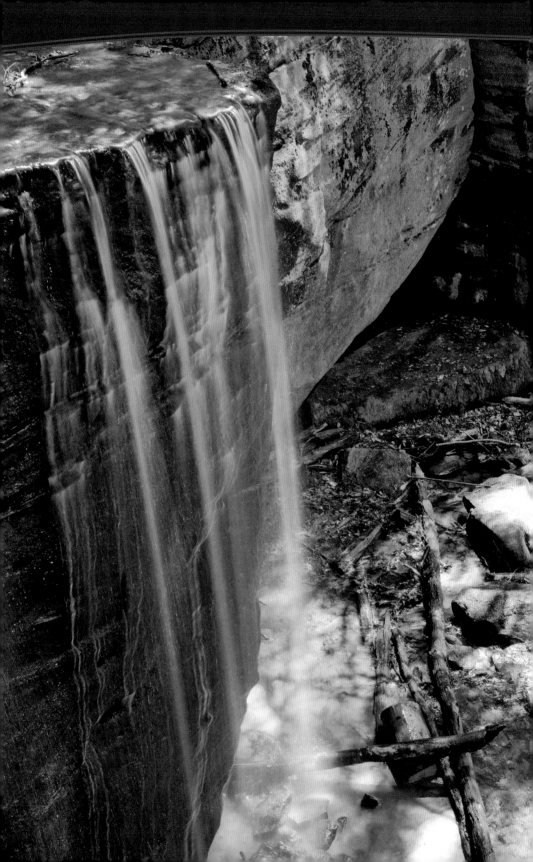

Hector Falls

LOCATION: Allegheny National Forest

ADDRESS/GPS FOR THE FALLS: 41.685306, -78.975056

DIRECTIONS: From US 6 W. in Ludlow, take a slight left onto Water St., and after 0.25 mile turn left again onto Scenic Dr. Carefully cross the unprotected train tracks, and in 0.9 mile bear right at the fork to continue southwest on Scenic Dr. In 2.1 miles, park next to the gate on the left side of the road.

WEBSITE: www.uncoveringpa.com/how-to-get-to-hector-run-falls

WATERWAY: Hector Run

HEIGHT: 20–25 feet **CREST:** 5–7 feet

NEAREST TOWN: Ludlow

HIKE DIFFICULTY: Moderate

TRAIL QUALITY: Gated dirt roads and trails

ROUND-TRIP DISTANCE: 2 miles

TRIP REPORT & TIPS:

Set amid a collection of large boulders that have been worn down over the years, Hector Falls plummets more than 20 feet off a rectangular rock face. When the water is high, it flows off two different faces, creating several streams of water cascading to the shallow pool below.

The waterfall itself is hidden among a collection of large boulders that obscure the bottom of the falls. While this makes the waterfall slightly tricky to find, it gives it a lost-world type of feel.

From the parking area, walk past the gate and head down an old dirt road for about 10 minutes until you come to a fork in the road just after a large clearing on the right.

At the fork, head downhill to the left. After walking a few hundred yards, you'll come to a small clearing at the bottom of the hill. A covered oil-well spout sits in the middle of the clearing. If you look at the circle like a clock, the path will be at about 2 o'clock and follows the small Hector Run downstream.

While this trail isn't especially well defined, the nearby stream makes it fairly easy to follow. All told, it'll take you about 5 minutes of walking along this trail to reach the waterfall, which is tucked behind the large boulders at the end.

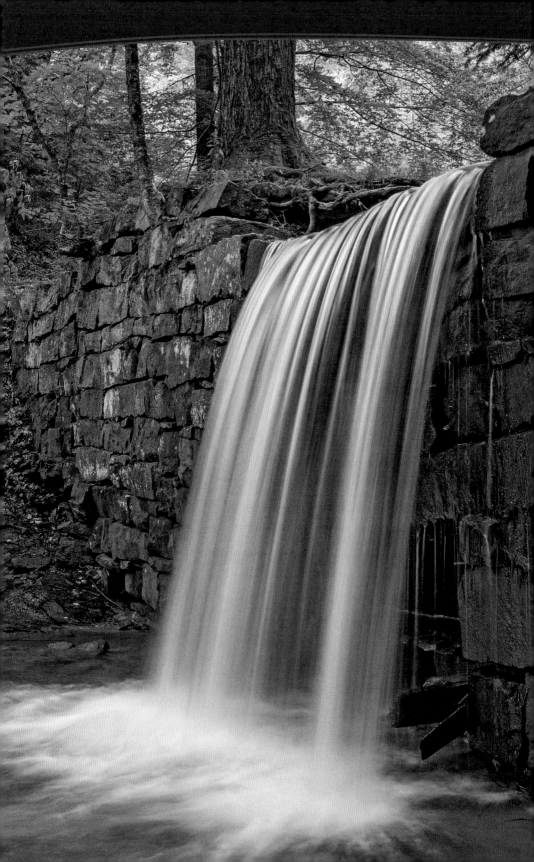

Henry Run Sawmill Dam

LOCATION: Cook Forest State Park

ADDRESS/GPS FOR THE FALLS: 41.321111, -79.226778

DIRECTIONS: From Sigel, take PA 36 N. for 11.5 miles. Turn left onto Miola Rd. and then left again onto Gravel Lick Rd. Park in a small dirt pull-off on your right in 1.2 miles.

WEBSITE: www.uncoveringpa.com/henry-run-sawmill-dam-in-cook-forest-state-park

WATERWAY: Henry Run

HEIGHT: 10–12 feet **CREST:** 10–15 feet

NEAREST TOWN: Sigel

HIKE DIFFICULTY: Moderate

TRAIL QUALITY: Good-quality dirt trail

ROUND-TRIP DISTANCE: 2.5 miles

TRIP REPORT & TIPS:

Most waterfalls in this guide are natural (versus man-made), but the beauty and history of Henry Run Sawmill Dam tipped the scales for its inclusion. This is also the only waterfall in Cook Forest State Park, one of the most beautiful parks in all of Pennsylvania and home to some of the largest trees in the state.

From the parking area, cross the road and pick up the North Country Trail, which is also called the Baker Trail at this point. The trail here soon ascends about 150 feet in the first 0.25 mile before leveling out. At 0.3 mile, you'll reach Scurry Overlook, which has a nice view and a place to sit if you need to rest.

Soon after the overlook, the trail begins to descend, losing about 300 feet of elevation in the next 0.75 mile. The trail descends through a beautiful forest and is easy to follow, though it's a bit narrow and overgrown in a few spots.

At 1.1 miles, the trail reaches an old dirt road and a trail register. Turn left onto the dirt road and then right to cross Henry Run on a wooden bridge.

After crossing the bridge, turn right and continue on the trail. Henry Run Sawmill Dam will be about 100 yards down the trail to your right, just before Henry Run's confluence with the Clarion River. All told, the old stone walls of this dam extend for 50–60 feet with a small cutout of about 10 feet for the water to flow through. This dam was built in the second half of the 19th century to support the logging operations that nearly clear-cut this entire portion of Pennsylvania.

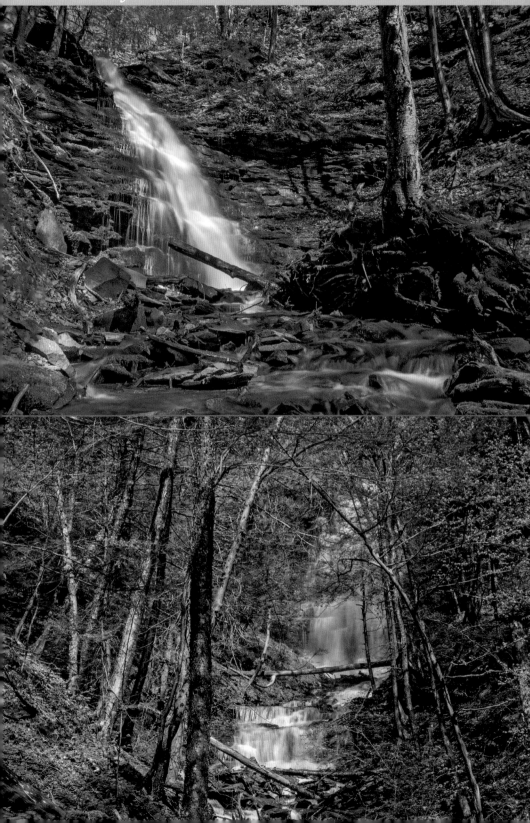

Water Tank Run Falls

LOCATION: Tioga State Forest

ADDRESS/GPS FOR THE FALLS: 41.589472, -77.383611

DIRECTIONS: From US 15 in Liberty, take PA 414 W. for 9.7 miles. Turn left to stay on PA 414, and in 0.7 mile bear right at the fork to continue west on PA 414. In 5.3 miles, park in the lot on your left just before crossing Pine Creek.

WEBSITE: www.uncoveringpa.com/water-tank-run-falls-pine-creek-rail-trail

WATERWAY: Water Tank Run

HEIGHT: 25–30 feet **CREST:** 2–4 feet

NEAREST TOWN: Slate Run

HIKE DIFFICULTY: Moderate

TRAIL QUALITY: Rail-trail and unblazed dirt trail

ROUND-TRIP DISTANCE: 5 miles

TRIP REPORT & TIPS:

The Pine Creek Rail Trail, the closest trail to the falls, makes for an easy but long walk. A bike would make this trip faster.

From the parking area, turn right and walk 200 feet. Cross the road and follow the Pine Creek Rail Trail north for 2.3 miles. Roughly halfway to Water Tank Run, you'll see the small waterfall on Stone Quarry Run adjacent to the trail.

It's possible to see the 25- to 30-foot-tall Water Tank Run Falls from the Pine Creek Rail Trail, but another path takes you directly to the base of the falls from the right side of the stream. This trail isn't well maintained, and a bit of scrambling is required to get to the base.

Chimney Hollow Falls

LOCATION: Pine Creek Gorge Natural Area

ADDRESS/GPS FOR THE FALLS: 41.722444, -77.444083

DIRECTIONS: From Wellsboro, take PA 660 W. for 2.5 miles. Keep straight to continue west on PA 362, and drive 5.3 miles. When the road ends, turn left onto US 6, and drive 0.4 mile. Turn left onto Colton Rd., and in 1.1 mile veer left onto Owasssee Rd. In 1.3 miles, park in the pull-off on the right just before the first bridge.

WEBSITE: www.uncoveringpa.com/chimney-hollow-falls

WATERWAY: Owassee Slide Run

HEIGHT: 45–50 feet **CREST:** 15–20 feet

NEAREST TOWN: Wellsboro

HIKE DIFFICULTY: Strenuous

TRAIL QUALITY: No trail; must creek-walk to falls

ROUND-TRIP DISTANCE: 0.3 mile

TRIP REPORT & TIPS:

Chimney Hollow Falls is known to few, but if you can time your visit to when the water is high, you'll be rewarded with a fantastically beautiful waterfall.

Picking your way along Owassee Slide Run is challenging but not impossible. Start by hiking up the right side; after 100 yards or so, you must cross the creek. Continue to the falls using extreme caution and crossing the creek as needed.

Chimney Hollow Falls has two drops. The first is around 40 feet tall, while the second is around 8–10 feet tall.

Note: Owassee Road is very rutted (a truck or SUV is recommended) and can flood when the water is high—*avoid hiking if the creek is covering the road or rising quickly.*

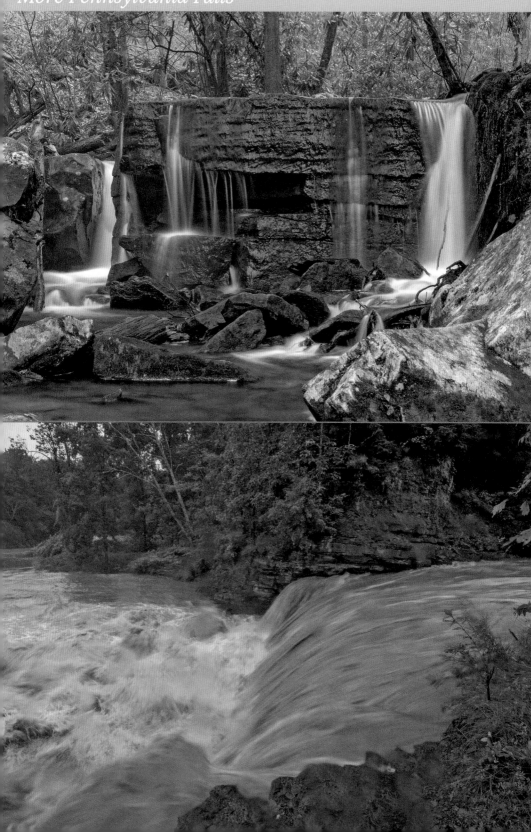

Table Falls

LOCATION: Quehanna Wild Area

ADDRESS/GPS FOR THE FALLS: 41.270722, -78.247111

DIRECTIONS: From Benezette, take PA 555 W. for 2.8 miles. Turn left onto Quehanna Hwy., and drive 11.7 miles. Take a hard left onto dirt Red Run Rd., and drive for 1.5 miles. Park in the pull-off at a nearly-180-degree turn in the road.

WEBSITE: www.uncoveringpa.com/table-falls-quehanna-wild-area

WATERWAY: Paige Run

HEIGHT: 5–6 feet **CREST:** 8–10 feet

NEAREST TOWN: Benezette

HIKE DIFFICULTY: Moderate

TRAIL QUALITY: User-created dirt trail

ROUND-TRIP DISTANCE: 0.1 mile

TRIP REPORT & TIPS:

Table Falls is a very distinctive waterfall in the Quehanna Wild Area. While it's not large, the shape of the rocks makes it appear that the water is flowing over a table before tumbling down the hillside.

Facing downstream from the middle of the U-bend, head to the left side of the stream, and walk past a sign for the falls. The trail is unblazed but easy to follow.

It's only about 100 feet down to the base of Table Falls, but because of some tricky footing near the bottom, I decided to rate this as moderate versus easy.

While there are no other waterfalls on Paige Run, the stream does make some beautiful cascades above the bridge, so take some time to enjoy those from the road during your visit.

Nelson Falls

LOCATION: Cowanesque Lake Recreation Area

ADDRESS/GPS FOR THE FALLS: 41.972028, -77.245056

DIRECTIONS: From US 15 in Lawrenceville, take the last or first exit in Pennsylvania (depending on which direction you're traveling), and turn onto PA 49 W. In 6 miles, cross the bridge over Cowanesque Lake. Just after the bridge, park on the shoulder on the left side of the road.

WEBSITE: www.uncoveringpa.com/nelson-falls-tioga-county

WATERWAY: Cowanesque River

HEIGHT: 4–6 feet **CREST:** 20–25 feet

NEAREST TOWN: Lawrenceville

HIKE DIFFICULTY: Easy

TRAIL QUALITY: User-created dirt trail

ROUND-TRIP DISTANCE: 0.3 mile

TRIP REPORT & TIPS:

Nelson Falls is a unique waterfall, not only because it spans an entire river but also because it falls directly into a lake. It is said that in the 1930s and '40s, Nelson Falls was created by a series of floods that bypassed an oxbow bend in the river and created a notch in the land for the water to flow.

From the pull-off on PA 49, a trail heads into the woods and leads just a few hundred yards to the top of Nelson Falls.

There are various good spots from which to view the falls, but make sure to stay back from the edge—the currents at the base of the waterfall can be quite strong, so you don't want to fall in.

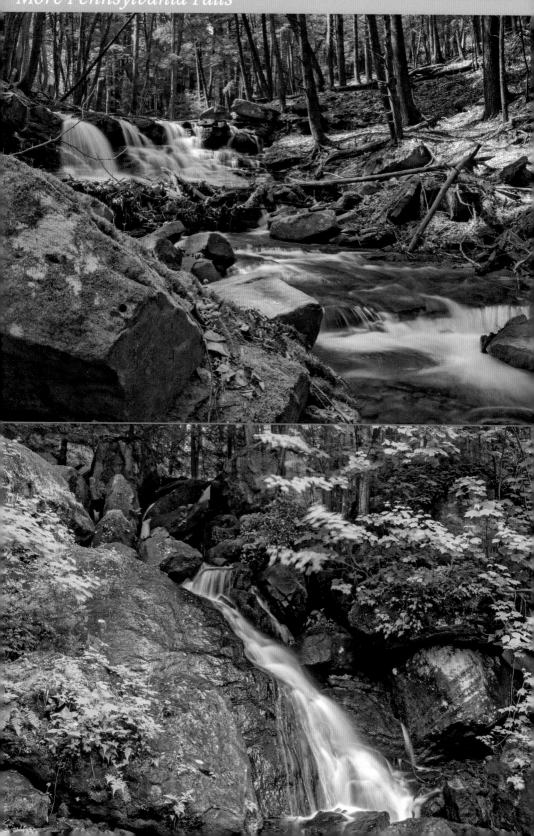

Rapp Run Falls

LOCATION: State Game Lands 72

ADDRESS/GPS FOR THE FALLS: 41.236556, -79.385639

DIRECTIONS: From downtown Clarion, head north out of town on N. 5th Ave. After 1.2 miles, turn left onto Bigley Rd. In 0.5 mile, park in a pull-off at the top of a 90-degree turn in the road.

WEBSITE: www.uncoveringpa.com/rapp-run-falls-clarion-pennsylvania

WATERWAY: Rapp Run

HEIGHT: 10–12 feet **CREST:** 12–15 feet

NEAREST TOWN: Clarion

HIKE DIFFICULTY: Easy–moderate

TRAIL QUALITY: User-created dirt trails and an optional creek crossing

ROUND-TRIP DISTANCE: 0.2–0.6 mile

TRIP REPORT & TIPS:

Rapp Run Falls is located in the southwestern corner of State Game Lands 72. There is a series of at least three small drops on Rapp Run, with the largest being approximately 10–12 feet tall.

From the parking area, find an unmarked trail that goes into the woods just up the hill. Rapp Run Falls should be visible shortly after you enter the woods.

From the start of the trail, you can look down and see the falls from above. Getting a closer look isn't difficult, but it does require a bit of bushwhacking. Because the sides of the gorge are deceptively difficult to hike down, follow the obvious trail upstream until it's safe to cross Rapp Run; then head downstream on the opposite bank to see the falls up close.

Bent Run Falls

LOCATION: Allegheny National Forest

ADDRESS/GPS FOR THE FALLS: 41.835083, -78.996972

DIRECTIONS: From Warren, cross the Allegheny River on the Hickory Bridge; then turn left onto Crescent Park. In 0.4 mile, turn left onto US 6 E. Drive for 2 miles, and then turn left onto PA 59. In 7 miles, park in the pull-off on the right just after Kinzua Dam.

WEBSITE: www.uncoveringpa.com/bent-run-falls

WATERWAY: Bent Run

HEIGHT: 18–20 feet **CREST:** 1–3 feet

NEAREST TOWN: Warren

HIKE DIFFICULTY: Strenuous

TRAIL QUALITY: Scramble down rocks to falls

ROUND-TRIP DISTANCE: 0.2 mile

TRIP REPORT & TIPS:

From the parking area, an obvious trail leads into the woods, following Bent Run upstream a short distance. The stream is quite beautiful as it cascades through a series of boulders and small drops.

Just past the trail's entrance, take a small trail to your right. From here, you should be able to see the top of Bent Run Falls. Make your way carefully down the rocks for about 50 feet to the base. When the water is flowing well here, Bent Run Falls splits into three different streams that cascade down the hillside.

After checking out Bent Run Falls, cross the road to check out the impressive Kinzua Dam, which is one of the largest dams east of the Mississippi River.

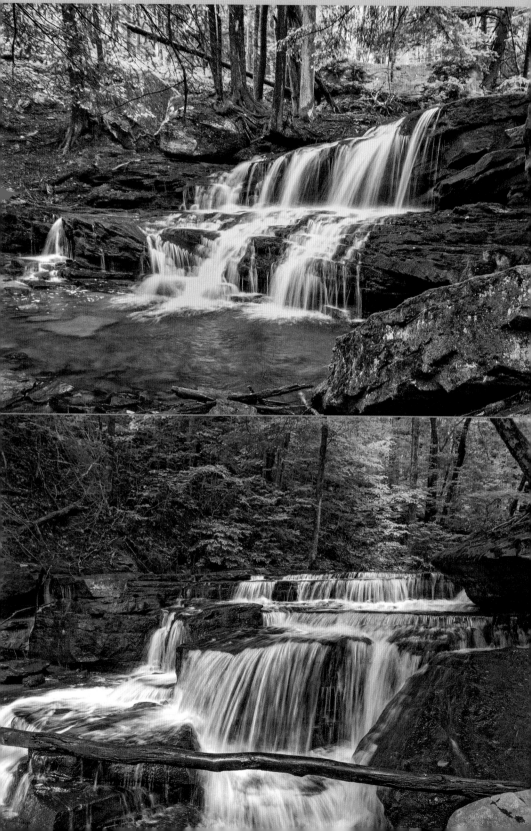

Logan Falls

LOCATION: Allegheny National Forest

ADDRESS/GPS FOR THE FALLS: 41.588389, -79.158306

DIRECTIONS: From Marienville, head out of town on N. Forest St., which becomes Beaver Meadows Rd. and Deadman Corners Rd. In 7.2 miles, turn left onto Coal Bed Run Rd. In 2.5 miles, park in the small pull-off on the right side of the road.

WEBSITE: www.uncoveringpa.com/how-to-get-to-logan-falls-in-the-allegheny-national-forest

WATERWAY: Logan Run

HEIGHT: 10–12 feet **CREST:** 12–15 feet

NEAREST TOWN: Marienville

HIKE DIFFICULTY: Moderate

TRAIL QUALITY: Somewhat overgrown dirt trail

ROUND-TRIP DISTANCE: 0.6 mile

TRIP REPORT & TIPS:

Hidden deep in the Allegheny National Forest along an unmarked trail, Logan Falls is one of the most isolated waterfalls in Pennsylvania.

From the parking area, a trail leads down to Logan Falls. The trailhead can get overgrown during the summer, so you may need to look carefully for it. This 0.3-mile trail isn't blazed but is very easy to follow.

The trail climbs a small hill before losing about 200 feet in elevation on the way to the falls; thus, it's a bit more difficult on the way out. If you visit during the summer, the forest is almost impossibly green.

After about 0.3 mile, Logan Falls comes into view on the right. The trail continues beyond the waterfall, but there are no other falls farther downstream.

Pigeon Run Falls

LOCATION: Allegheny National Forest

ADDRESS/GPS FOR THE FALLS: 41.469556, -78.960528

DIRECTIONS: From Marienville, head east out of town on E. Spruce St. In 8.6 miles, park in the pull-off on the right just after a bridge.

WEBSITE: www.uncoveringpa.com/pigeon-falls-allegheny-national-forest

WATERWAY: Pigeon Run

HEIGHT: 8–10 feet **CREST:** 8–10 feet

NEAREST TOWN: Marienville

HIKE DIFFICULTY: Moderate

TRAIL QUALITY: Overgrown dirt trail

ROUND-TRIP DISTANCE: 2 miles

TRIP REPORT & TIPS:

From the parking area, cross the road and follow the old dirt road. Soon the road ends, and the path becomes a narrow trail at a wet stream crossing.

The trail, unmarked but easy to follow, winds its way through the forest for 1 mile to Pigeon Falls. When water levels are high, be prepared to get your feet wet and muddy. Watch for horse droppings as well.

The trail crosses Pigeon Run just downstream of the falls. At Pigeon Run, there is a sign for Pigeon Falls and a picnic table.

The waterfall is about 150 feet upstream of the main trail, and it's quite easy to reach the base of the falls from the trail.

The last stretch of road before the parking area is very rutted. You can also park in a pull-off on your left about 0.25 mile before the parking area in the directions, then walk the rest of the way to the trailhead.

Cucumber Falls

Cucumber Falls is one of the largest waterfalls in Western Pennsylvania—and among the most beautiful.

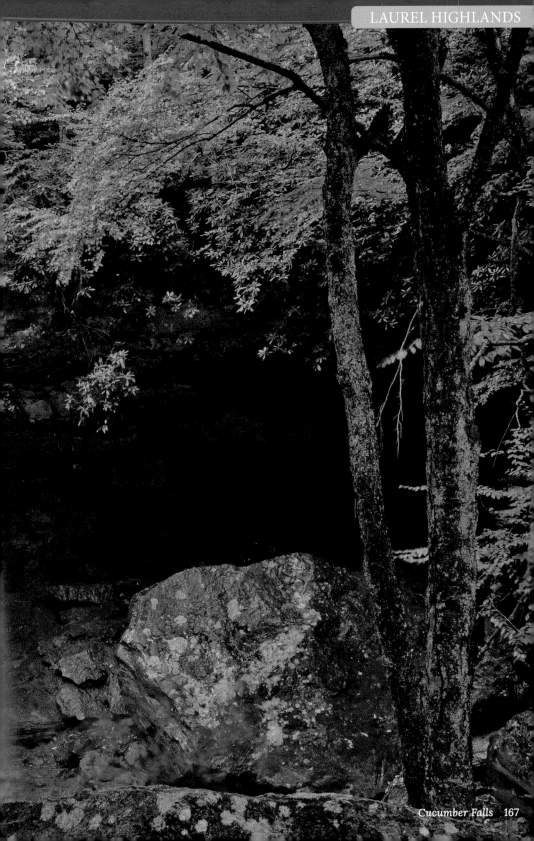

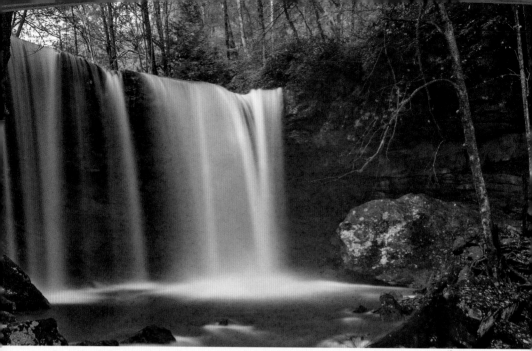
Cucumber Falls during high water

Cucumber Falls

Cucumber Falls can be easily seen from above; you can also take the steps to the bottom and go behind its beautiful veil.

LOCATION: Ohiopyle State Park

ADDRESS/GPS FOR THE FALLS: 39.863083, -79.502861

DIRECTIONS: In Ohiopyle, take PA 381 S. across the Youghiogheny River; then take the first right after the bridge onto Ohiopyle Rd. (a parking area will be on your left where you make the turn). The Cucumber Falls parking area will be on your right in 0.5 mile.

WEBSITE: www.dcnr.pa.gov/stateparks/findapark/ohiopylestatepark

WATERWAY: Cucumber Run

HEIGHT: 30 feet **CREST:** 10 feet

NEAREST TOWN: Ohiopyle

HIKE DIFFICULTY: Easy

TRAIL QUALITY: Dirt trail to the top of the falls, steps to the bottom

ROUND-TRIP DISTANCE: 0.25 mile

TRIP REPORT & TIPS:

Without a doubt, Cucumber Falls is one of my favorite waterfalls in southwest Pennsylvania—there's just something about the way the water streams off the cliff face and into the rocky pool below. Even better, the waterfall can be viewed from above very easily, but it also offers the chance for adventurous visitors to go behind its veil.

From the parking area, it's a 1-minute walk along a relatively flat dirt path to the top viewing area. This spot, which offers an impressive view of Cucumber Falls, is well worth taking the time to see.

From here, a set of stairs and dirt trails leads the short distance to the bottom of the falls. This is another great spot from which to view the waterfall.

Going farther requires picking your way across the boulders that surround the waterfall, and footing can be tricky in places.

There are great views of Cucumber Falls from downstream, and on summer weekends, whitewater rafters can be seen traversing the Youghiogheny River from where Cucumber Run meets it.

Going behind the veil is also popular— it's a lot of fun to stand in the small cave behind the falls as the water rushes in front of you.

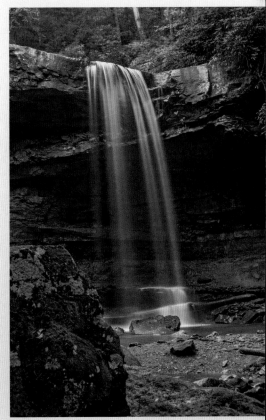

Cucumber Falls is still beautiful during low water.

Ohiopyle Falls

Spanning the entire Youghiogheny River, Ohiopyle Falls is one of the most powerful waterfalls in Pennsylvania.

Ohiopyle Falls from the main viewing area

Ohiopyle Falls

There are viewing areas for this waterfalls on both shores of the river, and the ones on the near side are accessible for everyone.

LOCATION: Ohiopyle State Park

ADDRESS/GPS FOR THE FALLS: 39.867750, -79.495444

DIRECTIONS: From US 40, turn onto PA 381 N. in Farmington. After 6.5 miles, park in the lot on the left, next to Ohiopyle State Park's visitor center.

WEBSITE: www.dcnr.pa.gov/stateparks/findapark/ohiopylestatepark

WATERWAY: Youghiogheny River

HEIGHT: 15–20 feet **CREST:** 100 feet

NEAREST TOWN: Ohiopyle

HIKE DIFFICULTY: NA

TRAIL QUALITY: NA

ROUND-TRIP DISTANCE: Roadside

TRIP REPORT & TIPS:

Ohiopyle Falls spans the entire length of the Youghiogheny River in the heart of Ohiopyle, Pennsylvania. While the waterfall is only about 15–20 feet high, the sheer volume of water that flows over the falls makes it one of the most impressive in all of Pennsylvania.

In 1754, a young George Washington visited the falls while looking for a route to Fort Duquesne in Pittsburgh. Unable to conquer the river at this spot, he moved on, eventually firing the first shots of the French and Indian War just a few miles away at a spot that is now part of Fort Necessity National Battlefield.

Ohiopyle Falls is located adjacent to the visitor center for Ohiopyle State Park, and there are viewing areas that have been constructed both outside the center and on the bottom floor of the visitor center.

Views can also be had from the opposite bank. Walk up river to the pedestrian bridge that sits just upstream of the waterfall. Once across the river, take an immediate left onto a dirt path that follows the shoreline of the river. Several viewing areas can be found along the large rocks that dot the shores of the river.

It's worth noting that this path is directly adjacent to the water, and during periods of high water, the trail might be covered with water and thus too dangerous to hike.

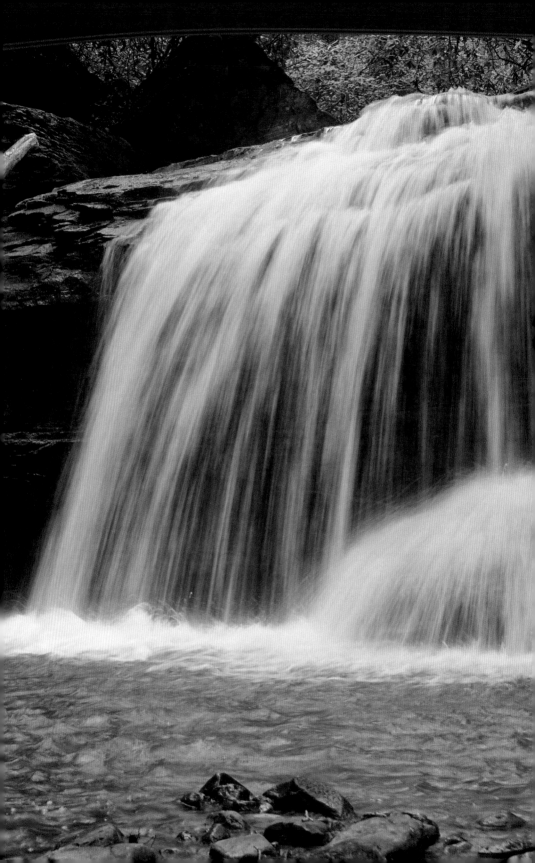

Jonathan Run Falls

LOCATION: Ohiopyle State Park

ADDRESS/GPS FOR THE FALLS: 39.902806, -79.490667

DIRECTIONS: In Ohiopyle, take PA 381 S. across the Youghiogheny River; then take the first right after the bridge onto Ohiopyle Rd., and drive for 1.5 miles. At the four-way stop, continue straight onto Holland Hill Rd. After 1.5 miles, the parking area for the Jonathan Run Trail will be on your right.

WEBSITE: www.dcnr.pa.gov/stateparks/findapark/ohiopylestatepark

WATERWAY: Jonathan Run

HEIGHT: 15 feet **CREST:** 10 feet

NEAREST TOWN: Ohiopyle

HIKE DIFFICULTY: Easy to top of falls but difficult to bottom of falls

TRAIL QUALITY: Wide trail to top of falls but steep off-trail descent to bottom of falls

ROUND-TRIP DISTANCE: 3.4 miles

TRIP REPORT & TIPS:

Jonathan Run is one of the hidden gems of Ohiopyle State Park. While many other areas can be crowded, this trail is usually lightly trafficked. The park map shows one waterfall on this stream, though there are actually two, along with a bonus waterfall on Fechter Run.

From the parking area, follow the trail, which will soon meet Jonathan Run. After about 1 mile, the trail will meet first the Sugar Run Trail and then the Kentuck Trail in quick succession. If water levels are high, take a short detour on the Fechter Run Trail to see Fechter Falls, which is about 100 yards up the trail.

Back on the Jonathan Run Trail, continue hiking on this trail for a few more minutes. The trail runs high above the stream, and you'll hear and then see Upper Jonathan Run Falls far below. For a closer look, carefully pick your way down the hillside on the user-created trail.

Lower Jonathan Run Falls is a few more minutes farther downstream. Again, the falls are visible from the trail but require a very tricky descent to get down to the water level. In my opinion, the descent at the lower falls is the harder of the two.

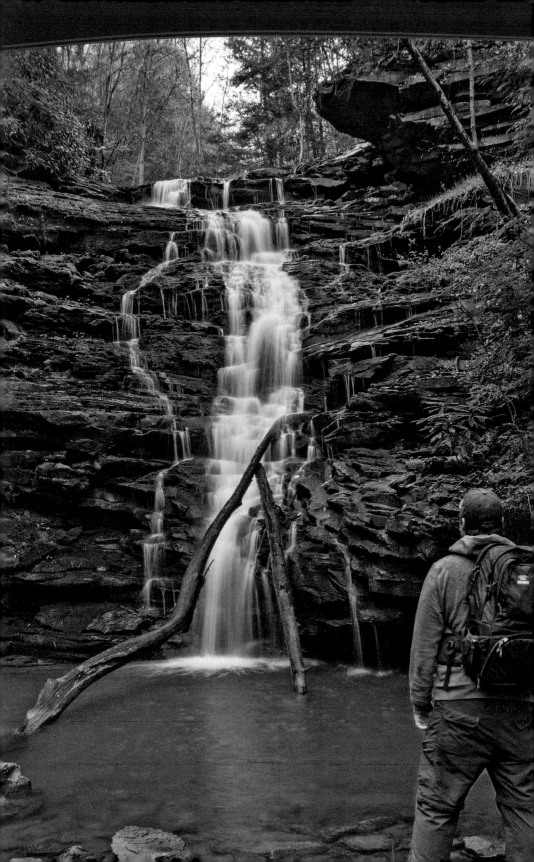

Yoder Falls

LOCATION: Just east of US 219 and west of the Stonycreek River

ADDRESS/GPS FOR THE FALLS: 40.248583, -78.892333

DIRECTIONS: From US 219, take the PA 403 exit for Hollsopple and Davidsville, 13 miles south of Johnstown. Turn onto PA 403 N. and follow it for 2.2 miles. Turn right onto Carpenters Park Rd. and follow it for 2 miles. Park in an unmarked parking area on the left side of the road.

WEBSITE: www.uncoveringpa.com/yoder-falls-near-johnstown-pennsylvania

WATERWAY: Unnamed

HEIGHT: 35 feet **CREST:** 5–7 feet

NEAREST TOWN: Johnstown

HIKE DIFFICULTY: Strenuous

TRAIL QUALITY: Steep unmarked trail followed by a stream walk around several small waterfalls

ROUND-TRIP DISTANCE: 0.5 mile

TRIP REPORT & TIPS:

Yoder Falls is located on land that belongs to the City of Johnstown. Despite this, it is located in Somerset County, not Cambria County.

From the parking area, the trailhead is overgrown and hard to find, but it's located at approximately 10 o'clock if you're facing the woods; once you get your bearings, the trail is unmarked but obvious. From the top of the hill, it descends approximately 200 feet to the Stonycreek River in about 0.25 mile.

When you reach the river, head to the left, and you'll immediately see the unnamed creek that feeds Yoder Falls. Notice the stone walls on opposite sides of the creek—these are the ruins of a bridge that once carried the trolley from Johnstown to Windber.

Yoder Falls is only about 0.25 mile upstream of the stream's confluence with the Stonycreek River. Unfortunately, there is no trail from this point, so you'll have to hike upstream to reach the falls.

Along the way, this unnamed creek flows over rocks and through two smaller waterfalls. One of these is a small series of steps, while the other is a beautiful drop of about 10 feet through a narrow chasm in the rocks.

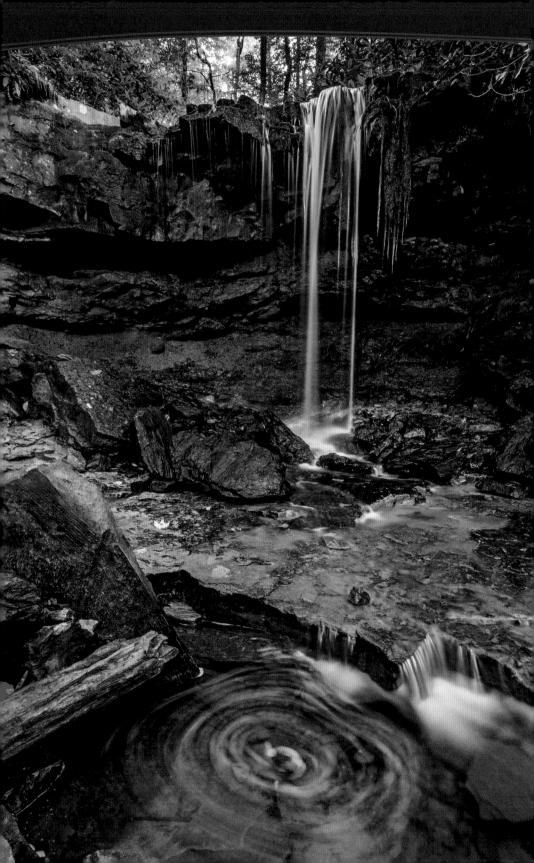

Cole Run Falls

LOCATION: Forbes State Forest

ADDRESS/GPS FOR THE FALLS: 39.972250, -79.284222

DIRECTIONS: From Exit 91 off the Pennsylvania Turnpike/I-76, head east on PA 31/ PA 711 for 2 miles; then turn right onto PA 711 S. In 1.3 miles, turn left on County Line Rd., and follow it 10.5 miles; then turn left on Barron Church Rd., and follow it 1.5 miles. Turn right onto Gary Rd., and in 1.5 miles turn left to stay on this road. Finally, in another 0.5 mile, turn right onto Cole Run Rd.; the parking area will be on your left in 0.25 mile, just after you cross the bridge over Cole Run.

WEBSITE: www.uncoveringpa.com/visiting-cole-run-falls

WATERWAY: Cole Run

HEIGHT: 12–15 feet **CREST:** 8–10 feet

NEAREST TOWN: Seven Springs

HIKE DIFFICULTY: Easy

TRAIL QUALITY: Unmarked but short and flat to top of the falls

ROUND-TRIP DISTANCE: 0.1 mile

TRIP REPORT & TIPS:

Cole Run Falls is one of the most isolated waterfalls in Pennsylvania. Those who make the drive, however, will discover that it's not only incredibly beautiful but also quite easy to see.

There are definitely taller waterfalls in Pennsylvania, but what makes Cole Run Falls so beautiful isn't its height, but rather the nearly-90-degree turn that it makes right after the main falls and the dense underbrush that surrounds it. This ensures that even when the water levels drop in the late summer and fall that the waterfall will still be beautiful and worth visiting.

Cole Run Falls is less than 100 feet from Cole Run Road. From the parking area, simply head away from the road down the well-trod path. Walk past the start of the Cole Run Trail and keep going until you run into the stream.

Getting to the bottom of Cole Run Falls is a bit more tricky, but it's worth the effort if you want to take photographs of this beautiful waterfall.

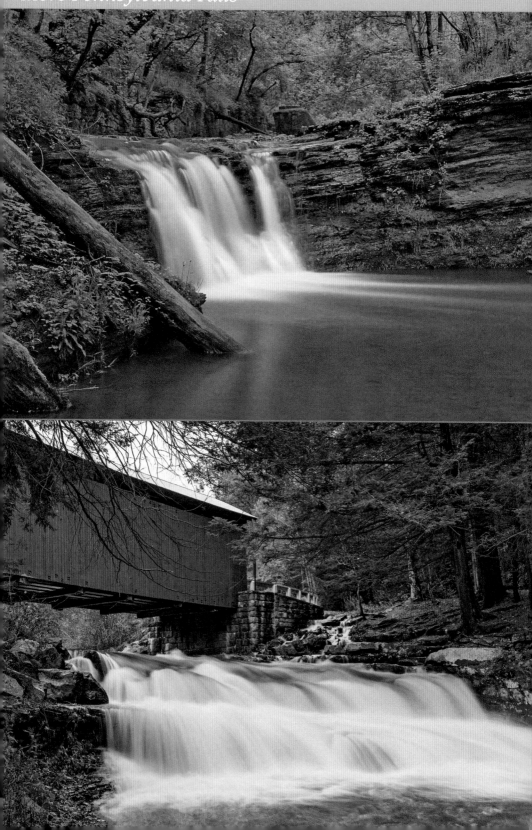

East Park Falls

LOCATION: East Park, Connellsville

ADDRESS/GPS FOR THE FALLS: 40.017944, -79.583028

DIRECTIONS: From E. Crawford Ave. in Connellsville, turn south onto S. Pittsburgh St. After 0.1 mile, turn left onto Wills Rd., and in 0.3 mile bear left at the fork onto Franklin Ave. In 0.2 mile, turn left onto Penn St., and when that dead-ends, turn left onto Run Ave. and follow it down into the park.

WEBSITE: www.connellsville.us/east-park

WATERWAY: Connell Run

HEIGHT: 7–8 feet **CREST:** 10 feet

NEAREST TOWN: Connellsville

HIKE DIFFICULTY: Easy

TRAIL QUALITY: A walking path provides access to both falls

ROUND-TRIP DISTANCE: 0.1 mile

TRIP REPORT & TIPS:

East Park sits in a residential area just outside of downtown Connellsville, on the eastern banks of the Youghiogheny River. This small park, located in a narrow gorge, is centered around Connell Run.

Along this stretch of Connell Run, there are two small waterfalls, both roughly 7–8 feet tall. These small but very beautiful waterfalls can not only be seen from the road but are also situated along a level walking path that goes 100 yards from the parking area to the second waterfall. These two waterfalls are close together, with only about 50 feet separating the bottom of the upper falls from the top of the second.

Note: Despite what most online maps show, you can access the park only from Run Avenue.

Packsaddle Falls

LOCATION: Southern Somerset County

ADDRESS/GPS FOR THE FALLS: 39.867556, -78.817222

DIRECTIONS: From Berlin, take PA 160 S. for 5.2 miles. Turn left onto Glencoe Rd., and in 2.1 miles turn right to continue on this road. In 2.2 miles, turn left onto Leister Rd.; in another 2.2 miles, bear right onto Packsaddle Rd. In 2 miles, just past Packsaddle Covered Bridge, look for parking on the left.

WEBSITE: www.uncoveringpa.com/packsaddle -covered-bridge

WATERWAY: Brush Creek

HEIGHT: 10–12 feet **CREST:** 20–25 feet

NEAREST TOWN: Berlin

HIKE DIFFICULTY: NA

TRAIL QUALITY: No trail; can be challenging to descend to stream level (where the best views are)

ROUND-TRIP DISTANCE: NA

TRIP REPORT & TIPS:

Pennsylvania is home to more than 200 historic covered bridges, but only one of these has a natural waterfall below it: Packsaddle Covered Bridge in Somerset County.

This beautiful waterfall along Brush Creek creates an amazing setting for both waterfall and covered bridge lovers. The waterfall can be viewed from the road, but the best viewing areas require a short but careful descent to water level.

Some of the land around the covered bridge is private property, as noted by signs, so please be mindful of this when exploring.

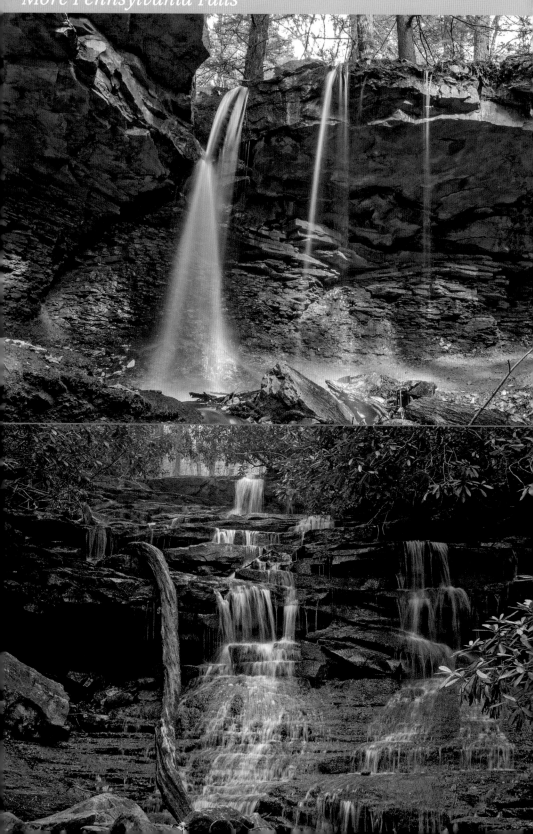

Adams Falls

LOCATION: Linn Run State Park

ADDRESS/GPS FOR THE FALLS: 40.167528, -79.231444

DIRECTIONS: From US 30 in Ligonier, head south on PA 711 for 3.5 miles. Turn left onto Darlington Rector Rd., and drive 1.3 miles; then turn right onto Linn Run Rd., and drive 1.9 miles. Turn left into a parking area; if possible, cross the bridge and park at the top of the steep hill.

WEBSITE: www.dcnr.pa.gov/stateparks/findapark/linnrunstatepark

WATERWAY: Unnamed

HEIGHT: 12–15 feet **CREST:** 3 feet

NEAREST TOWN: Ligonier

HIKE DIFFICULTY: Easy

TRAIL QUALITY: A flat trail leads directly to the top of the waterfall.

ROUND-TRIP DISTANCE: 0.25 mile

TRIP REPORT & TIPS:

Adams Falls, a beautiful spot in Linn Run State Park, is located along the Adams Falls Trail. While this trail is 1 mile long, accessing the falls requires hiking just a small portion of the trail.

To see the falls, hike along the trail for just a few minutes. This trail is quite beautiful, and you will soon cross a small bridge directly above the falls. The only official viewpoint for the falls is from above—descending into the gorge is not recommended, as the banks and the rocks can be quite slippery.

It should be noted that this is a seasonal waterfall that can dry up during the drier months of the year.

Sugar Run Falls

LOCATION: Ohiopyle State Park

ADDRESS/GPS FOR THE FALLS: 39.906000, -79.491056

DIRECTIONS: In Ohiopyle, take PA 381 S. across the Youghiogheny River; then take the first right after the bridge onto Ohiopyle Rd., and drive 1.5 miles. At the four-way stop, continue straight onto Holland Hill Rd. In 2.1 miles, bear right at the fork onto Sugar Run Rd. Follow this for 1.2 miles; then turn right into the parking area for the Old Mitchell Trail. Park at the top of the hill in the gravel lot.

WEBSITE: www.dcnr.pa.gov/stateparks/findapark/ohiopylestatepark

WATERWAY: Sugar Run

HEIGHT: 25–30 feet **CREST:** 5 feet

NEAREST TOWN: Ohiopyle

HIKE DIFFICULTY: Moderate

TRAIL QUALITY: A dirt trail with a steady decline to the falls

ROUND-TRIP DISTANCE: 2.5 miles

TRIP REPORT & TIPS:

Sugar Run Falls can be accessed as an extension of the Jonathan Run Falls hike (see page 175), but the quickest route to this waterfall is from the Mitchell Trail.

Hike down the Mitchell Trail for 0.5 mile. At this point, you'll reach an intersection with a sign pointing to the Mitchell Trail to the left. Stay right on the unmarked trail that's a spur trail for this trail. Follow it about 0.75 mile as it descends toward the river. Just before you reach the river and the Great Allegheny Passage, Sugar Run Falls will be on your right.

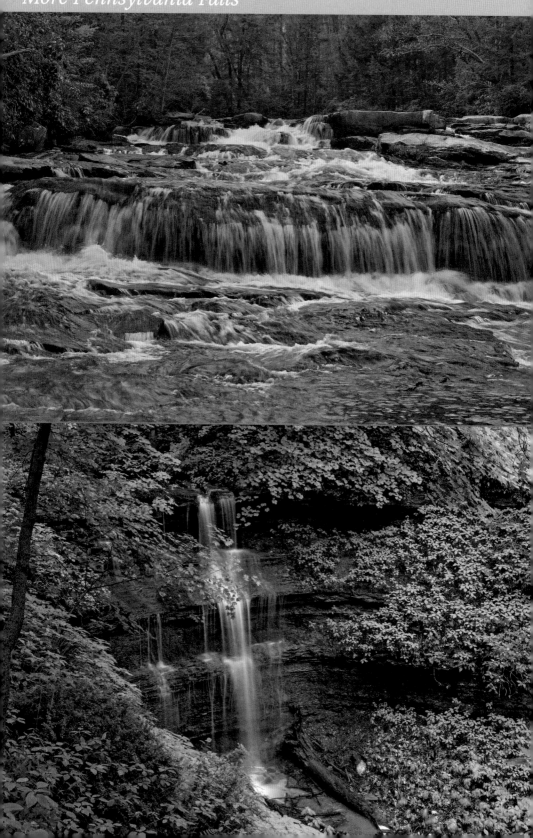

The Cascades

LOCATION: Ohiopyle State Park

ADDRESS/GPS FOR THE FALLS: 39.855694, -79.489056

DIRECTIONS: In Ohiopyle, take PA 381 S. across the Youghiogheny River; then, 0.6 mile after the bridge, bear left onto Dinner Bell Rd. Park in the lot on your left in 0.1 mile.

WEBSITE: www.dcnr.pa.gov/stateparks /findapark/ohiopylestatepark

WATERWAY: Meadow Run

HEIGHT: 10 feet **CREST:** 50 feet

NEAREST TOWN: Ohiopyle

HIKE DIFFICULTY: Moderate

TRAIL QUALITY: Dirt trail with a slow, steady descent to water level

ROUND-TRIP DISTANCE: 2 miles

TRIP REPORT & TIPS:

The Cascades are located along Meadow Run upstream of the popular Natural Waterslides. While not overly tall, their width and the way the water falls through the rocks in the stream make this a great spot to visit.

From the parking area, follow the Meadow Run Trail as it does a loop of the woods surrounding the stream. The Cascades are located at nearly the halfway point of the trail, so it doesn't really matter which direction you hike it. I prefer to hike it clockwise, as that allows me to walk upstream toward the falls.

The Cascades are most easily viewed from the side—a frontal view will require you to get your feet wet. Depending on water levels, however, it may be possible to view this waterfall only from the side.

Braddock's Falls

LOCATION: Braddock's Trail Park

ADDRESS/GPS FOR THE FALLS: 40.302806, -79.774750

DIRECTIONS: From US 30 in Irwin, turn southwest onto Robbins Station Rd. Follow this road for 3 miles until it dead-ends into the parking area for the park.

WEBSITE: www.uncoveringpa.com/braddocks -trail-park

WATERWAY: Unnamed

HEIGHT: 20 feet **CREST:** 8–10 feet

NEAREST TOWN: Irwin

HIKE DIFFICULTY: Easy

TRAIL QUALITY: A closed roadway for much of the hike and a flat dirt path for the last 100 feet

ROUND-TRIP DISTANCE: 0.25 mile

TRIP REPORT & TIPS:

Despite being in the Laurel Highlands, Braddock's Falls is actually the second-closest waterfall to downtown Pittsburgh.

The fastest route to Braddock's Falls is to hike along the road past the gate. After about 0.1 mile, take the Waterfall/ Wildflower Trail on your right to the top of the falls. A loop hike can be created by following the Eagle Trail back to the parking area.

Located along an unnamed waterway, Braddock's Falls is often between a trickle and totally dry. However, if you can plan a visit here after a period of rain, the waterfall should be flowing quite nicely.

Buttermilk Falls

A newly built trail system allows you to walk behind this waterfall.

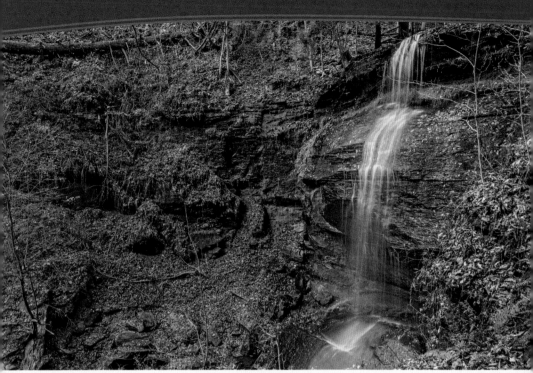

Fred Rogers used to visit this waterfall as a child.

Buttermilk Falls

This waterfall was once owned by the grandfather of TV's Mister Rogers.

LOCATION: Buttermilk Falls Natural Area

ADDRESS/GPS FOR THE FALLS: 570 Valley Brook Rd., New Florence, PA 15944

DIRECTIONS: From Armagh, take US 22 W. for 2 miles. Turn left onto Clay Pike Rd. After 1.5 miles, take the left fork onto Valley Brook Rd. The parking area is at the end of the road, 0.6 mile after the fork.

WEBSITE: www.indianacountyparks.org/parks/buttermilk_falls_park

WATERWAY: Hires Run

HEIGHT: 45 feet **CREST:** 8–10 feet

NEAREST TOWN: Armagh

HIKE DIFFICULTY: Easy

TRAIL QUALITY: An easy dirt trail to the top of the falls, metal stairs to the bottom

ROUND-TRIP DISTANCE: 0.66 mile

TRIP REPORT & TIPS:

Buttermilk Falls is one of the largest waterfalls in western Pennsylvania. It's also one of my favorite waterfalls in the state.

In the mid-20th century, the land around the falls was owned by Fred McFeely, the grandfather of TV's Mister Rogers. A young Fred would often visit his grandfather's cottage here and enjoy the waterfall. Ruins of this retreat still stand in the park.

Today, a wide gravel path leads from the parking area to the falls. The trail starts adjacent to the small restroom building and winds past several picnic tables along the 0.25-mile walk to the top viewing area for Buttermilk Falls.

The main viewing area offers a view from above Buttermilk Falls. While this spot is great throughout the year, the trees can block the view of the waterfall a bit during the middle of the summer.

This used to be the only sanctioned viewing area, but thanks to a construction project completed in 2017, it's also possible to safely cross Hires Run, then walk to the bottom and behind Buttermilk Falls.

To cross the stream, pass around the gate just up from the main viewing area. It's a bit of a tight squeeze around the gate and a short but steep trip down to stream level. Once at the bottom of the hill, cross the large, triangular-shaped bridge before descending the stairs to the bottom of Buttermilk Falls.

At the bottom of Buttermilk Falls, the pathway continues behind the waterfall, offering a unique vantage point behind the veil of water. While this walkway distracts a bit from the natural beauty of the waterfall, it's great that the waterfall is much easier for people to enjoy.

Note: Depending on the level of water at Buttermilk Falls, it may be impossible to get behind the veil of water without getting at least a little wet.

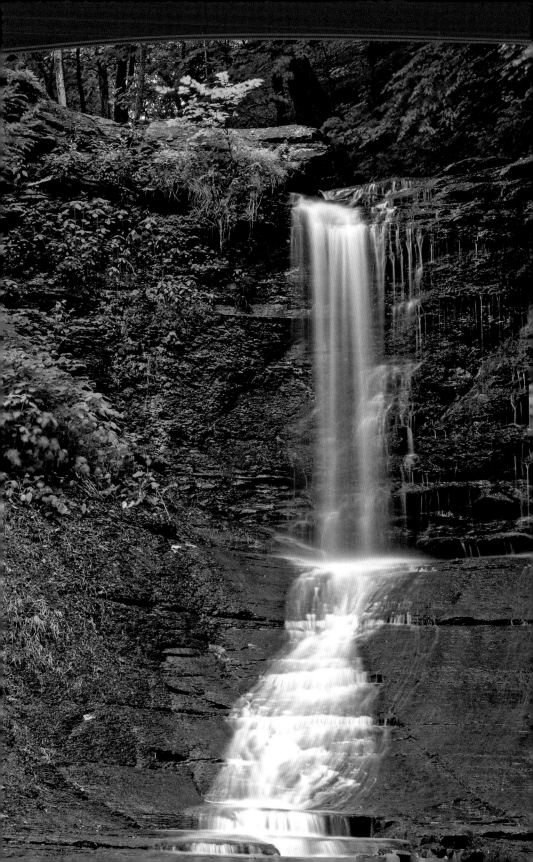

Fall Run Falls

LOCATION: Fall Run Park

ADDRESS/GPS FOR THE FALLS: 40.536194, -79.944833

DIRECTIONS: From downtown Pittsburgh, take PA 28 N. for 4 miles. Take Exit 5B, and follow PA 8 N. for 3 miles. Turn right onto Fall Run Rd., and then take the first left into the park. Park at the end of the road.

WEBSITE: www.shaler.org/349/fall-run-park-judge-dm-miller

WATERWAY: Fall Run

HEIGHT: 20–25 feet **CREST:** 3–5 feet

NEAREST TOWN: Pittsburgh

HIKE DIFFICULTY: Easy

TRAIL QUALITY: A fairly flat gravel path

ROUND-TRIP DISTANCE: 1 mile

TRIP REPORT & TIPS:

Located just 15 minutes from downtown Pittsburgh, Fall Run Falls is the closest waterfall to the city.

From the parking area, follow the park's sole trail past the sign. The gravel trail is relatively wide and flat for the 0.5-mile trip to the base of the falls. Along the way, the trail crosses Fall Run several times via bridges and goes past a small 5-foot waterfall. Because this is the only trail in the park, it's impossible to miss Fall Run Falls.

From the base of the waterfall, you can either return the way you came or continue along the trail another 0.5 mile, although there aren't any features of note beyond the top of the waterfall.

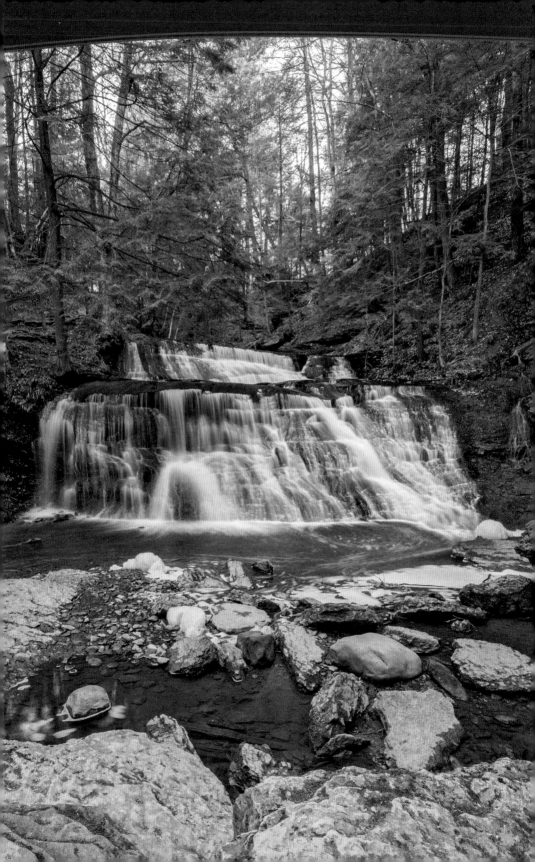

Hell's Hollow Falls

LOCATION: McConnells Mill State Park

ADDRESS/GPS FOR THE FALLS: 40.929278, -80.231167

DIRECTIONS: From New Castle, take PA 65 S. for 6 miles; then turn left onto Shaffer Rd. In 1.5 miles, the parking area for the trail will be on your right.

WEBSITE: www.dcnr.pa.gov/stateparks/findapark/mcconnellsmillstatepark

WATERWAY: Hell Run

HEIGHT: 10–15 feet **CREST:** 20–25 feet

NEAREST TOWN: New Castle

HIKE DIFFICULTY: Easy–moderate

TRAIL QUALITY: A flat dirt path becomes slightly difficult in the last 50 feet to the falls.

ROUND-TRIP DISTANCE: 1 mile

TRIP REPORT & TIPS:

Hell's Hollow Falls is located on the western edge of McConnells Mill State Park, just a few miles outside of New Castle, Pennsylvania.

From the parking area, it's an easy 0.5-mile hike to the waterfall. The trail is easy to follow, but make sure to stay right at the split about 0.1 mile into the hike, and then follow along the creek until you reach Hell's Hollow Falls.

Along the way, Hell Run cuts a scar across the land, with the stream running a few feet below ground level in a narrow flume. If you look carefully, you can also notice several sinkholes along the way that have been created by the limestone underneath the surface of this hollow.

Getting to the bottom of Hell's Hollow Falls is fairly simple, thanks to a wooden staircase next to the falls. Nevertheless, use caution in the area of the waterfall, as the rocks can be slippery and the lead-up to the stairs is a bit steep.

Just to the side of the waterfall are the remains of a brick-lined limekiln. This historical structure next to the waterfall adds to the beauty of the area and gives you one more reason to make the short hike to Hell's Hollow Falls.

It should also be noted that getting a side view of Hell's Hollow Falls is quite easy, but if you want to view it from the front, be prepared to get your feet wet: a crossing of Hell Run is required at the bottom of the falls.

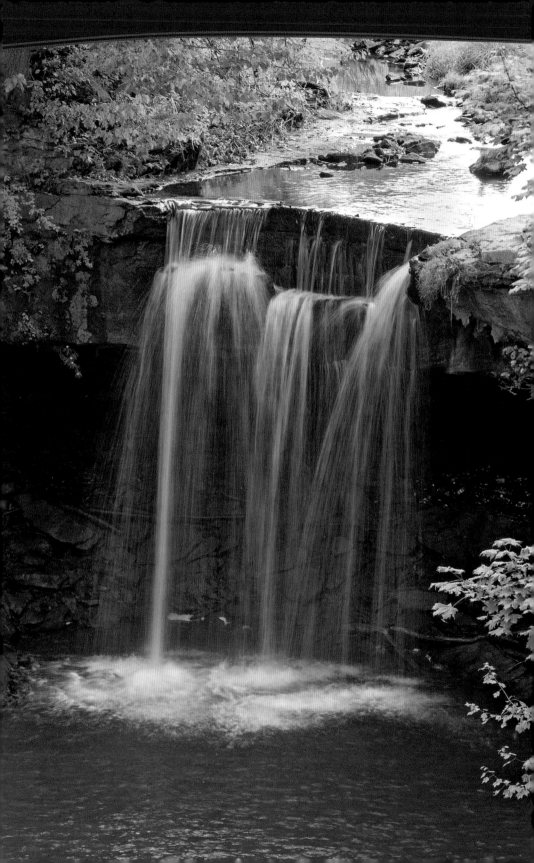

Big Run Falls

LOCATION: Cascade Park

ADDRESS/GPS FOR THE FALLS: 40.976972, -80.319583

DIRECTIONS: From downtown New Castle, take PA 65 S. for 1.5 miles. Turn right into Cascade Park, and then take the first left. Follow the road for 0.1 mile, and park in the dirt lot on the left.

WEBSITE: www.uncoveringpa.com/how-get-big-run-falls-new-castle-pennsylvania

WATERWAY: Big Run

HEIGHT: 20–25 feet **CREST:** 10–12 feet

NEAREST TOWN: New Castle

HIKE DIFFICULTY: NA

TRAIL QUALITY: NA

ROUND-TRIP DISTANCE: Roadside

TRIP REPORT & TIPS:

Big Run Falls is located in the center of Cascade Park on the outskirts of downtown New Castle. Cascade Park is a former amusement park that operated from 1897 until the early 1980s. The park was home to roller coasters, many amusement rides, and what at one time was the largest dance hall in Pennsylvania.

This 20- to 25-foot-tall waterfall is located along the edge of a very large hollow. This circular area makes it difficult to get close to Big Run Falls, but it also offers a great vantage point from which to view the waterfall. This viewing area is located adjacent to the roadway through the park and close to a parking area, making this a very easy waterfall to visit.

Just downstream of the waterfall, you can see supports that used to be part of The Comet, a roller coaster that was built in 1955 and used to dive into the valley near the waterfall. Also in the park are the remains of several buildings that used to house amusement park rides and concession stands.

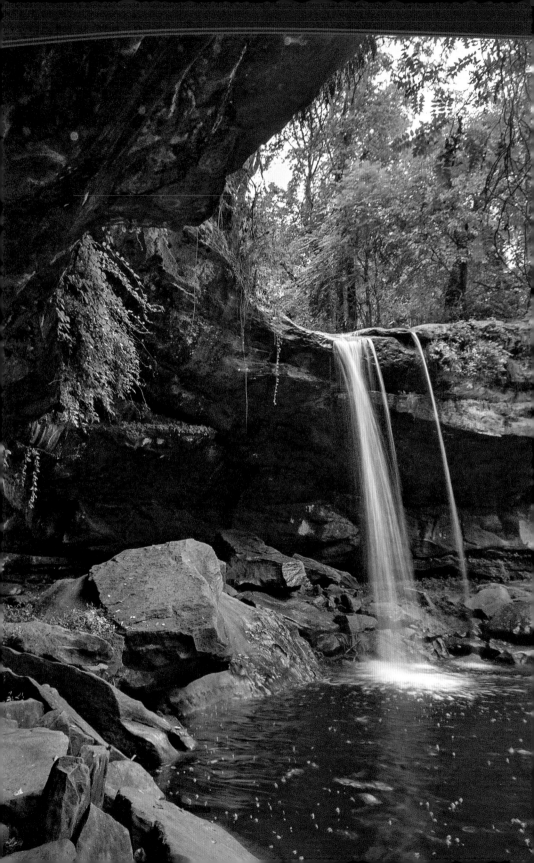

Buttermilk Falls

LOCATION: Buttermilk Falls Natural Area

ADDRESS/GPS FOR THE FALLS: 40.814361, -80.327861

DIRECTIONS: From Exit 13 off the Pennsylvania Turnpike/I-76, take PA 18 S. toward Beaver Falls. The entrance to the park is 0.1 mile south of the interstate on your right. Park in the small lot just past the park sign.

WEBSITE: www.beavercountypa.gov/depts/rectour/pages/buttermilkfallspark.aspx

WATERWAY: Clarks Run

HEIGHT: 20–25 feet **CREST:** 8–10 feet

NEAREST TOWN: Beaver Falls

HIKE DIFFICULTY: Easy

TRAIL QUALITY: A dirt trail to the base of the falls, with one set of wooden stairs

ROUND-TRIP DISTANCE: 0.5 mile

TRIP REPORT & TIPS:

Buttermilk Falls (also known as Homewood Falls) is a plunge waterfall that drops into a greenish pool. A train track runs just above the top of the falls, making this a great waterfall for those who, like me, love both trains and waterfalls.

The bottom of the falls, reached from the lower parking area, is a fairly easy 5-minute hike from the parking area along the only trail in the park. Along the way, you'll pass through an old quarry on your right and several smaller cascades along Clarks Run to your left.

From the lower area, it's possible to walk behind the falls, thanks to the overhang carved by the falling water.

To reach the top of the waterfall, return to your car and drive up the hill. Park in the church parking lot and walk to the right side of it; the top of the falls and an information sign are accessible down a very short path.

Pioneer Falls

LOCATION: Oil Creek State Park

ADDRESS/GPS FOR THE FALLS: 41.541583, -79.666639

DIRECTIONS: From Titusville, take PA 8 S. for 5.4 miles. Turn left onto Petroleum Center Rd., and travel for 1.2 miles; then turn left onto Pioneer Rd. After 1.7 miles, park in the pull-off to your left, adjacent to a state park sign.

WEBSITE: www.dcnr.pa.gov/stateparks/findapark/oilcreekstatepark

WATERWAY: Pioneer Run

HEIGHT: 15–20 feet **CREST:** 8–10 feet

NEAREST TOWN: Titusville

HIKE DIFFICULTY: Easy

TRAIL QUALITY: Well-established dirt trail

ROUND-TRIP DISTANCE: 1.2 miles

TRIP REPORT & TIPS:

A sign adjacent to the southernmost waterfall in Oil Creek State Park calls it Gregg Falls, but the park map and common usage refer to it as Pioneer Falls.

From the parking area, cross Pioneer Road and pick up the Gerard Trail. It's slightly overgrown in places but easy to follow as it meanders through the woods.

Soon you'll notice a large wooden tank in the woods to the left of the trail. This is one of the park's many remnants of the oil industry that once dominated the area. Just north of the park, the world's first purposefully dug oil well was built, and this valley was once home to tens of thousands of prospectors seeking their fortune during the world's first oil boom.

About halfway into the hike, the trail enters a couple of switchbacks and then descends a small wooden staircase. At the bottom of the stairs, turn right and continue the rest of the way to the top of Pioneer Falls.

Trying to get to the base of the falls isn't recommended from this spot, but there are great views from the top, as well as a bench where you can relax for a bit. It's also worth noting that Pioneer Falls is best seen when water levels are higher—it can be just a trickle during the drier times of the year.

The Gerard Trail continues over the top of the falls, but instead of following it farther, turn around and return to your car the way you came.

Frankfort Mineral Springs Falls

LOCATION: Raccoon Creek State Park

ADDRESS/GPS FOR THE FALLS: 40.498472, -80.431417

DIRECTIONS: From downtown Pittsburgh, take I-376 W. for 10 miles. Take Exit 60A onto US 22, and continue for 15 miles. Take the PA 18 N. exit, and turn left. After 5.7 miles, the parking lot will be on your left.

WEBSITE: www.dcnr.pa.gov/stateparks/findapark/raccooncreekstatepark

WATERWAY: Unnamed

HEIGHT: 8–10 feet **CREST:** 3–5 feet

NEAREST TOWN: Frankfort Springs

HIKE DIFFICULTY: Easy

TRAIL QUALITY: A relatively flat dirt trail

ROUND-TRIP DISTANCE: 0.6 mile

TRIP REPORT & TIPS:

From the parking area, take the Mineral Springs Loop Trail clockwise. The trail runs alongside the creek, and in about 0.25 mile, you'll arrive at a U-shaped grotto where you'll find Frankfort Mineral Springs Falls.

This unique plunge waterfall is named after the spring that flows out of the rocks just to the falls' right. While it's not overly tall, the setting makes this an amazing waterfall to visit.

To return to your car, continue following the trail up a short flight of stairs. At the top, you'll see some ruins from the resort that used to draw people here for the purported healing powers of the spring. Follow the trail to the right for 0.3 mile to return to the parking area.

Springfield Falls

LOCATION: State Game Lands 284

ADDRESS/GPS FOR THE FALLS: 41.144111, -80.217806

DIRECTIONS: From I-80, take Exit 15, and turn south onto US 19. Travel 3.5 miles, and turn left onto Leesburg Station Rd. After 0.1 mile, continue straight at the split, and park in the dirt lot on your right.

WEBSITE: www.uncoveringpa.com/springfield-falls

WATERWAY: Hunters Run

HEIGHT: 15–20 feet **CREST:** 40–50 feet

NEAREST TOWN: Mercer

HIKE DIFFICULTY: Easy

TRAIL QUALITY: Dirt trail to top of falls, a slippery hillside to bottom

ROUND-TRIP DISTANCE: 0.1 mile

TRIP REPORT & TIPS:

From the parking area, cross the road and follow the trail into the woods. In less than 100 feet, you'll come to the top of Springfield Falls. From here, you'll have great views overlooking the falls and the mill ruins on the other side of Hunters Run.

If you want to go to the bottom, carefully descend the steep hillside next to the viewing area. This can be difficult if the ground is muddy, so use caution; also note that at the bottom, the opposite bank of the stream is private property.

On the far side of the stream are the remains of Springfield Furnace, also known as Seth and Hill Furnace, after the men who built it. Built in the mid-to-late 1830s, this iron furnace operated until 1862.

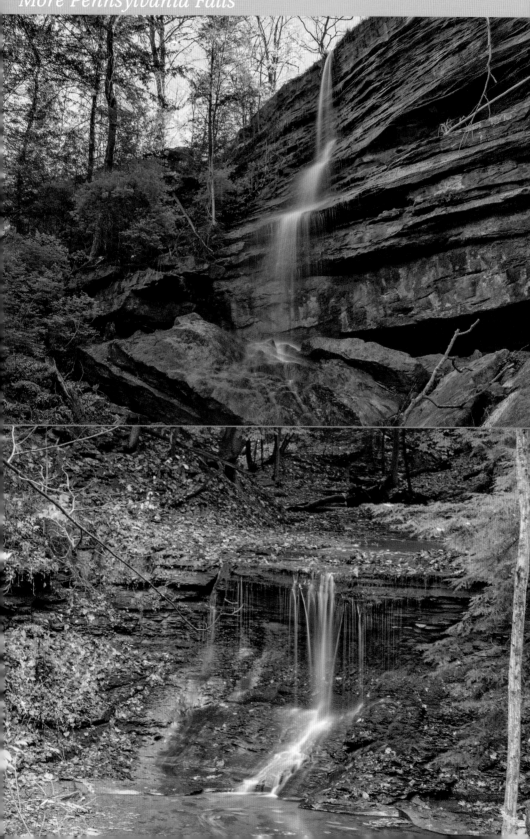

Alpha Falls

LOCATION: McConnells Mill State Park

ADDRESS/GPS FOR THE FALLS: 40.960639, -80.169167

DIRECTIONS: From New Castle, take US 422 E. for 9 miles. Turn right onto McConnells Mill Rd. In 0.6 mile, park in the small dirt lot on your right next to a sign that says ALPHA PASS.

WEBSITE: www.dcnr.pa.gov/stateparks /findapark/mcconnellsmillstatepark

WATERWAY: Unnamed

HEIGHT: 40–50 feet **CREST:** 1–3 feet

NEAREST TOWN: New Castle

HIKE DIFFICULTY: Moderate

TRAIL QUALITY: Wooden steps and a rock trail

ROUND-TRIP DISTANCE: 0.25 mile

TRIP REPORT & TIPS:

Alpha Falls is the tallest waterfall in McConnells Mill State Park, but as it flows only seasonally, you'll want to hit this one only if it's been very rainy recently.

From the parking area, take the trail away from the road down the North Country Trail (also known as the Alpha Pass Trail at this point). The trail follows a set of switchbacks and steps to the bottom of the rock wall.

After a short distance, the railing opens at the bottom of the cliff. Looking along the cliff to your right, you'll notice an obvious but unmarked trail. Follow this trail for less than 100 yards to the base of Alpha Falls.

If you find yourself near the park's mill and covered bridge, you can also follow the Alpha Pass Trail for 1.5 miles to Alpha Falls.

Grindstone Falls

LOCATION: McConnells Mill State Park

ADDRESS/GPS FOR THE FALLS: 40.915472, -80.194500

DIRECTIONS: From US 19 N. in Portersville, turn left onto W. Portersville Rd., and in 1.9 miles turn right onto Mountville Rd. After driving for 0.8 mile, park in the dirt lot on the right.

WEBSITE: www.uncoveringpa.com /grindstone-falls

WATERWAY: Grindstone Run

HEIGHT: 8–10 feet **CREST:** 8–10 feet

NEAREST TOWN: Portersville

HIKE DIFFICULTY: Moderate

TRAIL QUALITY: An unmarked but easy-to-follow dirt trail

ROUND-TRIP DISTANCE: 1 mile

TRIP REPORT & TIPS:

Grindstone Falls is a fantastic hidden gem in McConnells Mill State Park. This trail isn't overly difficult, but be aware that while you are on park land and along a well-trod path to the falls, there are no markings along the route.

From the parking area, return to the road and turn right. Walk along the road for 400 feet until you come to a gated road on your right. Take this for a couple hundred feet until you come to a clearing with a tower. Keeping the tower on your right, walk to the back left corner of the clearing, where you'll find an obvious but unmarked trail.

The trail winds downhill about 0.4 mile, taking you directly to Grindstone Falls.

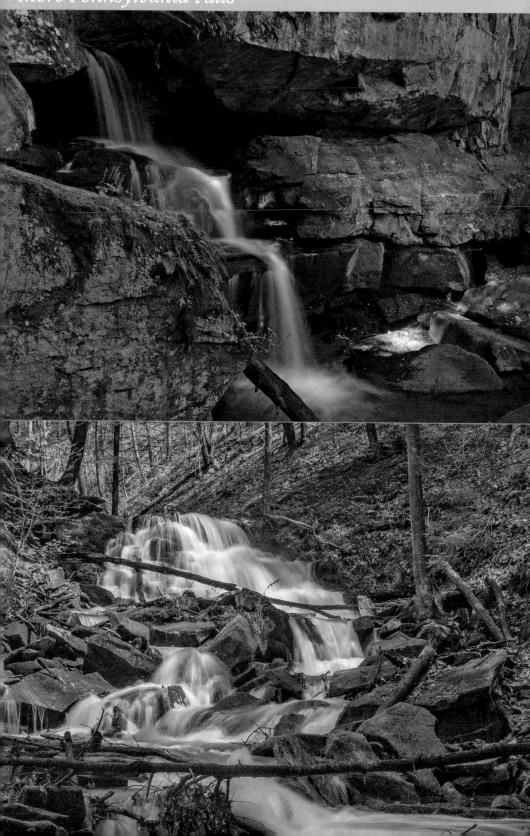

Breakneck Falls

LOCATION: McConnells Mill State Park

ADDRESS/GPS FOR THE FALLS: 40.937528, -80.178639

DIRECTIONS: From US 19 N. in Portersville, turn left onto Cheeseman Rd., and drive 2 miles. Park in the dirt lot on the right side of the road.

WEBSITE: www.uncoveringpa.com/breakneck -falls-mcconnells-mill-state-park

WATERWAY: Cheeseman Run

HEIGHT: 25 feet **CREST:** 3–5 feet

NEAREST TOWN: Portersville

HIKE DIFFICULTY: Moderate

TRAIL QUALITY: Quiet road and dirt trail

ROUND-TRIP DISTANCE: 1.25 miles

TRIP REPORT & TIPS:

From the parking area, turn right and follow Cheeseman Road downhill. Where the road makes a sharp right turn, you can get some views of the falls from the old bridge. If you opt to view the falls from above, use caution and don't cross the guardrail—people have died after getting too close to the edge of the cliffs.

To reach the base of the falls, continue following the road downhill for a total of about 0.3 mile. At the bottom of the road, you'll reach Eckert Bridge. Parking next to the bridge would cut your hike in half, but the road here is very rutted (an SUV is recommended).

Once at the bridge, turn left to follow the trail downstream along Slippery Rock Creek. After about 0.3 mile, you'll come to Cheeseman Run. Turn up this waterway, and follow it a few hundred feet to the base of Breakneck Falls.

Miller Falls

LOCATION: Oil Creek State Park

ADDRESS/GPS FOR THE FALLS: 41.576472, -79.652361

DIRECTIONS: From Titusville, take PA 8 S. for 1.8 miles; then turn left onto Black Rd. After 0.7 mile, turn right onto Miller Farm Rd., and follow it 1.9 miles to a small pull-off on the left side of the road.

WEBSITE: www.dcnr.pa.gov/stateparks /findapark/oilcreekstatepark

WATERWAY: Miller Run

HEIGHT: 12–15 feet **CREST:** 5–7 feet

NEAREST TOWN: Titusville

HIKE DIFFICULTY: Moderate

TRAIL QUALITY: Established dirt trails to top of falls but a difficult descent to bottom

ROUND-TRIP DISTANCE: 0.5 mile

TRIP REPORT & TIPS:

Of the waterfalls in Oil Creek State Park, Miller Falls is by far the quickest to see, though a steep descent is required to get to the base. It's also typically the last waterfall to run dry, though it may be little more than a trickle in drier months.

From the pull-off, head back up the road for about 100 feet until you see a trail on your right. Follow this trail for about 5 minutes to the top of Miller Falls.

Getting to the bottom of Miller Falls is quite difficult—the unofficial path down is very steep and often muddy. If you choose to do this, use extreme caution.

Also note that the road to the parking area is rutted in places, so be careful when driving.

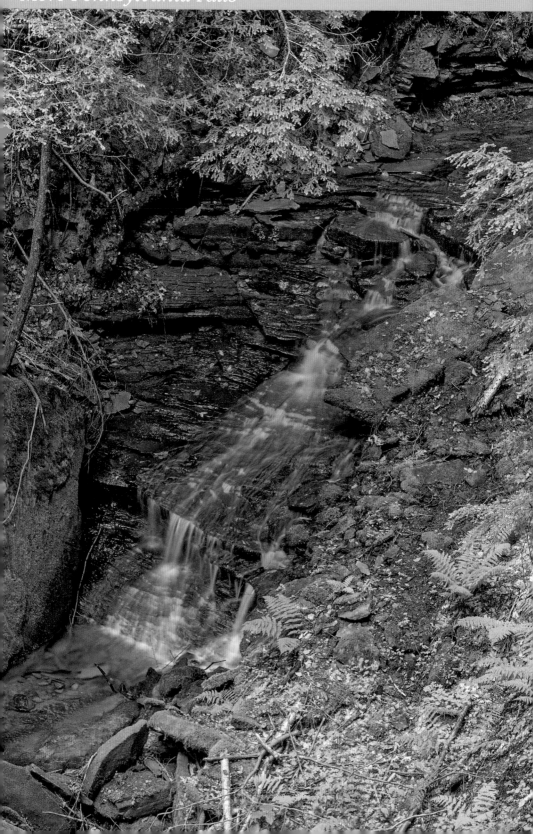

Plum Dungeon Falls

LOCATION: Oil Creek State Park

ADDRESS/GPS FOR THE FALLS: 41.556694, -79.645139

DIRECTIONS: From Titusville, take PA 8 S. for 1.8 miles; then turn left onto Black Rd. After 0.7 mile, turn right onto Miller Farm Rd., and drive 3.2 miles, crossing Oil Creek on an old bridge, to a pull-off on the left side of the road.

WEBSITE: www.dcnr.pa.gov/stateparks/findapark/oilcreekstatepark

WATERWAY: Unnamed

HEIGHT: 10–12 feet **CREST:** 3–5 feet

NEAREST TOWN: Titusville

HIKE DIFFICULTY: Moderate

TRAIL QUALITY: A well-established dirt trail with a few small stream crossings

ROUND-TRIP DISTANCE: 1.8 miles

TRIP REPORT & TIPS:

From the parking area, cross the road and pick up the Gerard Trail as it heads into the woods. The trail starts off flat but quickly gains elevation, climbing 200 feet in the first 0.3 mile. If it's been raining a lot recently, this part of the trail can also be fairly muddy.

The last two-thirds of the trail is relatively flat and meanders along the edge of the park. Between 0.6 and 0.75 mile, you'll cross six small and usually dry stream-beds, only one of which has a bridge.

Once you cross the last dry stream, it's a short climb to the top of the rise and the view of Plum Dungeon Falls.

Located deep in a ravine about 100 yards from the viewing area, Plum Dungeon is best seen after heavy rains, as it can run dry during much of the year.

Note that the dirt road to the parking area is rutted in places, so be careful when driving.

18 More Waterfalls to Explore

	GPS Coordinates	Location	Height
Buttermilk Falls 41.009083, -75.132611		The Poconos Roadside northeast of Stroudsburg	15–20 feet
Saylorsville Dam Falls 41.040333, -75.699306		The Poconos Hickory Run State Park	18–20 feet
Mineral Spring Falls 41.449972, -76.575306		Northeastern Pennsylvania Loyalsock State Forest	12–15 feet
Andrea Falls 41.426944, -76.686194		Northeastern Pennsylvania Loyalsock State Forest	15 feet
Middle Branch Falls 41.492278, -76.770444		Northeastern Pennsylvania Loyalsock State Forest	15–20 feet
Colley Falls 41.521222, -76.291806		Northeastern Pennsylvania State Game Lands 66	15–20 feet

	GPS Coordinates	Location	Height
	Bowling Alley Falls 41.696000, -76.227111	Northeastern Pennsylvania Roadside near Wyalusing	10–12 feet
	Big Run Falls 41.333917, -76.335806	Northeastern Pennsylvania Roadside in State Game Lands 13	15 feet
	Falling Springs Falls 41.363111, -75.802361	Northeastern Pennsylvania Roadside near Pittston	40–50 feet
	Letort Falls 40.235083, -77.141861	Southeastern Pennsylvania Carlisle	5 feet
	Caledonia Falls 39.907500, -77.478111	Southeastern Pennsylvania Caledonia State Park	10 feet
	Wykoff Run Falls 41.267667, -78.152972	Pennsylvania Wilds Quehanna Wild Area	3–4 feet

18 More Waterfalls to Explore (continued)

	GPS Coordinates	Location	Height
	Bear Run Falls 41.713417, -77.464750	Pennsylvania Wilds Colton Point State Park	6–8 feet
	Stone Quarry Run Falls 41.572472, -77.382944	Pennsylvania Wilds Tioga State Forest	6–8 feet
	Natural Waterslides 39.862083, -79.494333	Laurel Highlands Ohiopyle State Park	15–20 feet
	Stewarton Falls 39.928472, -79.478056	Laurel Highlands Bear Run Nature Reserve	15 feet
	Great Passage Falls 39.983917, -79.589889	Laurel Highlands Great Allegheny Passage south of Connellsville	12–15 feet
	Kildoo Falls 40.950056, -80.170889	Western Pennsylvania McConnells Mill State Park	10–12 feet

Pennsylvania Waterfalls Checklist

The Poconos

Northeastern Pennsylvania

Rail-Trails Pennsylvania

Rails-to-Trails Conservancy

**ISBN: 978-0-89997-967-0 • $18.95 • 5.5 x 8.5
paperback • 272 pages • full color • 2nd edition**

Explore 70 of the best rail-trails and multiuse pathways across Pennsylvania

All across the country, unused railroad corridors have been converted into public multiuse trails. Here, the experts from Rails-to-Trails Conservancy present the best of these rail-trails, as well as other multiuse pathways, in Pennsylvania. Take a cultural journey along Pittsburgh's Three Rivers Heritage Trail, or enjoy a speedy out-and-back on the Greene River Trail. Explore Harrisburg via the Capital Area Greenbelt, or experience the countryside along the Redbank Valley Trail.

You'll appreciate the detailed maps for each trail, plus driving directions to trailheads. Quick, at-a-glance icons indicate which activities each trail can accommodate, from biking to fishing to snowmobiling. Best of all, the succinct descriptions are written by rail-trail experts, so you know it's information that you can rely on! Whether you're on feet, wheels, or skis, you'll love the variety in this collection of multiuse trails—from beautiful waterways and scenic areas to the hustle and bustle of the state's urban centers!

60 Hikes Within 60 Miles: Philadelphia

Lori Litchman

ISBN: 978-1-63404-066-2 • $18.95 • 6 x 9
paperback • 256 pages • full color • 2nd edition

The Best Way to Experience Philadelphia Is by Hiking It

Get outdoors with local author and hiking expert Lori Litchman. These trails transport you to scenic overlooks, wildlife hot spots, and historical settings that renew your spirit and recharge your body. Go bird-watching at John Heinz National Wildlife Refuge. See the unique ecosystem at the New Jersey Pine Barrens, with its diverse plant and animal life. Enjoy nature in Wissahickon Valley Park, which is only minutes from the city center and has over 50 miles of trails. Whether you are a local looking for new places to explore, or a visitor in the area for business or pleasure, *60 Hikes Within 60 Miles: Philadelphia* will provide plenty of options for outings lasting a full day to a couple of hours, all within about an hour's drive of Philadelphia and the surrounding communities.

60 Hikes Within 60 Miles: Harrisburg

Matt Willen

ISBN: 978-1-63404-014-3 • $18.95 • 6 x 9
paperback • 320 pages • 2nd edition

It's Time to Take a Hike in Harrisburg, Pennsylvania!

Although known predominantly for its Pennsylvania Dutch culture, the Gettysburg battlefield, and the cities of Harrisburg, Lancaster, and York, south-central Pennsylvania is home to many tracts of public lands that offer a diverse array of hiking experiences. From the gentle farm country of Lancaster and York Counties to the steep-sided ravines along the Susquehanna River and the rugged ridges north of Harrisburg to the rolling hills of South Mountain, you'll find hikes to suit about any taste and interest. *60 Hikes Within 60 Miles: Harrisburg*, by local outdoorsman Matt Willen, provides the first and most comprehensive hiking guide to the region. This guide features information on the history and natural history of the areas the hikes pass through, detailed trail maps and elevation profiles, clear directions to the trailheads and trailhead GPS data, and tips on nearby activities.

About the Author

Jim Cheney has been exploring Pennsylvania since 2013 and is the author of the popular travel website **UncoveringPA.com.** Jim has visited every county in Pennsylvania and hiked to hundreds of waterfalls throughout the state. Before he started his Pennsylvania explorations, he spent two and a half years living and traveling in Asia, where he also enjoyed visiting many beautiful waterfalls in exotic locales such as South Korea, Laos, and Mongolia. He lives in Harrisburg with his wife and two children.